Chuck,
 I thought you'd enjoy
this book since you
love history!
 Merry Christmas
 & Happy New Year
 Sunny

Christmas 2011

HISTORIC PHOTOS OF
NORFOLK

TEXT AND CAPTIONS BY PEGGY HAILE McPHILLIPS

TURNER
PUBLISHING COMPANY

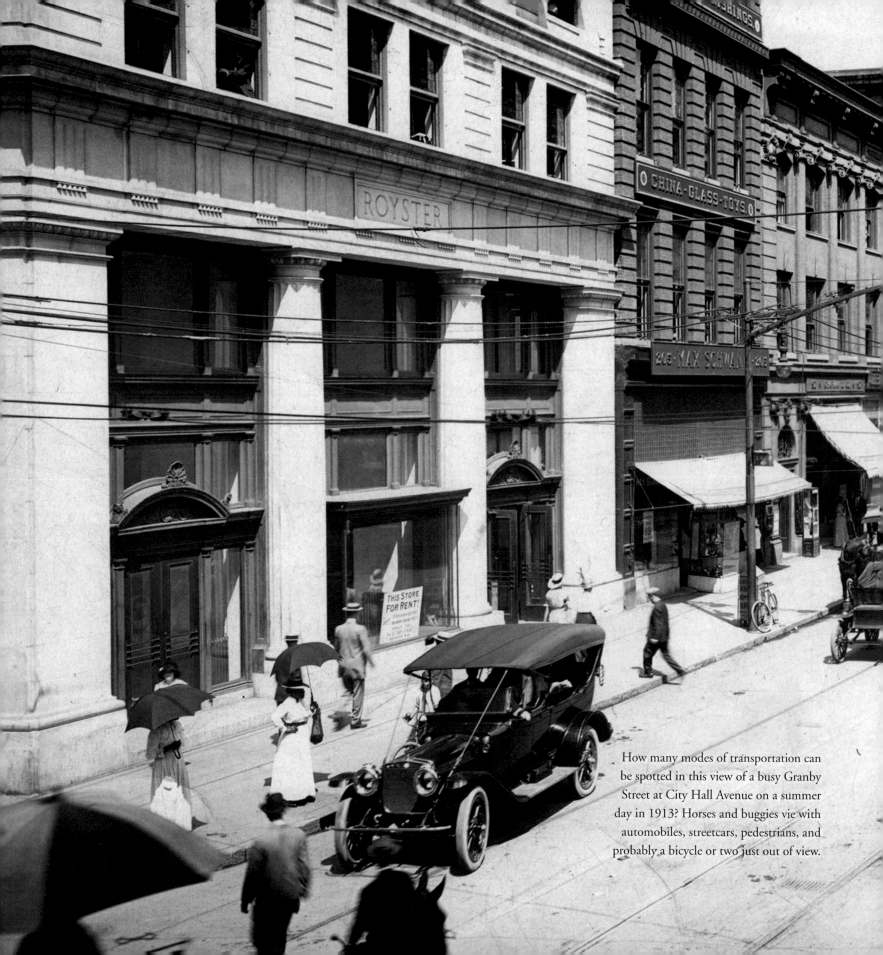

How many modes of transportation can be spotted in this view of a busy Granby Street at City Hall Avenue on a summer day in 1913? Horses and buggies vie with automobiles, streetcars, pedestrians, and probably a bicycle or two just out of view.

HISTORIC PHOTOS OF
NORFOLK

Turner Publishing Company
200 4th Avenue North • Suite 950
Nashville, Tennessee 37219
(615) 255-2665

www.turnerpublishing.com

Historic Photos of Norfolk

Library of Congress Control Number: 2006937086

ISBN: 978-1-59652-332-6

Printed in The United States of America

11 12 13 14 15—0 9 8 7 6 5 4 3

CONTENTS

Ocean View Park in 1920, with the Ocean View Hotel in the
foreground. There are at least as many people strolling the boardwalk or
relaxing on benches in the park as there are in the water.

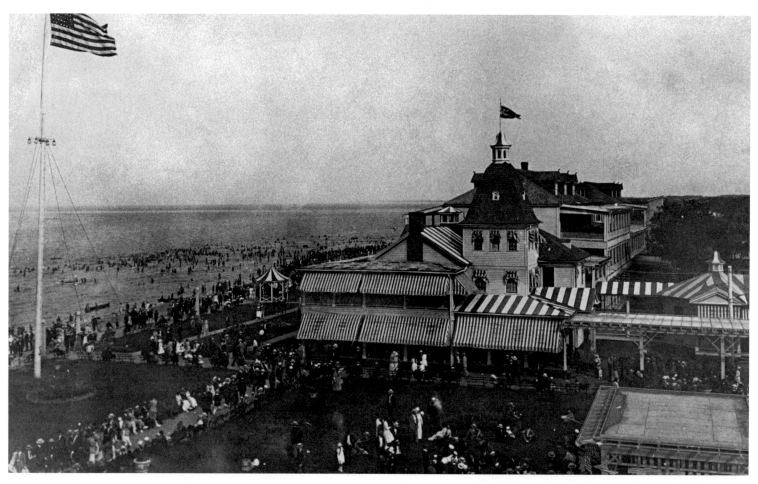

ACKNOWLEDGMENTS

This volume, *Historic Photos of Norfolk,* is the result of the cooperation and efforts of many individuals, organizations, and corporations. It is with great thanks that we acknowledge the valuable contribution of the following for their generous support:

The Sargeant Memorial Room, Norfolk Public Library
The Harry C. Mann Collection of the Library of Virginia
Library of Congress

We would also like to thank the following individuals for valuable contributions and assistance in making this work possible:

W. Troy Valos, for his discovery of many previously unprinted negatives in the Norfolk Public Library collection; Terry McPhillips, for giving up use of the dining room table and many weekends while his wife was laying out this book; and all the gentlemen on the other side of the lens—photographers such as Harry C. Mann, Charles Borjes, H. D. Vollmer, Carroll Walker, and more, who captured our triumphs, our tragedies, and glimpses into our everyday lives, represented on the pages of this book.

PREFACE

Norfolk has thousands of historic photographs that reside in archives, both locally and nationally. This book began with the observation that, while those photographs are of great interest to many, they are not easily accessible. During a time when Norfolk is looking ahead and evaluating its future course, many people are asking, "How do we treat the past?" These decisions affect every aspect of the city—architecture, public spaces, commerce, infrastructure—and these, in turn, affect the way that people live their lives. This book seeks to provide easy access to a valuable, objective look into the history of Norfolk.

The power of photographs is that they are less subjective than words in their treatment of history. Although the photographer can make decisions regarding subject matter and how to capture and present it, photographs do not provide the breadth of interpretation that text does. For this reason, they offer an original, untainted perspective that allows the viewer to interpret and observe.

This project represents countless hours of review and research. The writer has reviewed thousands of photographs in numerous archives and greatly appreciates the generous assistance of the individuals and organizations listed in the acknowledgments of this work, without whom this project could not have been completed.

The goal in publishing this work is to provide broader access to this set of extraordinary photographs that seek to inspire, provide perspective, and evoke insight that might assist people who are responsible for determining Norfolk's future. In addition, the book seeks to preserve the past with adequate respect and reverence.

With the exception of touching up imperfections caused by the damage of time and cropping where necessary, no other changes have been made. The focus and clarity of many images is limited to the technology and the ability of the photographer at the time they were taken.

The work is divided into eras. Beginning with some of the earliest known photographs of Norfolk, the first section

records photographs through the first five years of the twentieth century. The second section continues with the early years of the twentieth century through World War I and up to 1920. Section Three moves from the 1920s through World War II. The last section covers the postwar era to recent times.

In each of these sections we have made an effort to capture various aspects of life through our selection of photographs. People, commerce, transportation, infrastructure, religious institutions, and educational institutions have been included to provide a broad perspective.

We encourage readers to reflect as they go walking in Norfolk, strolling through the city, its parks, and its neighborhoods. It is the publisher's hope that in utilizing this work, longtime residents will learn something new and that new residents will gain a perspective on where Norfolk has been, so that each can contribute to its future.

—Todd Bottorff, Publisher

Taken in 1875 by Richmond photographer George Cook, this may be the earliest existing
photograph of the downtown Norfolk waterfront along the eastern branch of the Elizabeth River.
Town Point is at the right, and the end of today's City Hall Avenue is at the left where the dome of
the 1850 Norfolk City Hall and Courthouse (today's MacArthur Memorial) can be seen faintly.

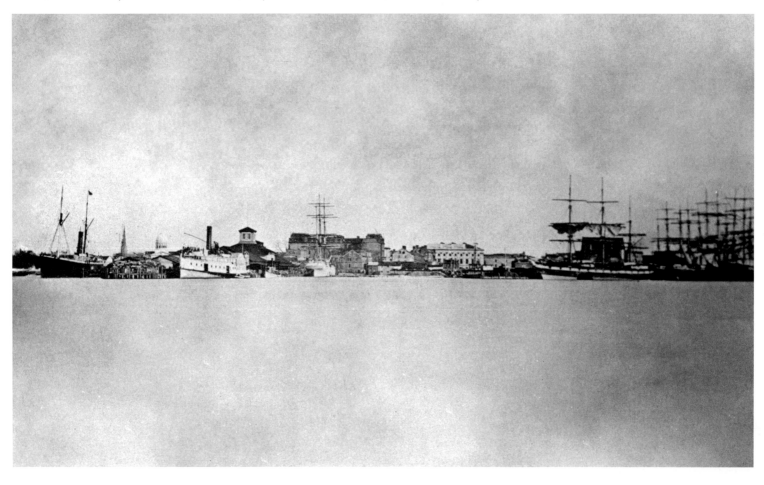

WAR AND PEACE AND A NEW CENTURY

(1860–1905)

Norfolk was established in 1683 as a port of 50 acres, primarily because of its deep, ice-free natural harbor. It achieved borough status in 1736 and, with a population of 6,000 on the eve of the American Revolution, was the largest town in Virginia and the eighth largest in the American colonies. Norfolk was burned to the ground by a combination of British and Patriot forces in early 1776, but the town had surpassed its pre–Revolutionary War population by 1800 and was a thriving port carrying on a brisk trade with Europe and the West Indies until the Embargo Act of 1807 almost ruined it economically. Nearly every family in the city was affected by an epidemic of yellow fever in the summer of 1855 and a third of the resident population died. As if in the next breath, war—the American Civil War—was on our doorstep.

In 1862, with lines drawn between loyal Union states and the newly-formed Confederacy, one of the most famous naval battles in history took place in Hampton Roads, as the USS *Monitor* and CSS *Virginia* (formerly the USS *Merrimac*) engaged in the first battle between ironclad warships, changing the course of naval warfare forever, as it became clear that a wooden Navy had no future. Two months after the battle, Norfolk Mayor William Lamb surrendered the city to Federal troops, and Norfolk was occupied for the duration of the war.

After the Civil War, Norfolk County's rich waterways and farmland supported a gradual return to economic stability. Princess Anne and Norfolk counties became leaders in truck farming, supplying more than half of all greens and potatoes consumed on the East Coast. Lynnhaven oysters were another major export. Railroads opened the way for the transportation of coal, and by the mid-1880s coal would replace cotton as Norfolk's primary export.

A group of Union soldiers, bottom center, march up Bank Street from Main around 1865. Norfolk was occupied by Federal troops from May 10, 1862, until the end of the Civil War.

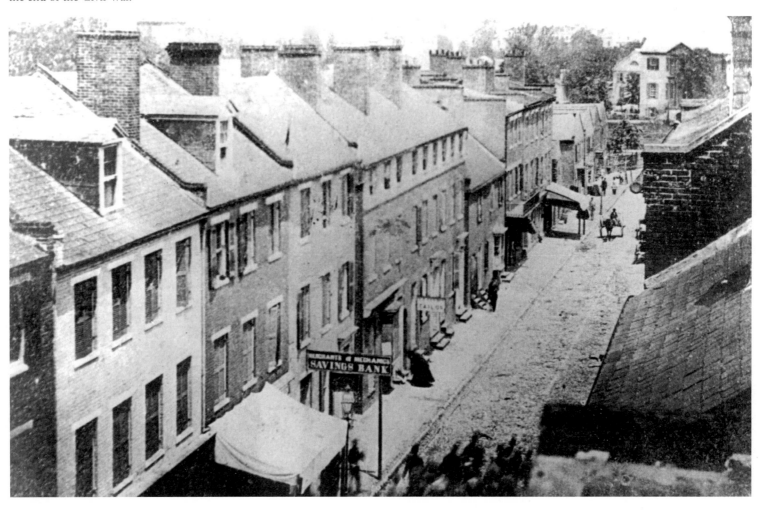

The Stone Bridge, also known as the Humpback Bridge, was built in 1818 to connect south Granby Street with north Granby Street, spanning Town Back Creek. The improved access enabled the development of a residential community to the north of the original town. Town Back Creek was completely filled by 1905 and is the site of City Hall Avenue today.

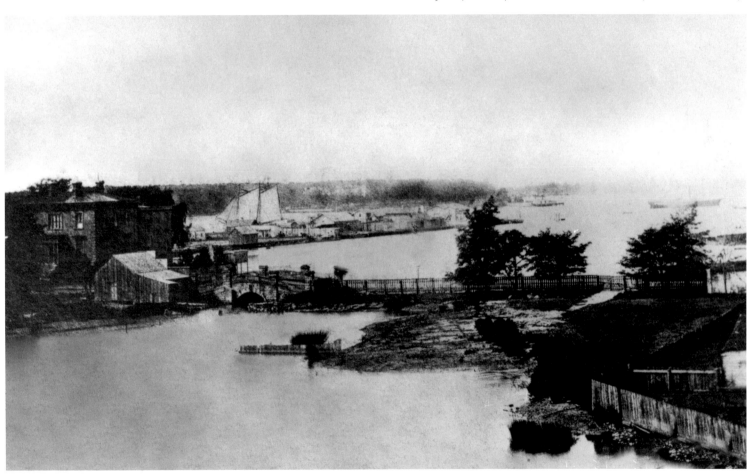

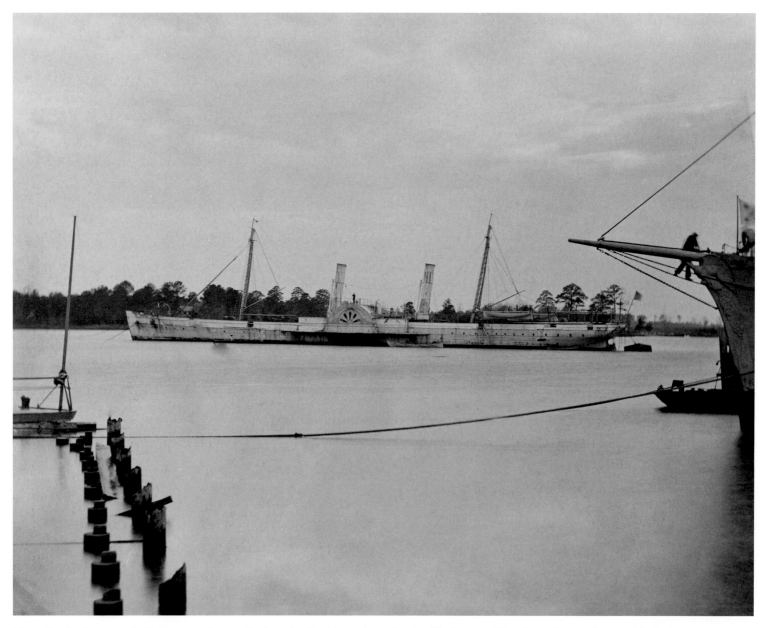

The side-wheel steamer USS *Fort Donelson* was built in Scotland in 1860 as the *Giraffe*. She served briefly as the Confederate blockade runner *Robert E. Lee* before being captured in November 1863 and converted into a warship for the Union Navy, assigned to the North Atlantic Blockading Squadron. She assisted in the capture of Fort Fisher and is seen here at the Norfolk Navy Yard in December 1864.

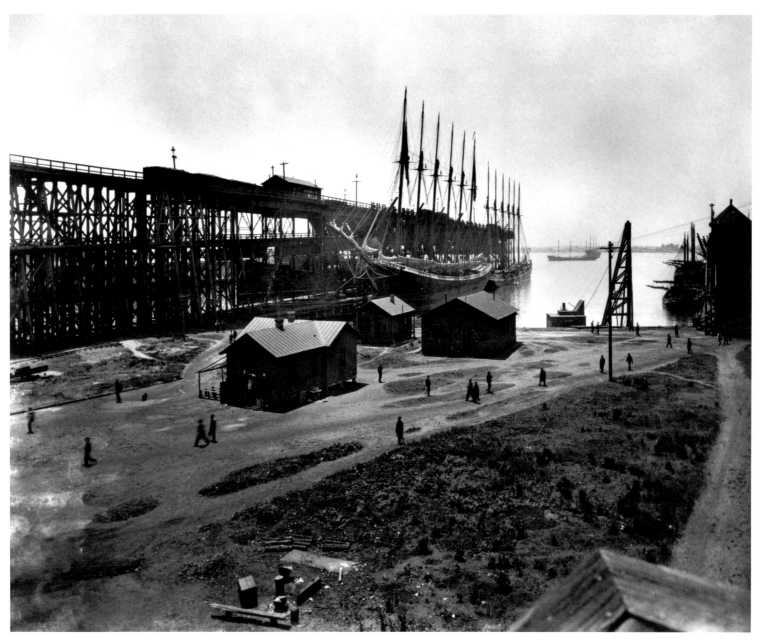

The first carload of coal arrived in Norfolk by rail from West Virginia in 1883 and soon replaced cotton as Norfolk's number one export. Coal and cargo piers were moved from downtown to this location, Lamberts Point, in 1886, and a residential community soon developed to house and serve the workers and their families. By 1900, Norfolk was the leading coal-exporting port on the East Coast—the industry continued to grow even through the Great Depression. Lamberts Point was annexed to the city of Norfolk in 1911.

Replacing an 1824 structure, this U.S. Customhouse and Post Office on Main Street was begun in 1852 and completed in 1859. Construction was delayed by the months-long yellow fever epidemic of 1855, in which many workers died and more deserted the Norfolk job permanently. Built after the design of Ammi B. Young, first Supervising Architect of the U.S. Treasury Department, the Customhouse was renovated in the 1990s and, in September 2000, was rededicated as the Owen B. Pickett U.S. Customhouse.

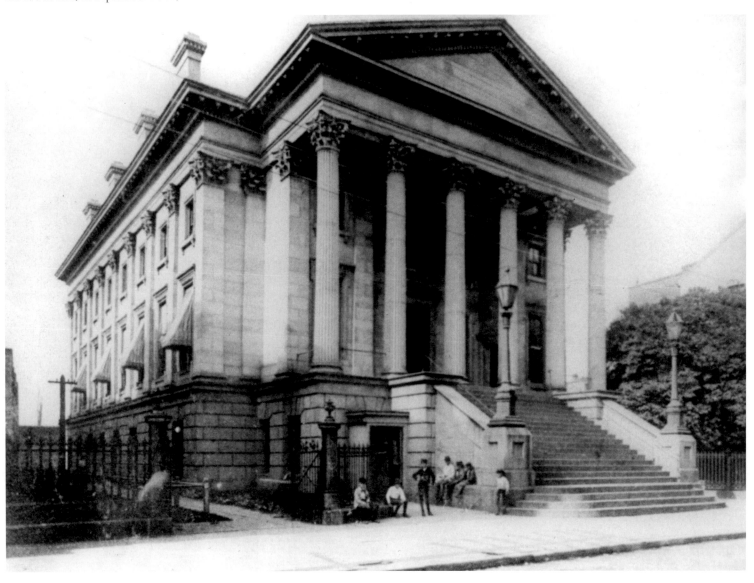

The Norfolk Academy, around 1892. Norfolk Academy was founded in 1804. Thomas U. Walter of Philadelphia, Architect of the United States Capitol, designed this building for the private boys' academy in 1840, patterning it after the Grecian-Doric Temple of Theseus at Athens. It served as a hospital for Union soldiers during the Civil War and as the Norfolk post office during the yellow fever epidemic of 1855. The Academy occupied the building until 1916. It serves as the headquarters for the Hampton Roads Chamber of Commerce today.

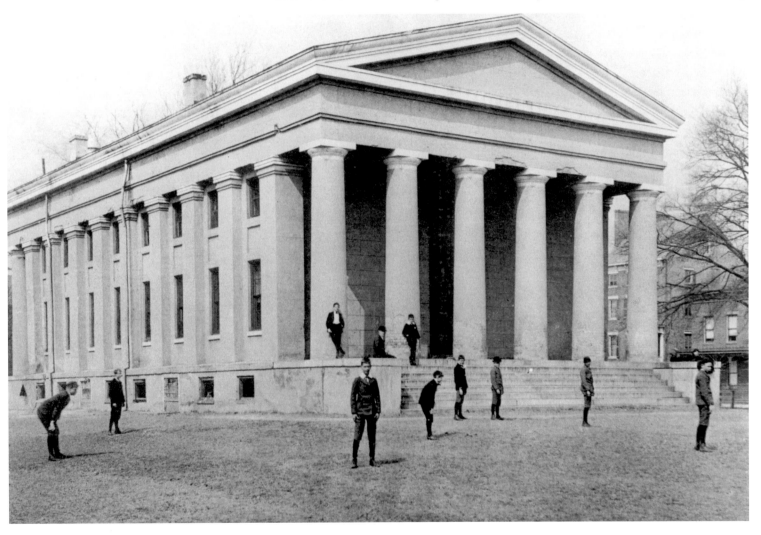

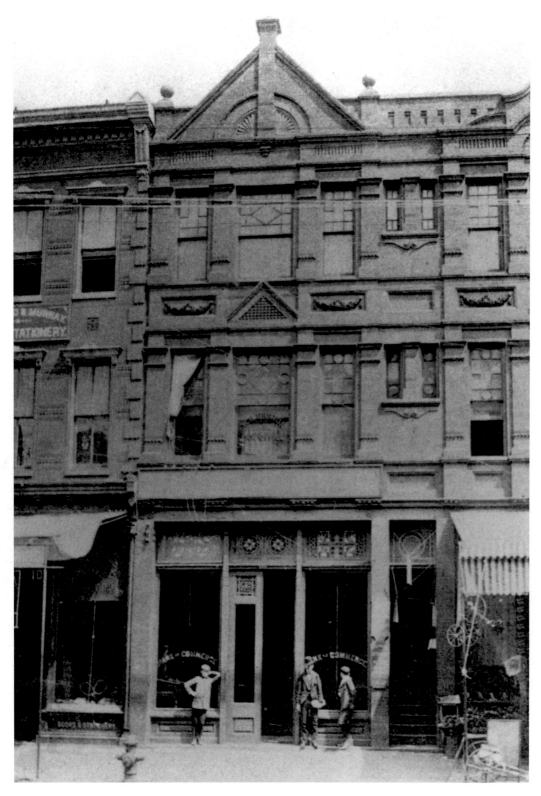

The Bank of Commerce on Main Street, around 1897. The Bank of Commerce of Norfolk was chartered as the People's Bank in 1867, and operated as the Bank of Commerce from 1878 to 1901, taking advantage of its original name for many years by proclaiming that it was "still the People's Bank."

Main Street at Commercial Place, seen here around 1900, was the site of Norfolk's earliest commercial district. When Norfolk County Surveyor John Ferebee laid out the original Norfolk Town on his 1680 survey, he designated this site for a marketplace, in which function the same spot continued for more than 200 years. Although the horse-drawn drays filled with produce from Princess Anne and Norfolk counties are gone, the commercial aspect remains. Today, lined with towering banks and office buildings, the site is the location of Norfolk's financial district.

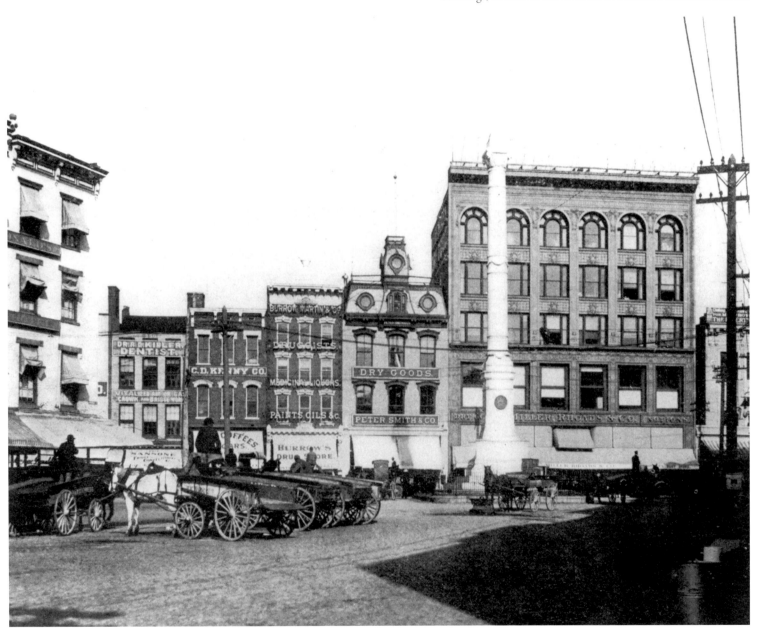

Built at the northwest corner of Granby Street and College Place in 1880 as the College for Young Ladies, this building became the Algonquin Hotel around 1900. Later renamed the Lee, the structure burned in 1983 and the site is occupied today by the Tidewater Community College.

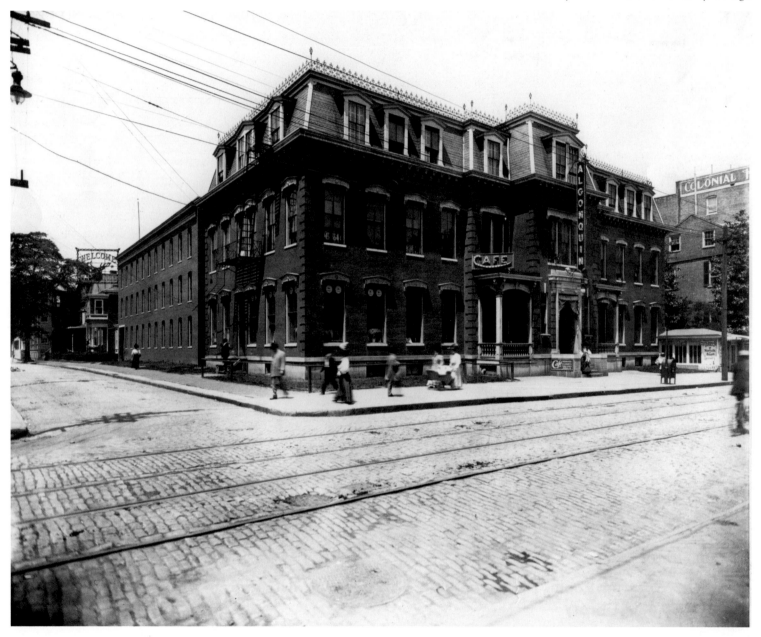

The YMCA of Norfolk was established on Bute Street in 1856, 12 years after the organization was founded in London. The Norfolk Y disbanded in 1858 and reorganized in 1884. It occupied its first permanent building, shown here, on Main Street from 1888 until 1907.

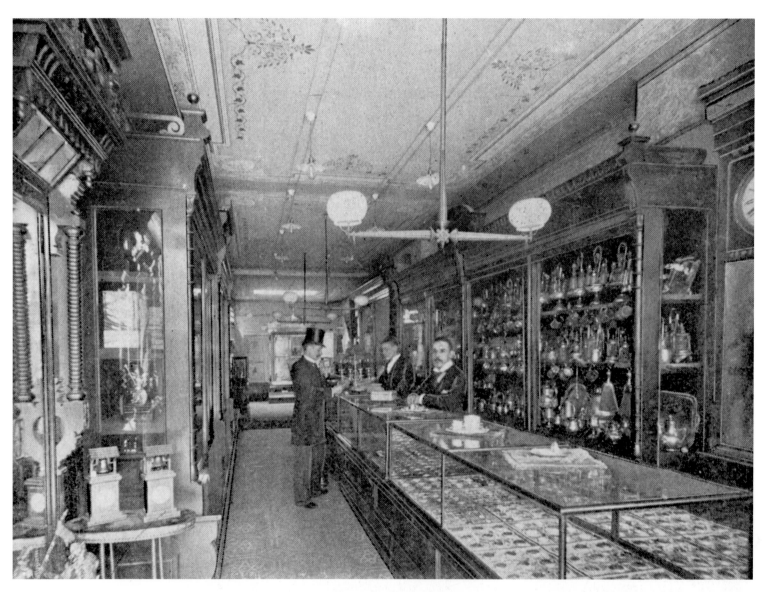

A. Spertner's "Jewelry Palace" at 106 Church Street was said to live up to its name when this picture was taken in 1893. It was described as "one of the handsomest stores of its kind in the city." Spertner's stock included watches, diamonds, clocks, jewelry, silverware, lamps, and ornamental wares. His shop was very popular with the railroad trade.

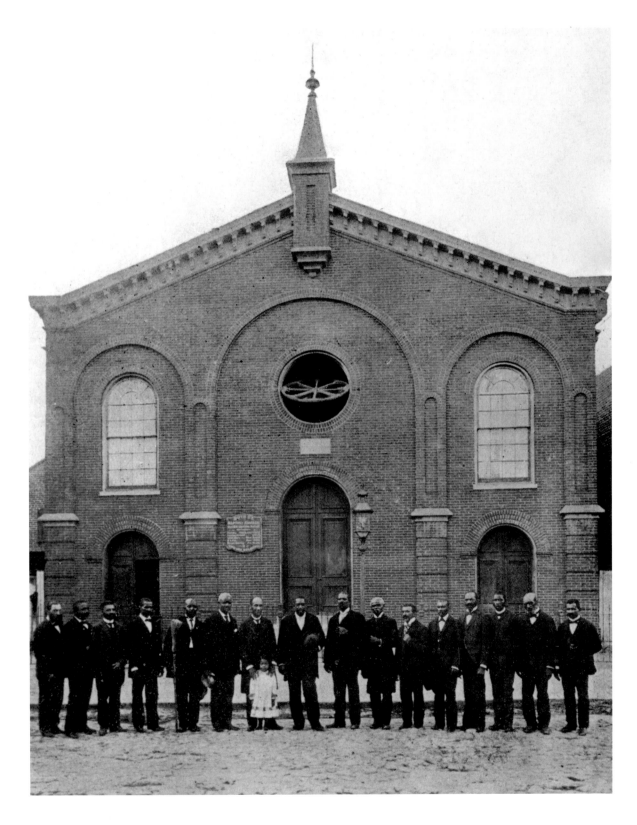

Members of the First Baptist Church congregation on Bute Street, around 1880. The Baptist Church was established in Norfolk in 1800 and was formally organized in 1805, with an interracial congregation. The white members separated in 1815 to form a new congregation. The remaining African American congregation took the name First Baptist Church Bute Street at that time. The congregation worshiped in the building pictured here from 1877 to 1904.

When this image of Boush Street at College Place was recorded in 1904, most of downtown Norfolk north of today's City Hall Avenue was still residential; however, as residents continued to move northward into the new neighborhood of Ghent, their imposing homes were gradually replaced by businesses. Here, cobblestones and Belgian blocks were still the pavement of choice. Tracks for the electric streetcar share the road with a family buggy that leans tiredly against the curb, waiting for its next passengers.

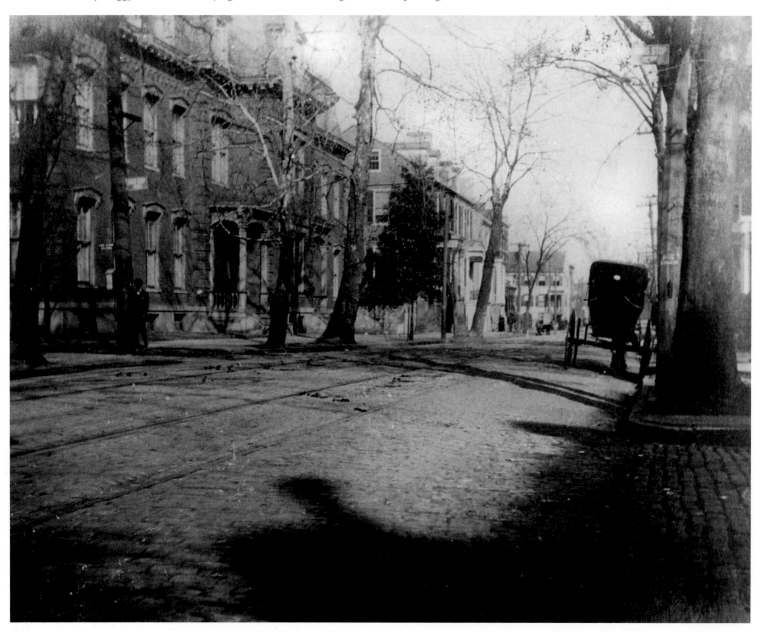

Main Street, 1905. This delivery vehicle belonging to Norfolk hatter Walter J. Simmons served as a mobile advertisement for his work in more ways than one—from the shiny top hat worn by the driver to the oversized chapeau perched on the back of the carriage.

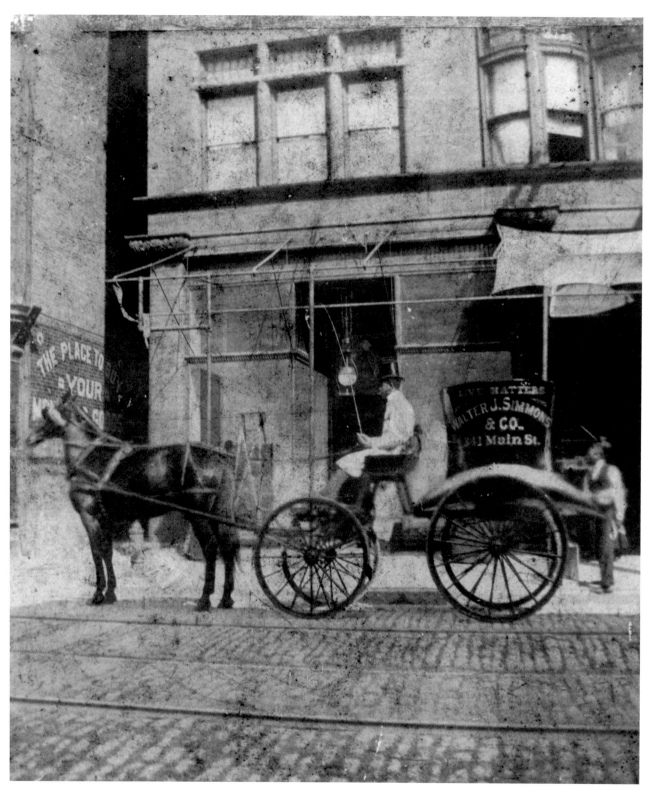

Frank H. Gale opened a small jewelry store on Church Street in January 1876 and moved to this location on Main Street two years later. After extensive remodeling in 1892, the store was described by customers as the "Tiffany of Norfolk." Noteworthy among the new features was the illuminating of silverware cases by electric light.

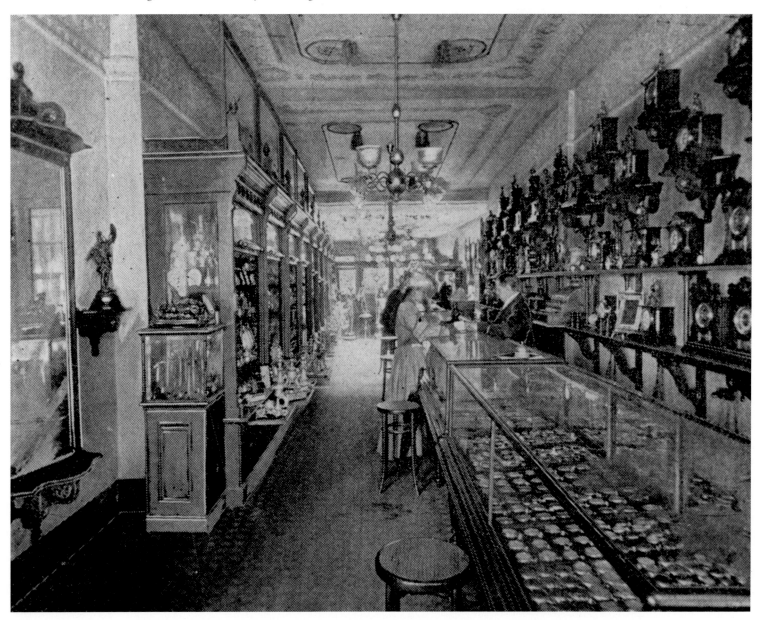

Looking west on Main Street from Commerce Street in 1892. The Norfolk Cab and Carriage Company at the right was the nineteenth-century version of today's taxi company, occupying number 144 ½ Main. Peter Smith & Co. next door was a popular dry goods and notions store run by Peter and Cosmos Smith.

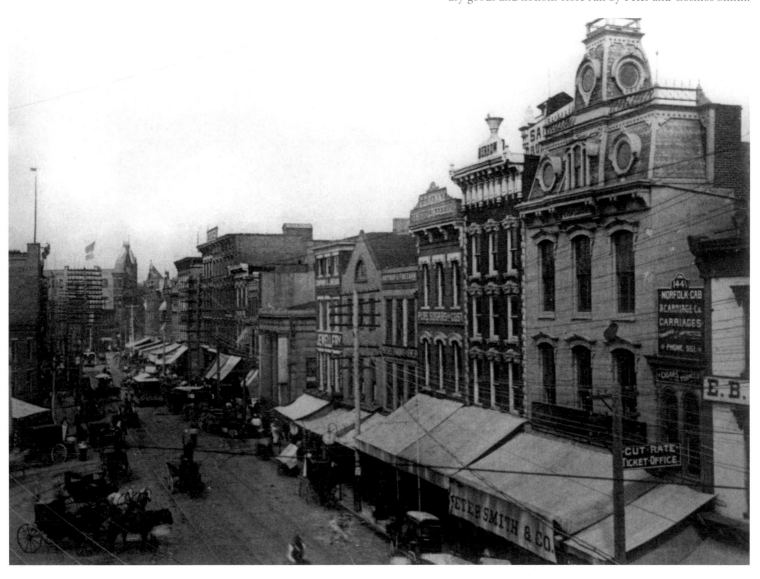

The Ghent Bridge, crossing the Hague from Botetourt Street to Drummond Place in January 1904. The people on the bridge are returning to their homes in Ghent after attending worship services at Christ Episcopal Church on Freemason Street.

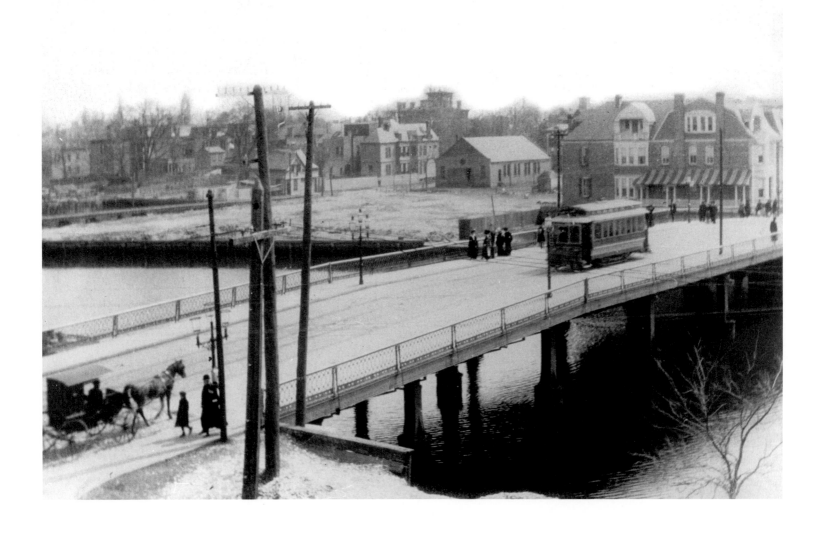

Election Day in 1903 was a boisterous affair, as voters turned out to elect candidates to the Virginia House of Delegates. Anticipating trouble at the polls, Police Chief M. J. Vellines posted officers at each precinct to break up crowds and fights. As a result, only three fights were reported, one at the first precinct of the first ward, a vacant store at the northeast corner of Main and Fenchurch Streets, shown here at a calmer moment.

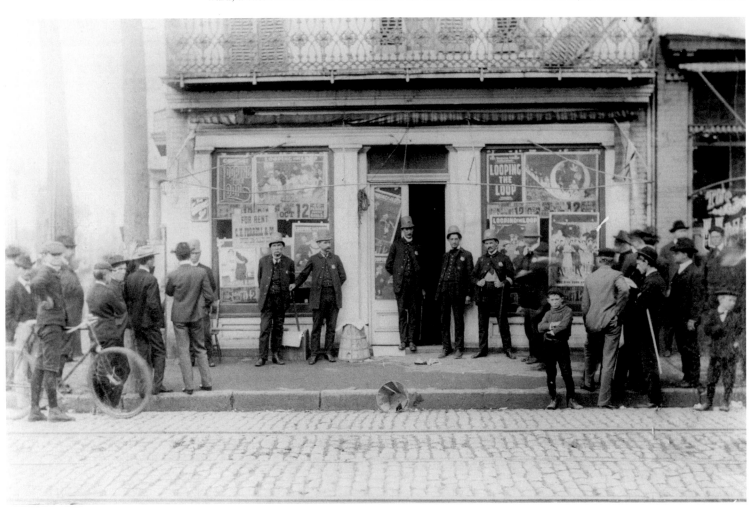

Seen here in 1904, the Hospital of St. Vincent DePaul was established in 1856 in the former home of Ann Plume Behan Herron, who had opened her Church Street home to victims of yellow fever the previous year. Miss Herron died of the fever, but her legacy survives. She left her home and estate to the Daughters of Charity so that they might establish Norfolk's first public hospital. St. Vincent's was housed here until moving to its current location on Granby Street in 1944. It was transferred to the Bon Secours Health System in 1996.

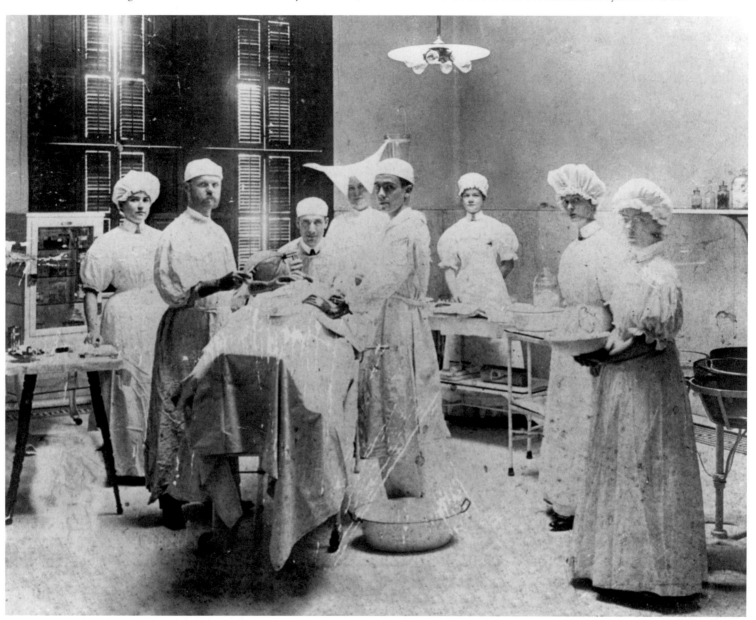

The street trolley chugs west along Main Street, about to turn north onto Granby around the turn of the century. On the near left is the Stevens Furniture Building, constructed in 1869 after the design of Baltimore architect Edmund Lind. Many Norfolk citizens set their watches by the large clock outside Citizens' Bank Building, on the right.

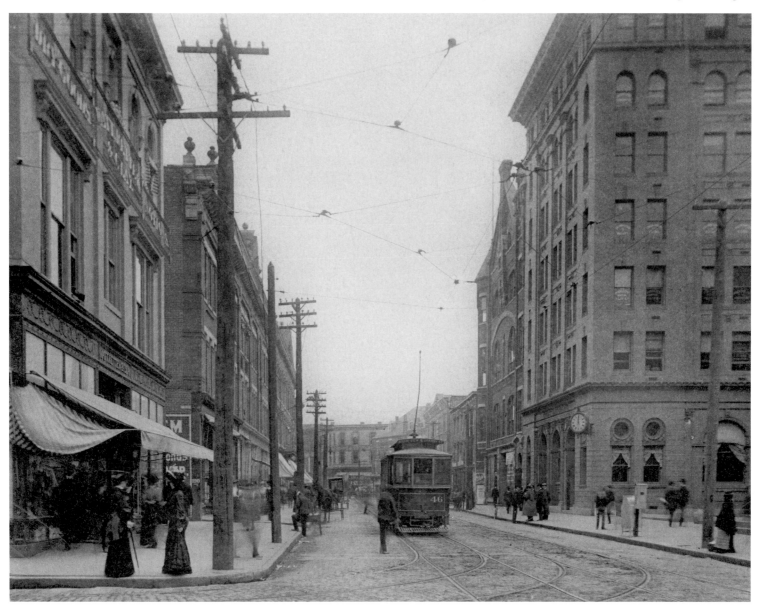

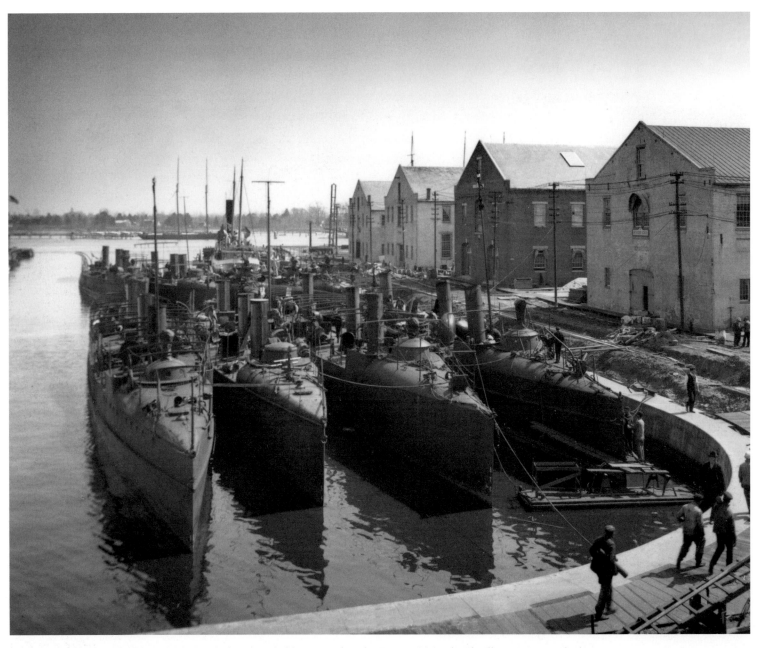

In the Norfolk Navy Yard in 1905, torpedo boats probably assigned to the Reserve Torpedo Flotilla wait in wet dock.

Henry Posner was known as a dealer in dry goods, fancy goods, notions, millinery, hosiery, and ladies' and gentlemen's underwear. He specialized in millinery and even had hairdressing and manicuring parlors on the premises of his Main Street store, shown here in 1893.

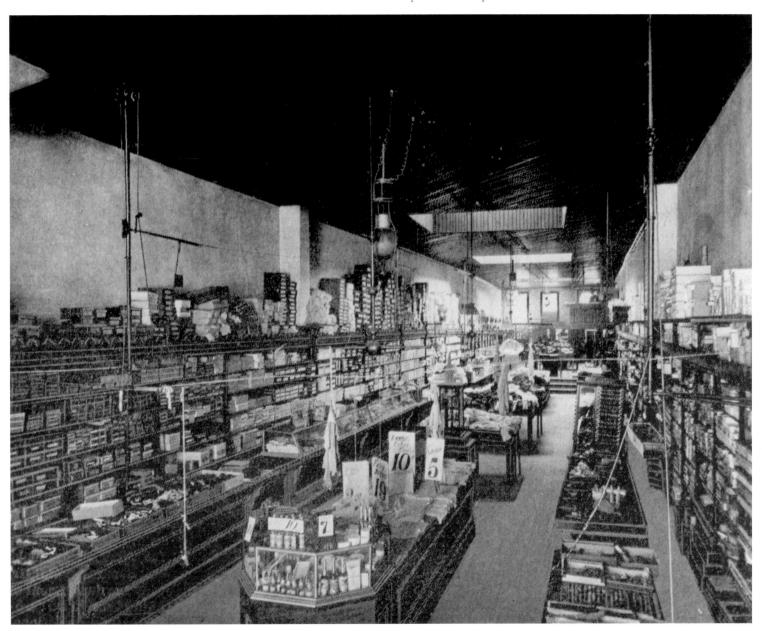

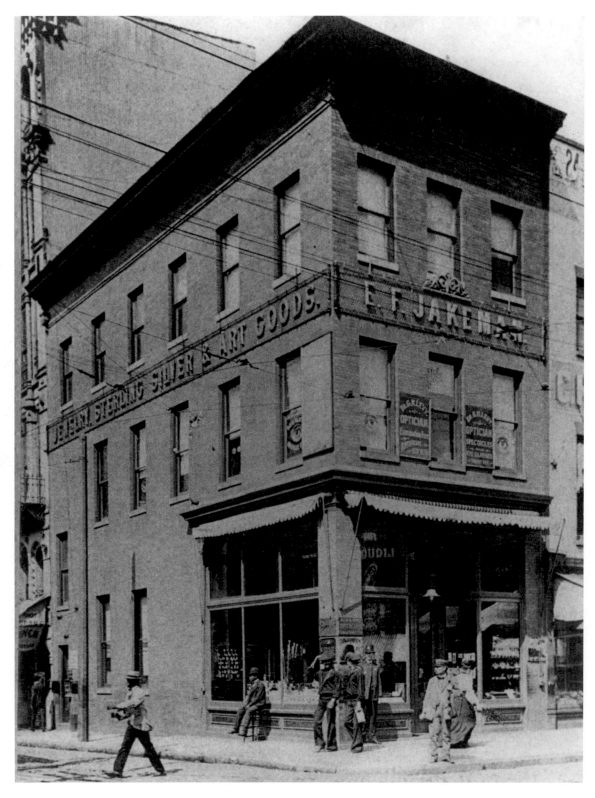

Edward F. Jakeman's establishment at Main and Bank streets was the self-proclaimed place to shop for "Jewelry, Sterling Silver & Art Goods" when this picture was taken around 1905. On the second floor front, the unblinking eyes from Dr. G. H. Levy's optician's practice gaze down steadily at passersby.

Ocean View beach, 1905. The development of Ocean View began in 1854 but was halted by the 1855 yellow fever epidemic and the Civil War. After the Norfolk Traction Company laid a narrow-gauge rail to Ocean View in 1879, development took off and the area became a destination for locals and visitors alike. Ocean View was annexed to the city of Norfolk in 1923.

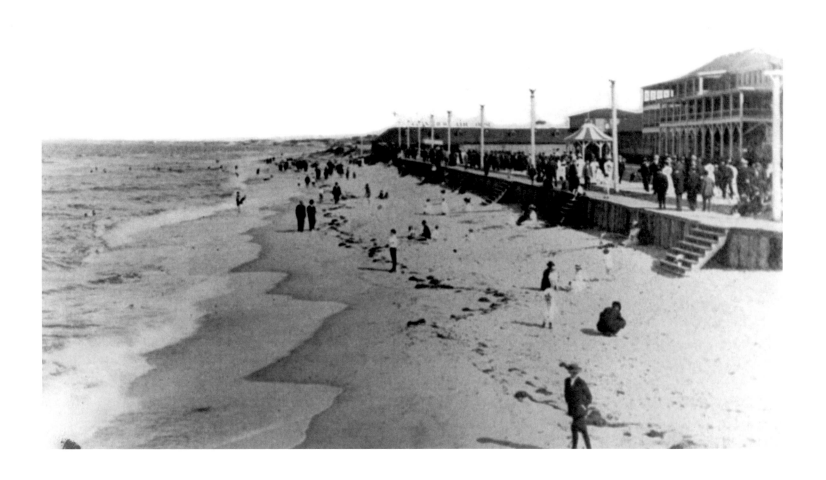

The Ocean View Hotel, around 1905. With its wraparound wooden porch, the hotel offered guests a respite from the summer sun, while music from the bandstand, at left, provided an evening's accompaniment to the gentle sounds of the surf and children being called in from play.

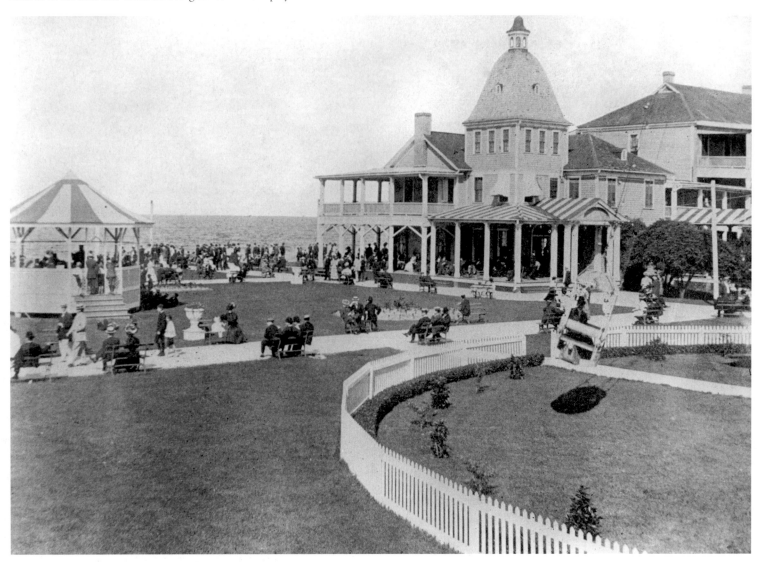

THE WORLD AT OUR DOOR

(1906–1920)

Norfolk welcomed the new century by inviting the world to stop in. The 1907 Jamestown Exposition, commemorating the 300th anniversary of the first permanent English settlement in America, was a world's fair in which 21 states and more than a dozen foreign countries participated. Norfolk prepared for the event by building modern hotels and apartment hotels downtown to lodge the thousands of expected visitors, and by extending streetcar tracks the length of what is now Hampton Boulevard so that visitors could travel back and forth from downtown to the Exposition grounds at Sewells Point, 10 miles north of the city. The tracks also served the community, enabling the family breadwinner to move his family away from the city into the suburbs' wide-open spaces while still being able to travel to his job in the city by streetcar. The Exposition ended with the departure of the Great White Fleet—16 U.S. battleships that headed out on a 14-month, round-the-world tour to demonstrate American naval power.

If the Jamestown Exposition was a temporary attraction, the Ocean View resort to the east was well on its way to becoming a permanent feature of the landscape. Already prized for its summer breezes, gentle surf, and good fishing, Ocean View's assets were enhanced in 1899 when the streetcar company set up rides and other amusements at its northern terminus, and the Ocean View Amusement Park was born. Manager Otto Wells lost little time developing concessions at the park, among them that of Abe Doumar, inventor of the ice cream cone.

After the United States entered World War I in April 1917, the federal government purchased the Jamestown Exposition property for use as a naval base. This was the beginning of Naval Station Norfolk, the largest naval station in the world.

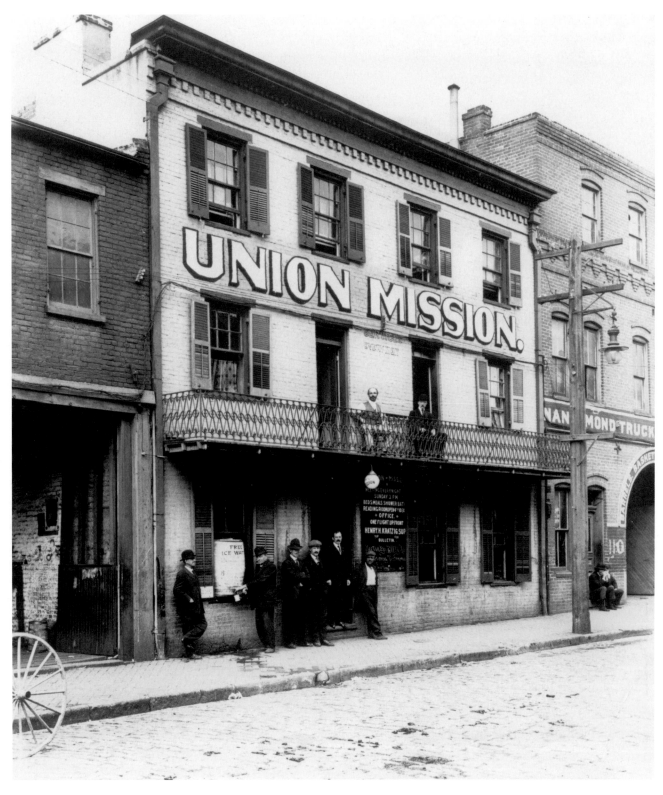

The Union Mission on Church Street, early 1900s. The Norfolk Union Mission was founded in 1892 to serve homeless and impoverished men. The Mission occupied this building on Church Street until moving to East Main Street in 1919. Amenities including beds, meals, showers, and a reading room were provided to residents, as well as nightly and Sunday non-denominational religious services. The gentleman on the sidewalk at the left of the picture demonstrates another amenity: free ice water.

The 1907 Jamestown Exposition at Sewells Point in Norfolk County was both entertaining and educational. This relief map of the Panama Canal, then under construction, was created by the Isthmian Canal Commission. The map was 122 feet by 60 feet, with its concrete surface roughened and painted green to represent land. Scale models of ships two to five inches long "sailed" along the Canal's course, demonstrating the size of the largest ships then in operation and the largest projected.

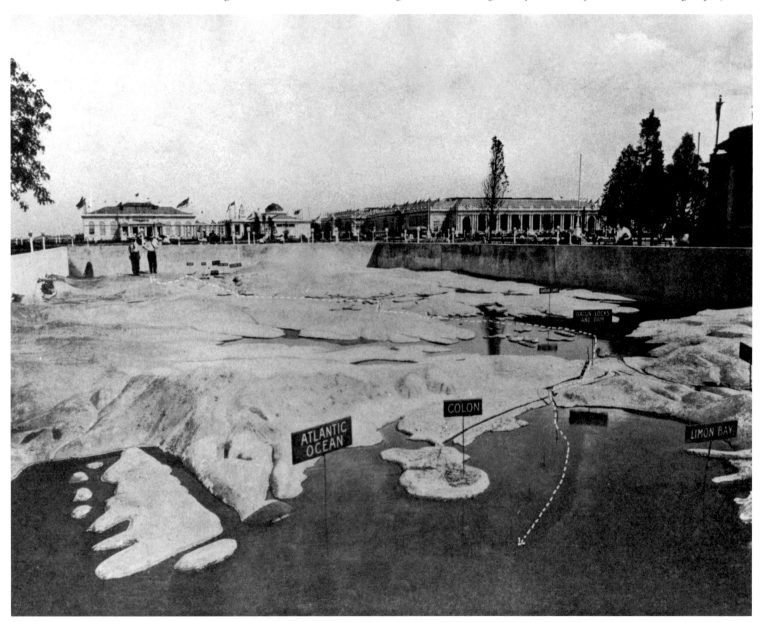

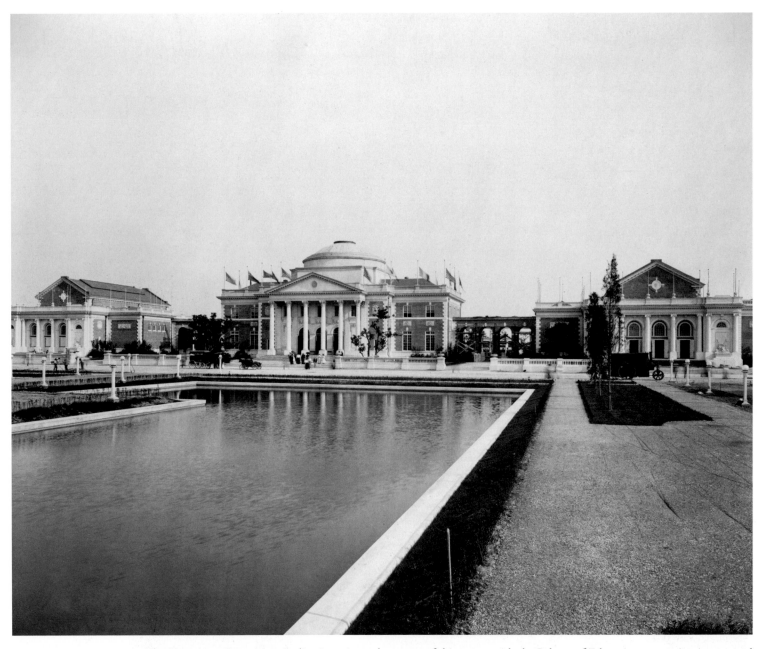

The Jamestown Exposition Auditorium sits at the center of this scene, with the Palaces of Education occupying its east and west wings. The Fine Arts Building lies to the right of the Auditorium, and the Marine Exhibits Building to the left.

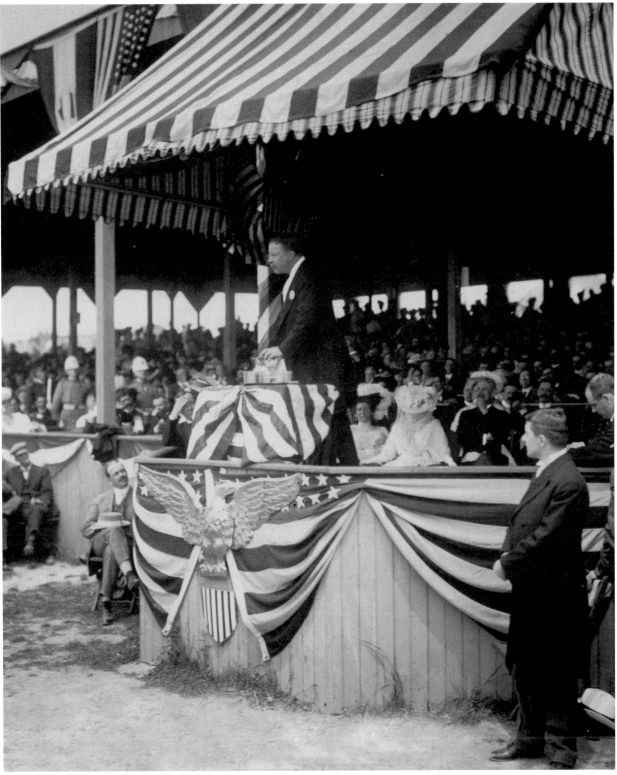

Twenty-sixth United States President Theodore Roosevelt was a guest at the Jamestown Exposition two times—on opening day, shown here, and on Georgia Day, which honored his mother's native state. He returned on December 16, 1907, to participate in the send-off of the Great White Fleet on a round-the-world cruise meant to demonstrate American naval power.

The Ferrari Wild Animal Show at the 1907 Jamestown Exposition was part menagerie and part theater. Lions, tigers, bears, panthers, wolves, and snakes performed hourly. Here, Seleca dances among the lions.

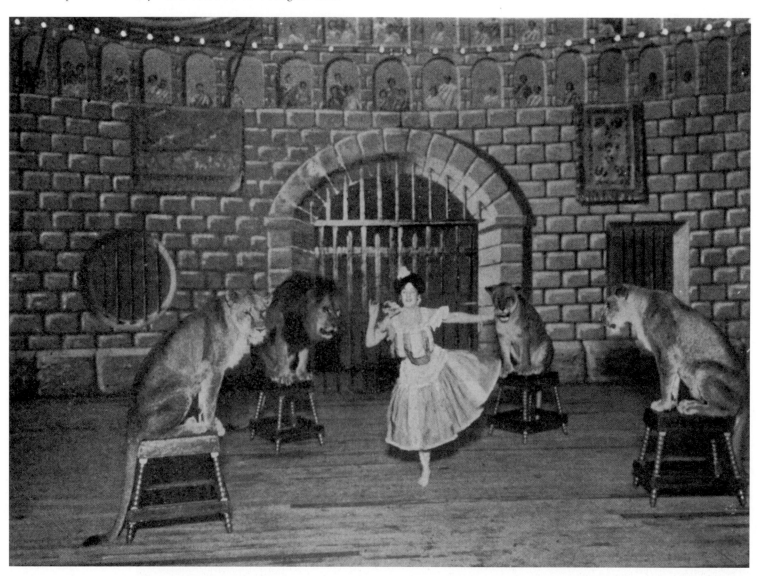

The most successful concession at the Jamestown Exposition was that demonstrating the Battle of the *Merrimac* (CSS *Virginia*) and *Monitor*. On some days, the box office receipts for this concession exceeded those of the main gate, due to the number of return visitors.

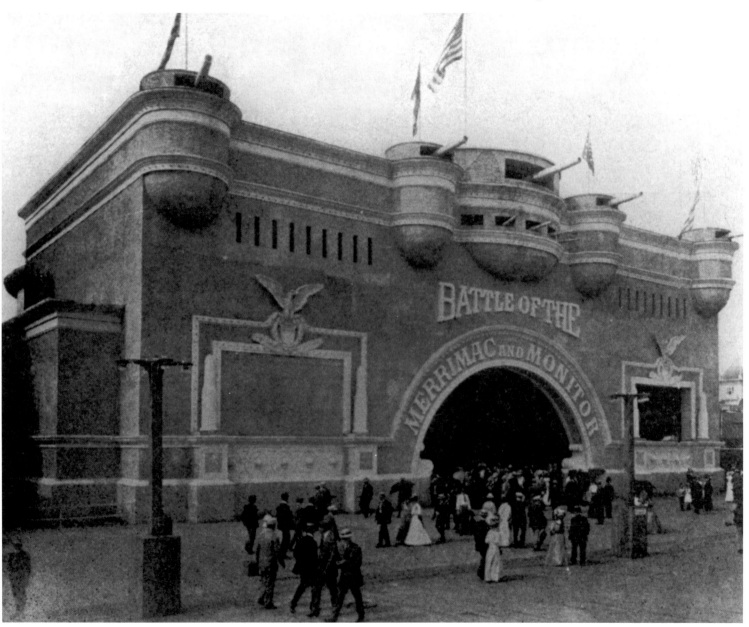

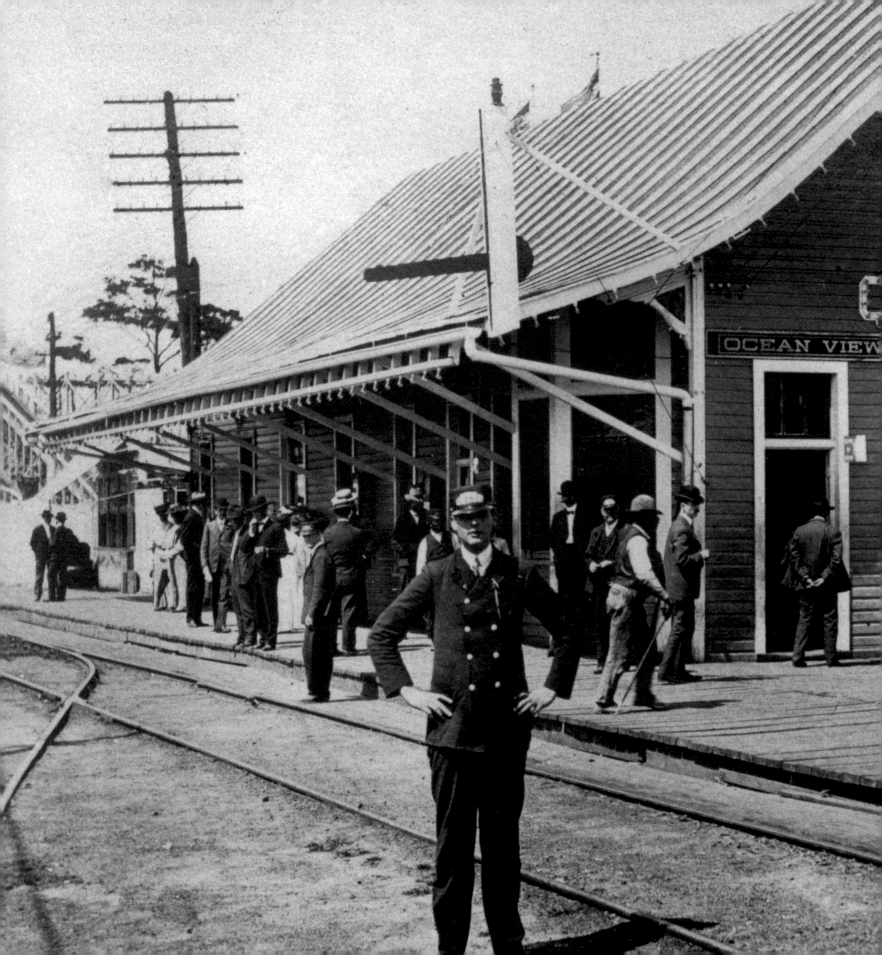

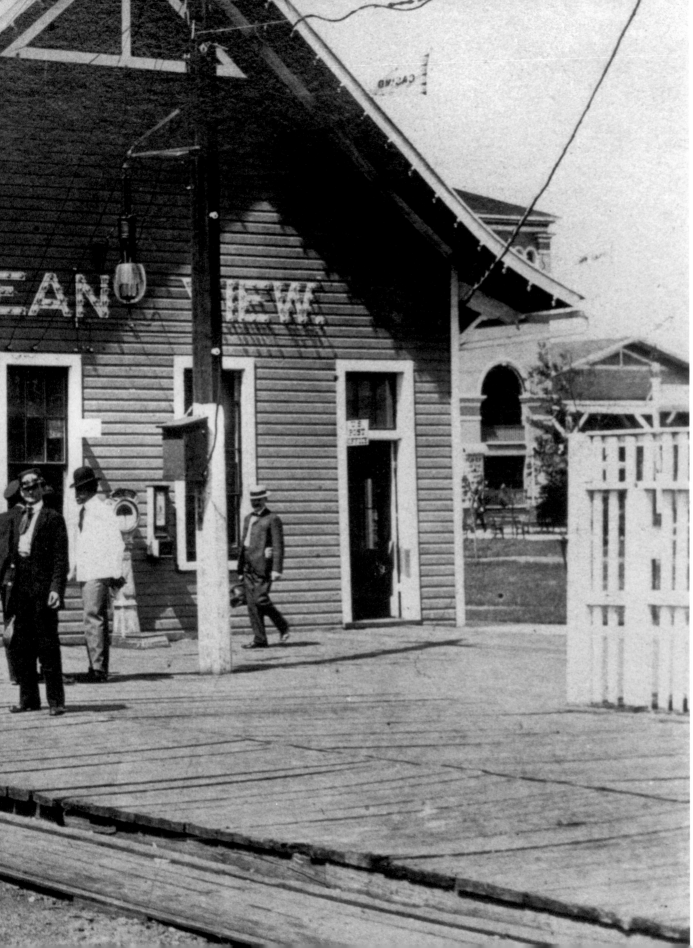

The Norfolk & Portsmouth Traction Company built this passenger station, seen here around 1908, at its Ocean View terminus shortly after the turn of the century. The station was particularly busy during the summer months, as vacationers poured from the cars with their trunks and suitcases for lengthy stays in the guest cottages that lined the beach, while locals disembarked for day excursions at Ocean View Park or picnics overlooking the Chesapeake Bay.

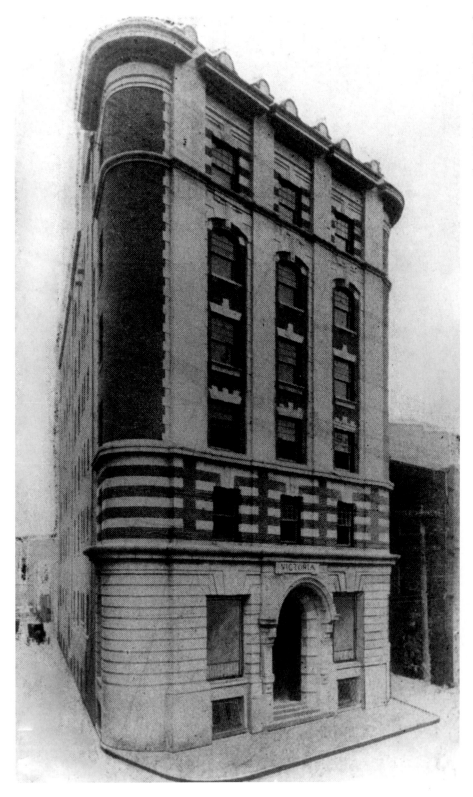

The Victoria Hotel on Main Street was one of five hotels built in Norfolk to house the anticipated thousands of visitors to the 1907 Jamestown Exposition. Shown here in 1908, it occupied this site until the end of 1961.

The Marine Bank was organized in July 1872 and for many years occupied its own building, shown here, at the northwest corner of Main and Bank streets. The Marine Bank's assets and liabilities were taken over by the National Bank of Commerce in 1921. Behind the bank, on Bank Street, Steve Seelinger's café and buffet was a popular place to lunch.

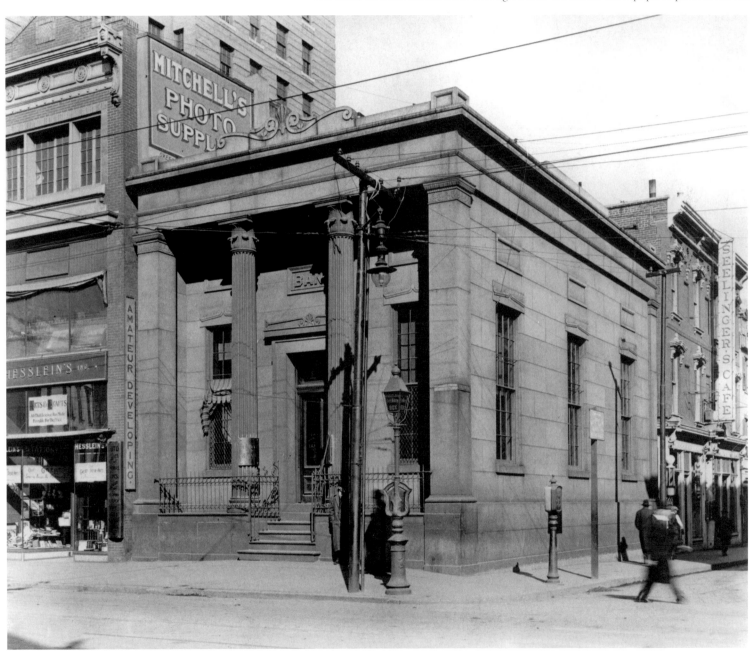

The introduction of rail service to Ocean View by the Norfolk Traction Company in 1879 greatly accelerated the growth of the community. The Traction Company set up the first rides at its Ocean View terminus in 1899; by the turn of the century, the area was a popular summer resort. The traditional cowcatcher on the front of the car, seen here round 1908, may never have caught a cow in Norfolk, but it was a popular challenge for youngsters to catch a ride on it until the conductor chased them away.

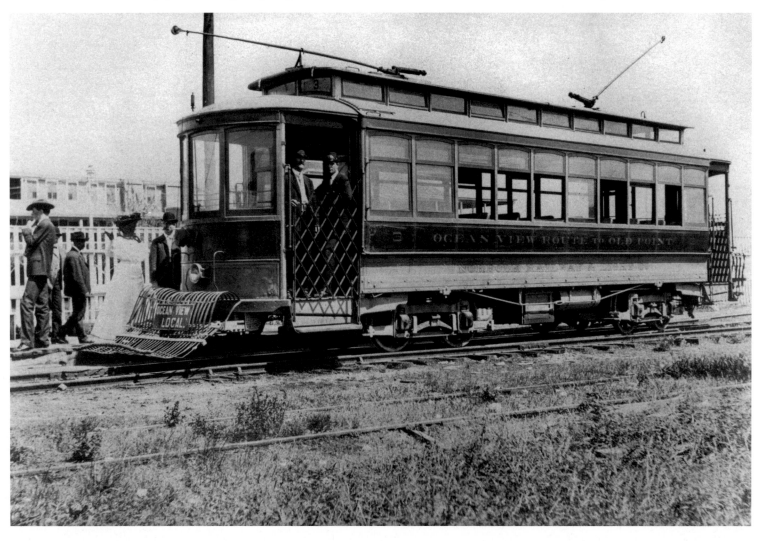

An unidentified photographer recorded Norfolk's business community in the vicinity of East Main and Water streets in 1919. The Tagliavia Grocery and Fruit Market, operated by Anthony and Philip Tagliavia, stood at 908 ½ East Main Street.

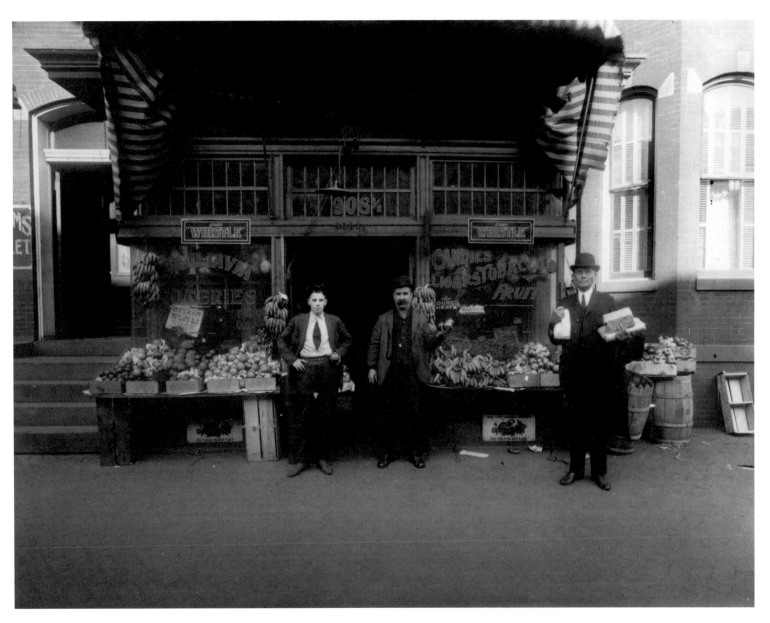

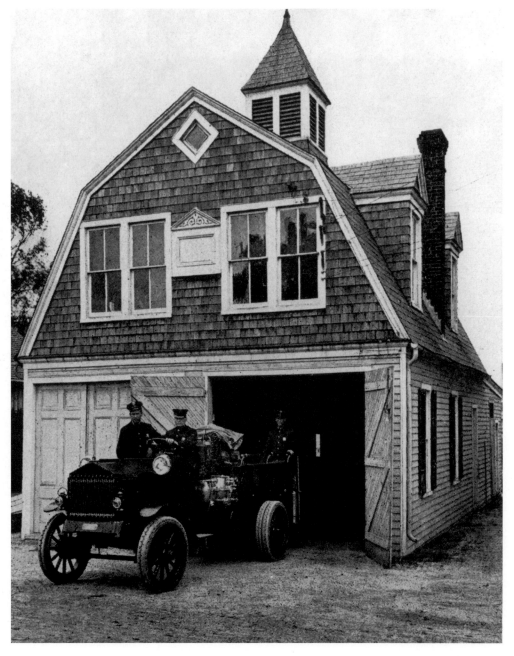

A paid fire department was established by Norfolk City Council in 1871 to replace a series of volunteer companies that too often lacked the training or equipment to do a proper job of fighting fires in the growing city. A headquarters building was completed in 1872, and outlying stations were added as Norfolk continued to grow by annexation. The Berkley station, shown here in 1915, was completed shortly after the town of Berkley was annexed to the city of Norfolk in 1906.

A barefoot, middy-bloused youngster appears to be supervising his elders as they prepare to pave Church Street along the newly laid streetcar tracks in front of the Atlantic Auction House and N. S. Horton Grocers, around 1910.

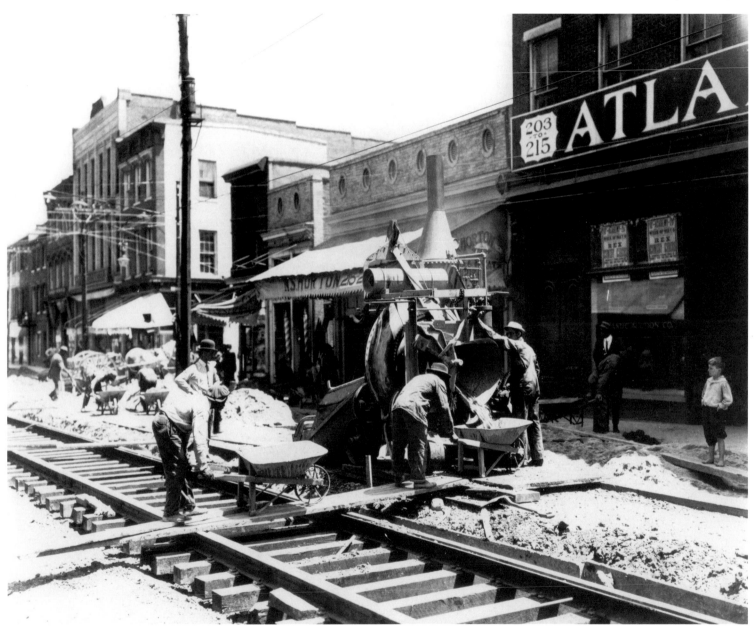

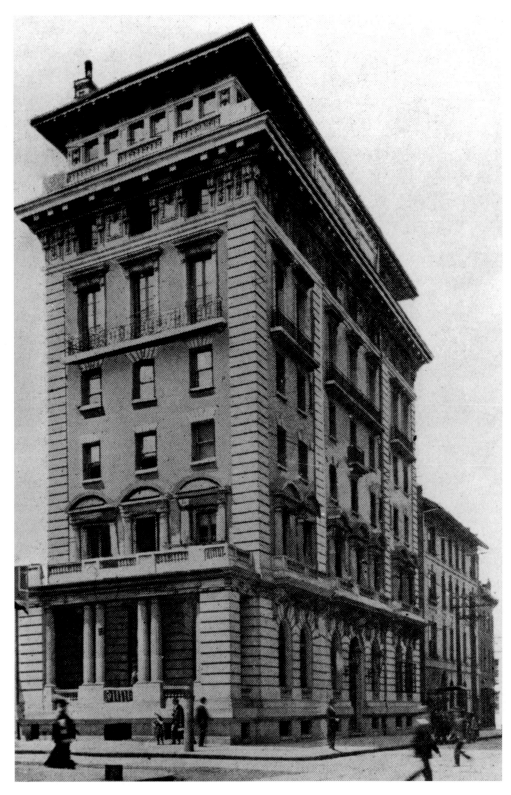

The Virginia Club was founded in 1873 by a group of Norfolk men. The Club built this structure at the southwest corner of Plume and Granby streets in 1904 and occupied it until 1916. Accommodations for women were provided on the sixth floor of this all-men's club, which there included a ladies' café, described as "one of the daintiest apartments imaginable."

Looking north on Granby Street from City Hall Avenue, January 1, 1918. Fire fighters battle the blaze that devastated the Monticello Hotel and four nearby buildings on New Year's Day.

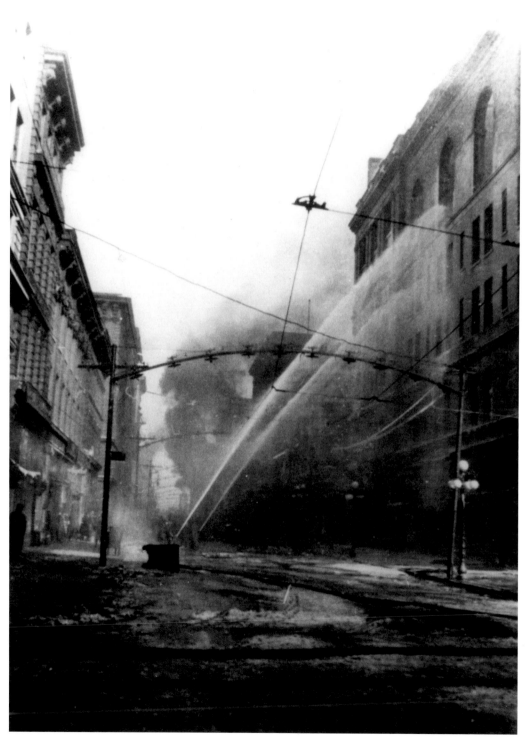

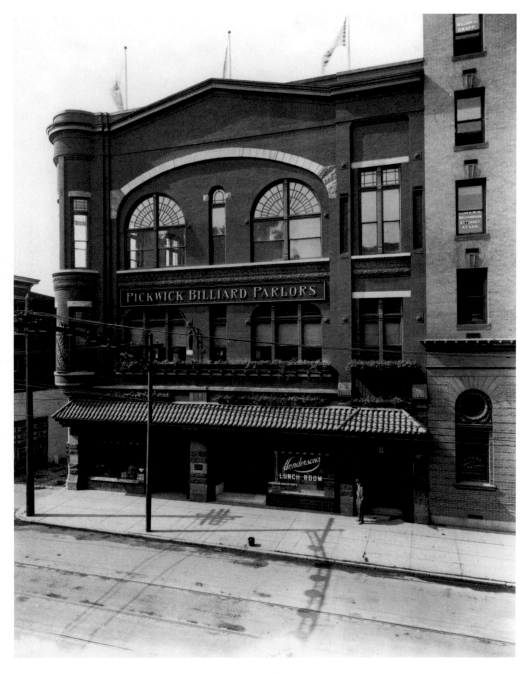

The Pickwick Club and Billiard Parlors opened in the former YMCA building on Main Street around 1912. Amenities on the upper floors were supplemented by those at street level—Henderson's Restaurant and Harry Tabb's Bar, both of which were open to the public as well as to Pickwick members.

The interior of the Pickwick Billiard Parlors, where players might choose straight-rail or pocket billiards, and where there was plenty of seating for spectators.

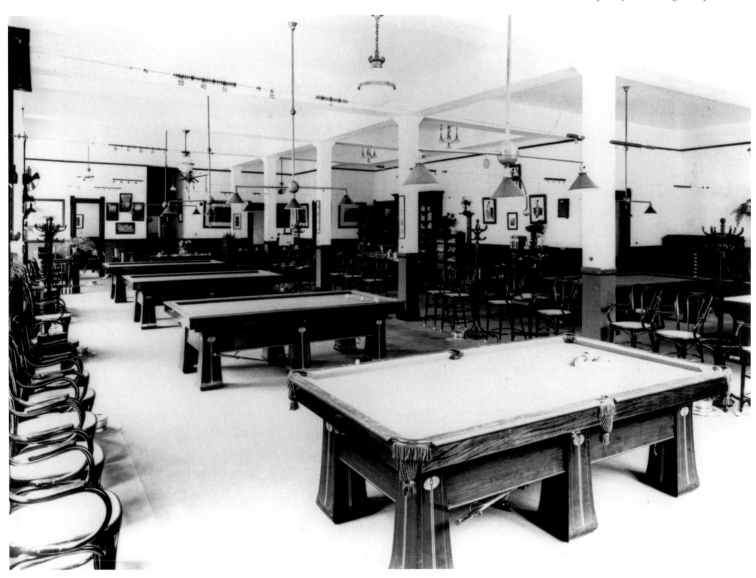

Main Street at Commercial Place, January 3, 1918. A mule-drawn sleigh makes its way through the snow around the base of the Confederate Monument at Commercial Place. During this coldest winter on record in Norfolk, the Elizabeth River froze solid and the adventurous crossed the river between Norfolk and Portsmouth by sleigh or on foot. Could the passenger in the sleigh have been a Portsmouth resident come to observe the detritus from the New Year's Day 1918 fire?

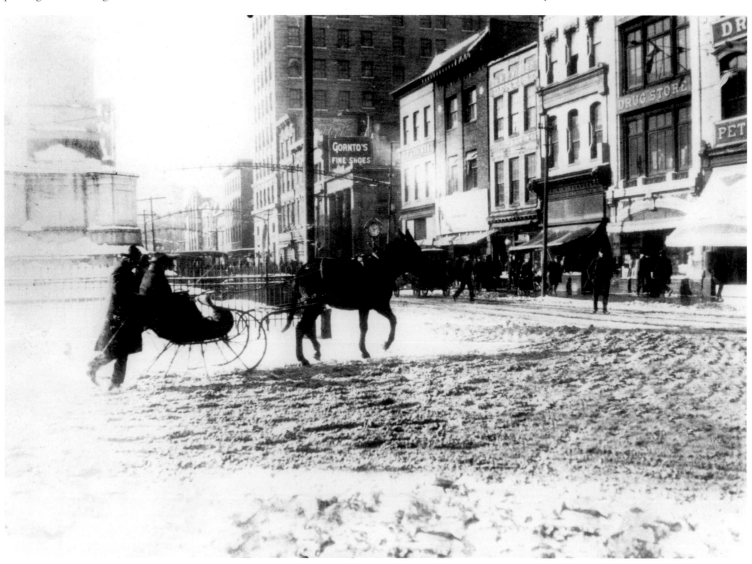

The same view of Main Street at Commercial Place as in the previous image, but what a difference a season makes. Here, a summer day around 1909, snow and slush have been replaced by dusty streets, umbrellas to shelter the draymen from the heat, and straw hats all around.

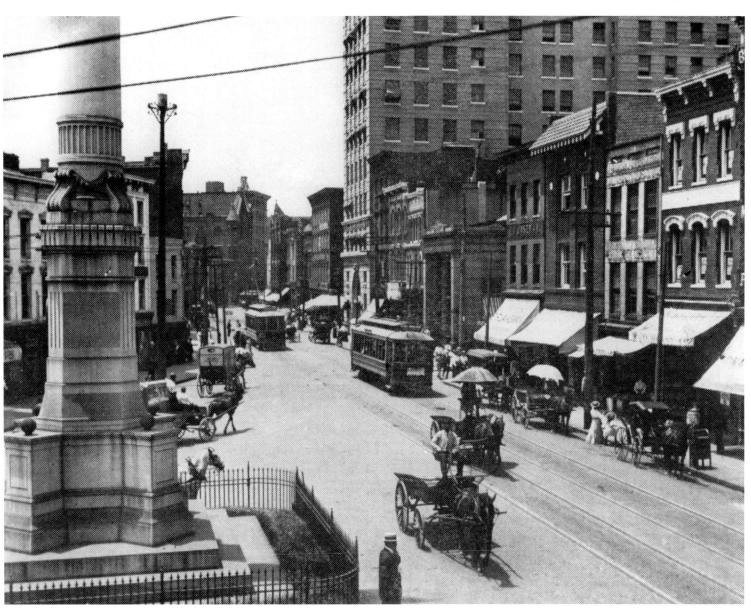

Perhaps it is proprietor Vona Pellegrino himself standing in the doorway of Wall, Tailors
on Main Street around 1910, tape measure around his neck and ready to help the "critical"
Norfolk shopper find a handsome outfit at a cost below the competitors'.

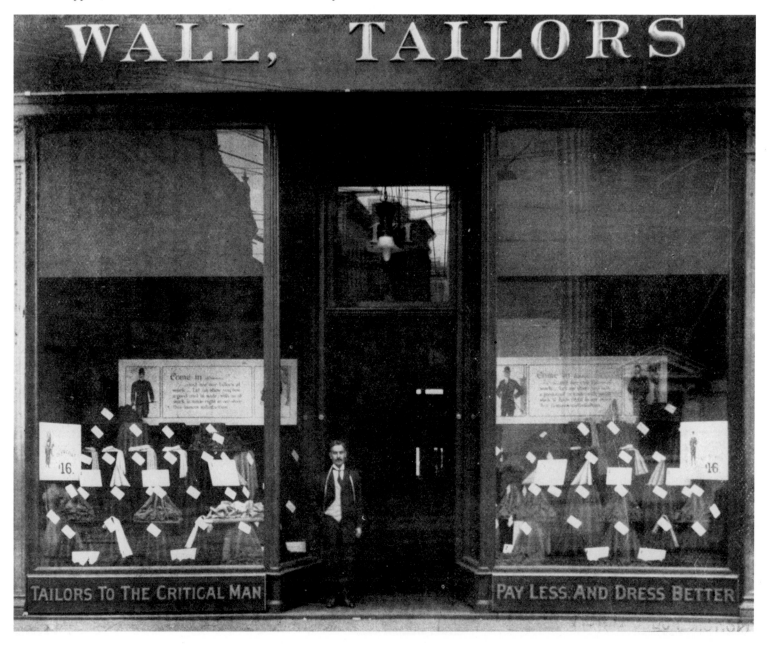

An elaborate arch festooned with bunting greeted President William Howard Taft on his visit to Norfolk on November 19, 1909. Taft made several trips to Norfolk during his presidency, usually staying in a private room over Seelinger's Restaurant on Bank Street and making day trips to Princess Anne County to hunt game.

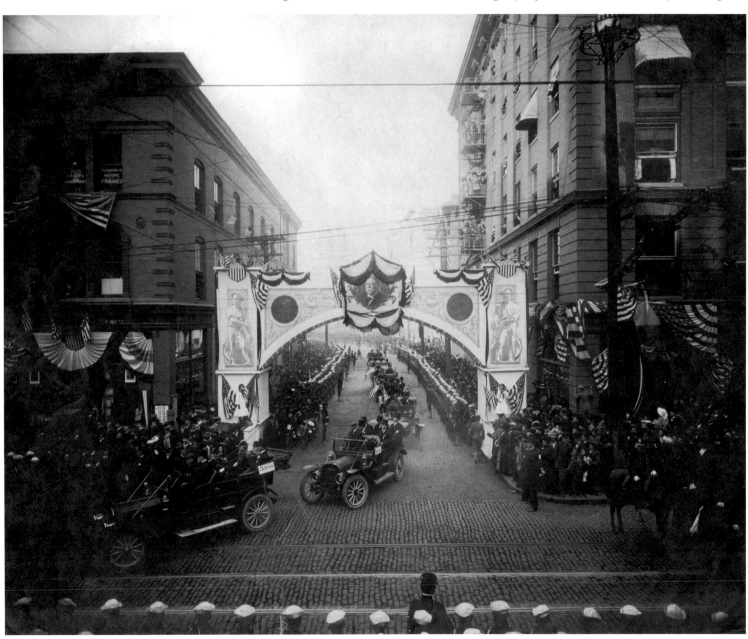

The Naval YMCA was established in rented quarters in a three-story building on Church Street in 1902. This stunning building on Brooke Avenue opened in February 1909, with a formal dedication on March 17, 1909. The Navy Y was a gift from John D. Rockefeller to the enlisted men of the Navy.

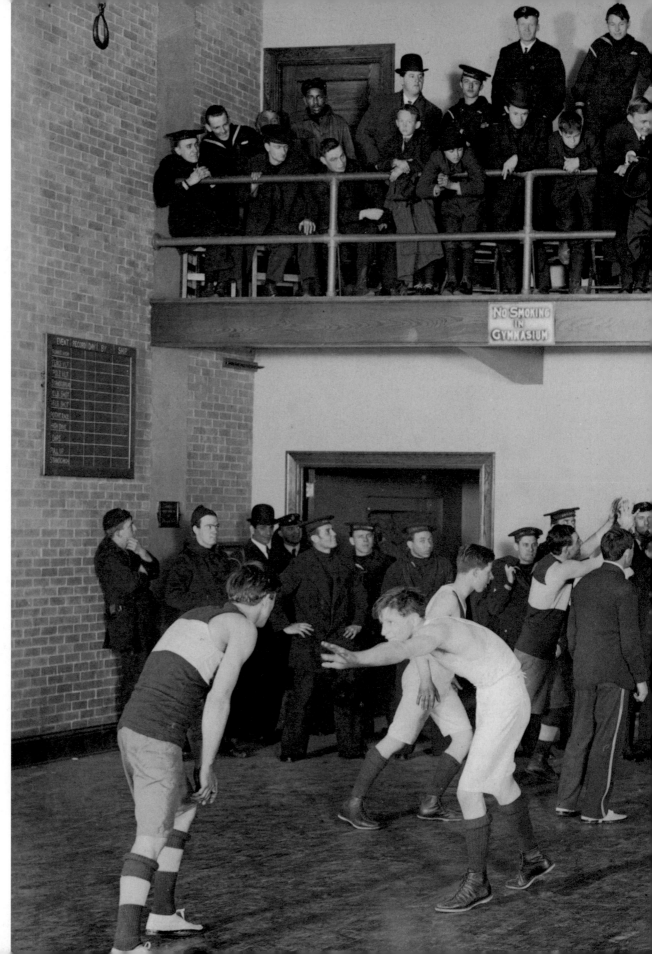

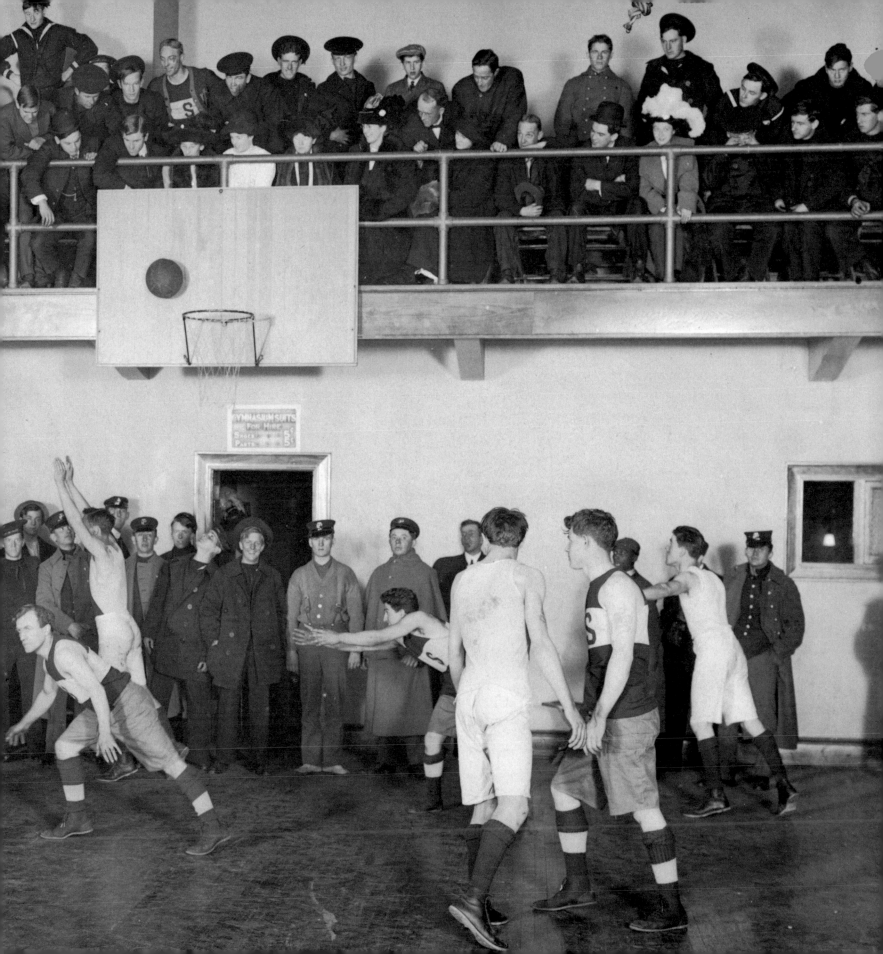

At the Chesapeake and Ohio rail station on Brooke Avenue, President Taft waits in his car for the parade in his honor to begin. The president was a large man, famous for his appetite. On this visit, it was reported that he downed between a few dozen and three barrels of oysters at one sitting. The number grew with the retelling of the tale.

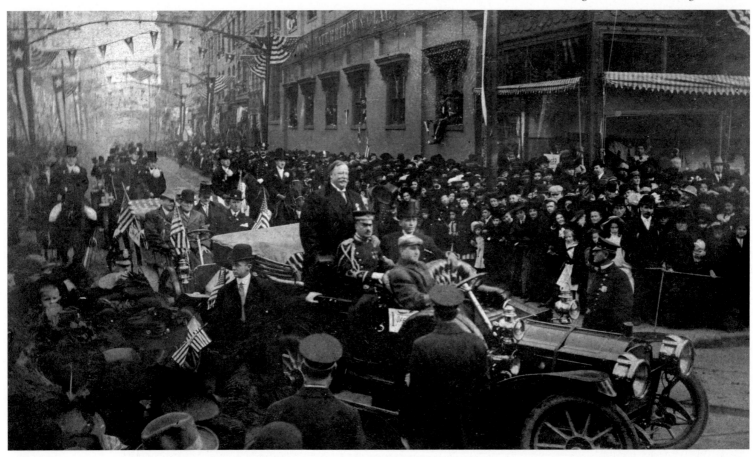

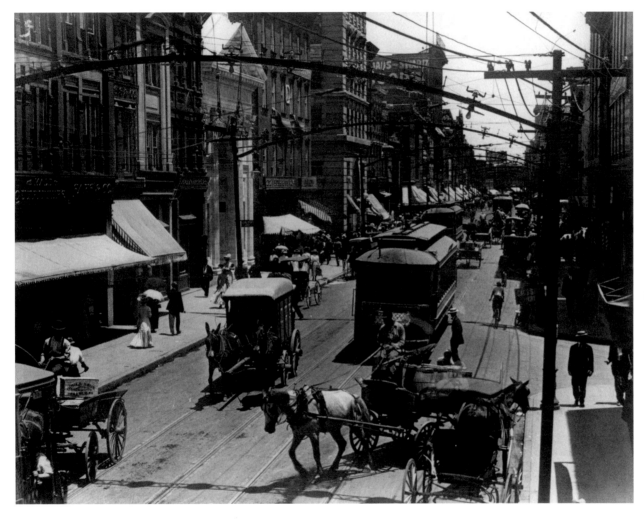

Pedestrians intermingle with electric streetcars and horse-drawn wagons and buggies in this busy Main Street vista looking east from Commerce. The Saks store to the left sold men's clothing and furnishings. The building with columns a few doors down was occupied by the Norfolk Bank for Savings and Trust.

The two-horse-powered Engine Number Five races down East Main Street on the morning of January 4, 1918, possibly to the scene of the fire still smoldering at the Monticello Hotel from New Year's Day.

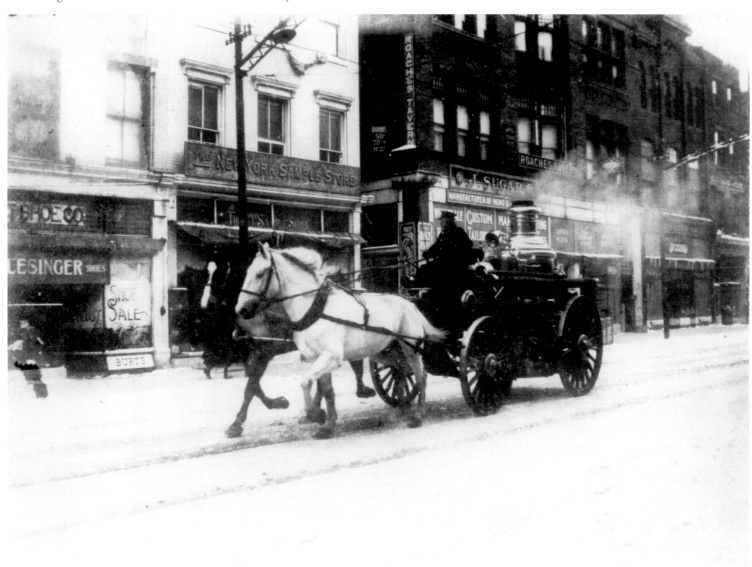

Peter Wright became Norfolk's first automobile owner in June 1900. By 1910, around the time of this photo, there were more than a dozen Norfolk companies in the business of selling, storing, repairing, or accessorizing the family motor car. Edward J. Allen's Rambler Garage & Supply Company on Granby Street specialized in repairs and supplies for Rambler and Maxwell motor cars.

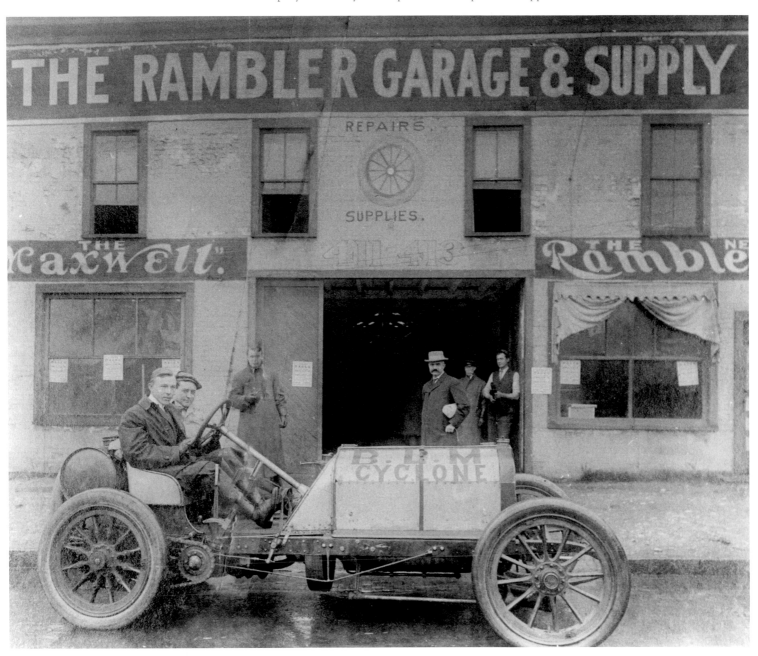

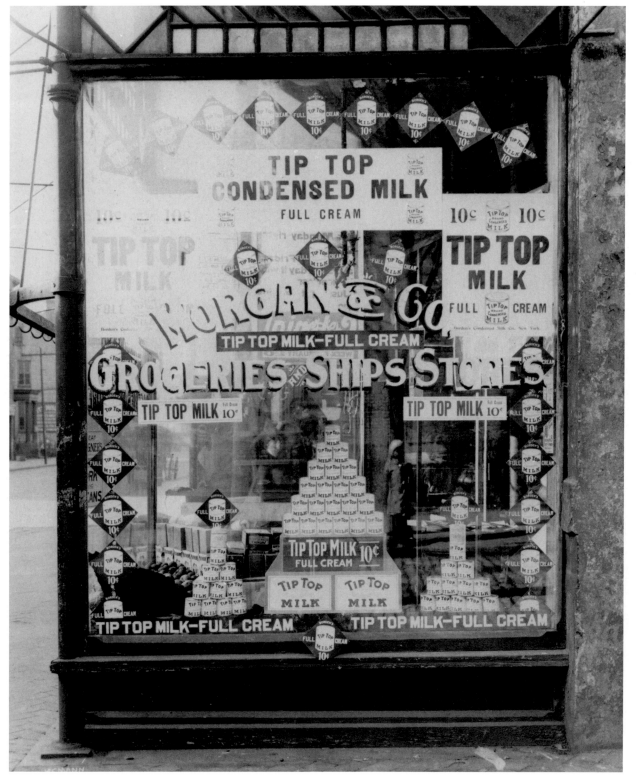

A display of Tip Top Milk fills the display window at Benjamin F. Morgan & Company grocers on Main Street, possibly to remind the thoughtful shopper of the family kitty waiting at home.

56

St. Joseph's Catholic Church on East Queen Street (now Brambleton Avenue) around 1910. St. Joseph's Parish for African Americans was established in Norfolk in 1889. A school and parish building were dedicated in 1893. The parish was absorbed by St. Mary's Parish in 1961.

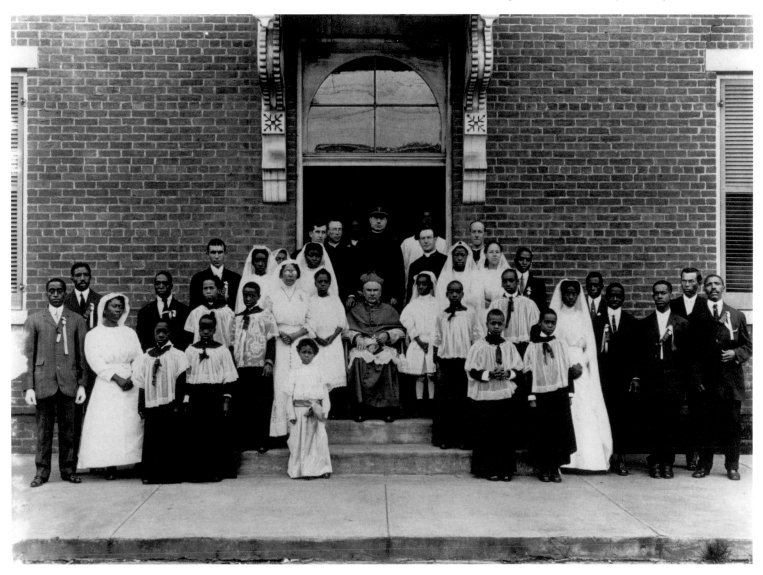

Sometimes our transportation needs transportation. Here, a sick horse is brought by horse-drawn ambulance to Dr. Herbert Nash Holmes's Veterinary Hospital at the corner of Granby and 10th streets, around 1910. Dr. Holmes advertised his specialties as "Horses, Dogs and Cattle."

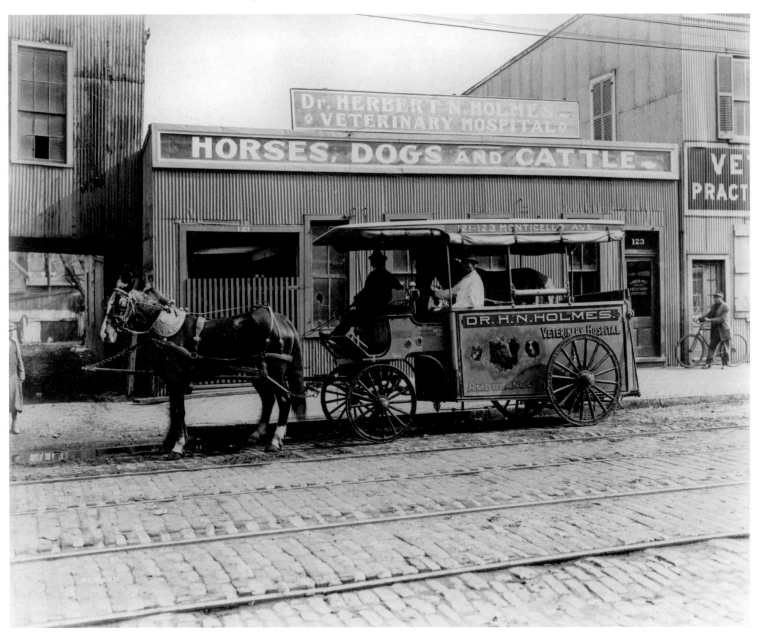

Baltimore architects James Wyatt and William Nolting designed this structure for Virginia Bank & Trust Company in 1908, employing both Greek and Roman motifs. The building housed a series of banking operations until the 1970s, and later housed the collection of Auslew Galleries. The Virginia Club, founded in 1873, moved into the building in 1997 and continues to occupy it.

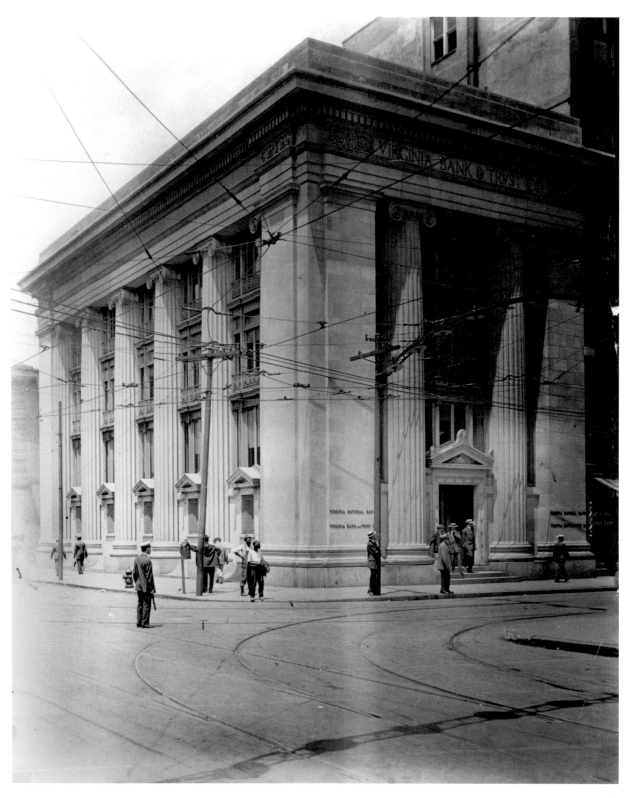

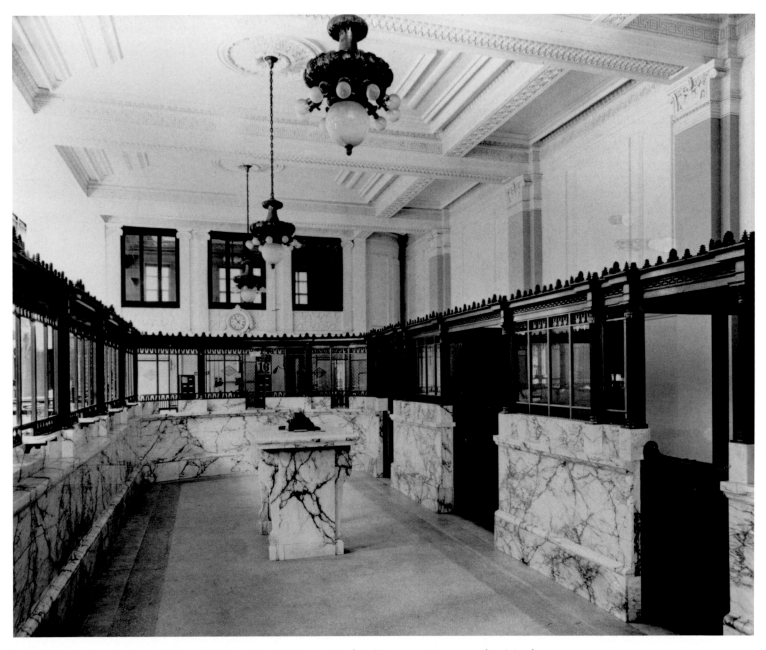

Interior of the Virginia Bank & Trust Building. Virginia Savings Bank & Trust was incorporated in March 1902. The name was changed to Virginia Bank & Trust in January 1906.

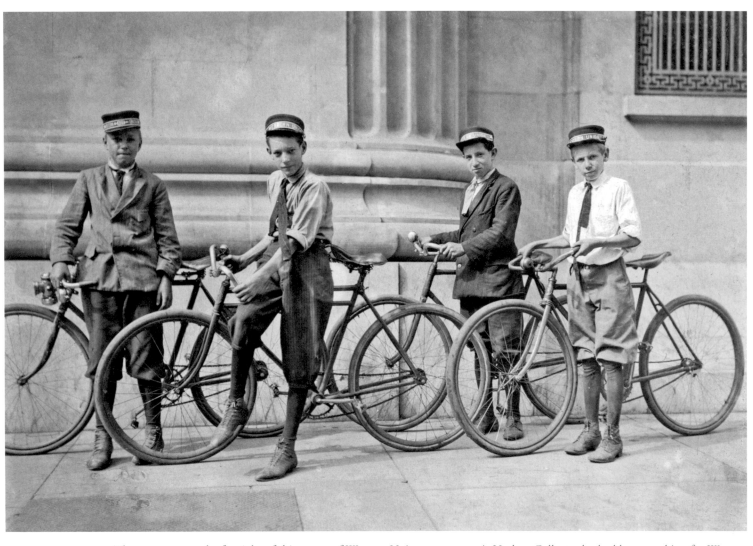

The youngster at the far right of this group of Western Union messengers is Hodges Gallop, who had been working for Western Union for one month when Lewis Hine took this photo in June 1911.

Enjoying a shave and a haircut in the Atlantic Hotel barbershop on Granby Street around 1910. This was the second of three Atlantic Hotels that stood in the same location on Granby. The first two, designed by Baltimore architect Edmund Lind in 1859 and 1867, were both destroyed by fire.

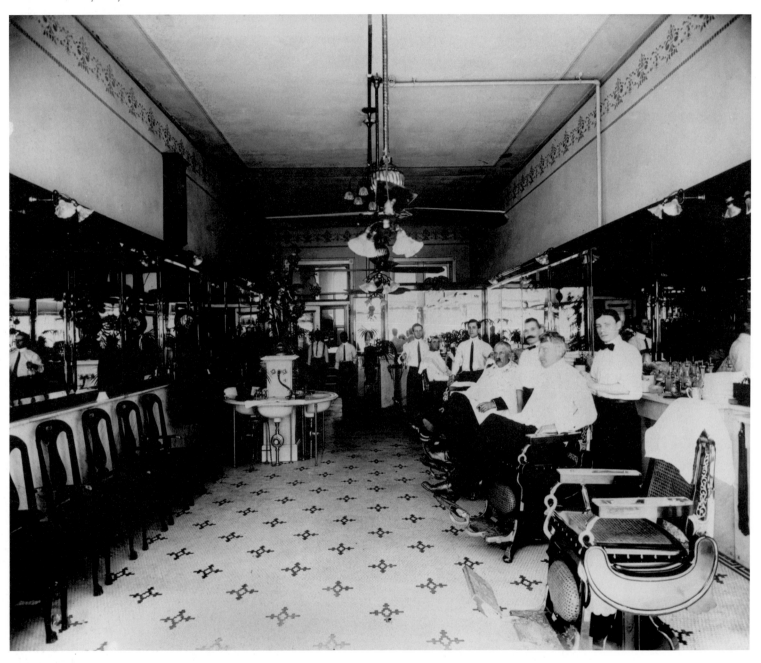

The Benjamin Altschul Department Store Building on Church Street, seen here on the inside around 1910, was designed by the Norfolk architectural firm of Clarence A. Neff and Thomas P. Thompson.

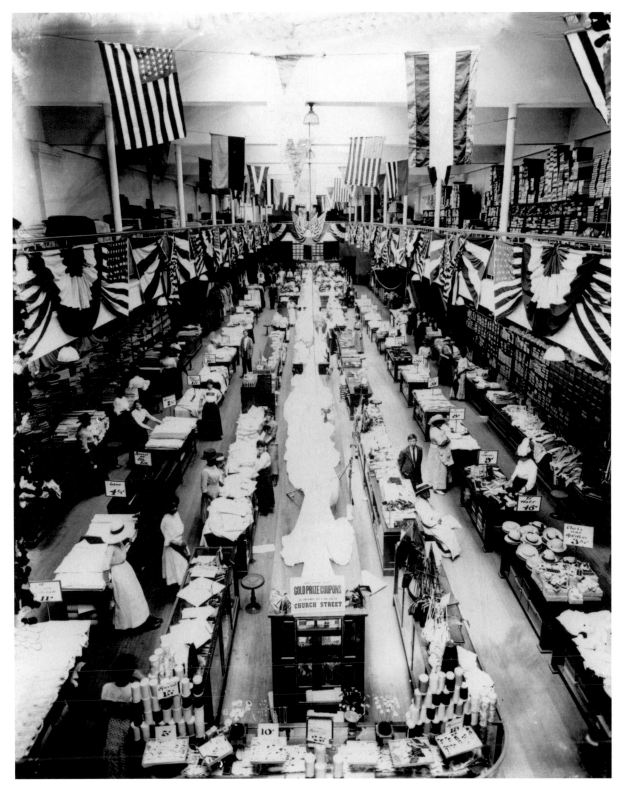

The circus is in town, around 1915. A parade of circus attractions matches the pace of the electric trolley as a crowd gathers along the 300 block of Church Street to catch a preview of what awaits them under the big top.

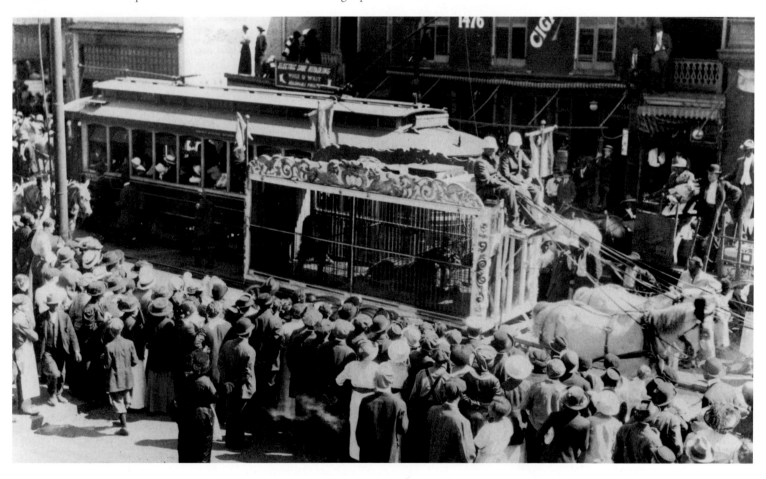

Horses pulling drays at Commercial Place pause for a drink from their own water fountain, around 1910. As in many southern cities of the time, the designated parking space for automobiles is in a row right down the middle of the street.

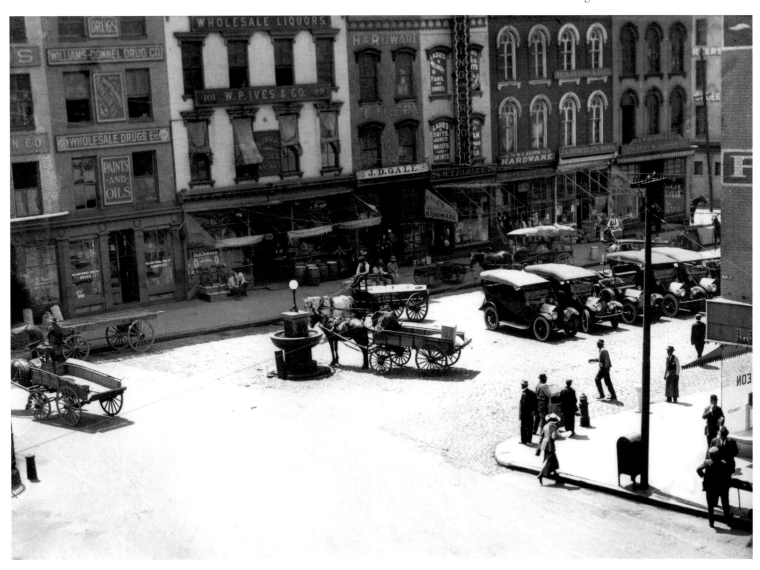

Employees of the S. S. Kresge 5&10¢ Store
on East Main Street prepare to set off for their
annual outing in the summer of 1917.

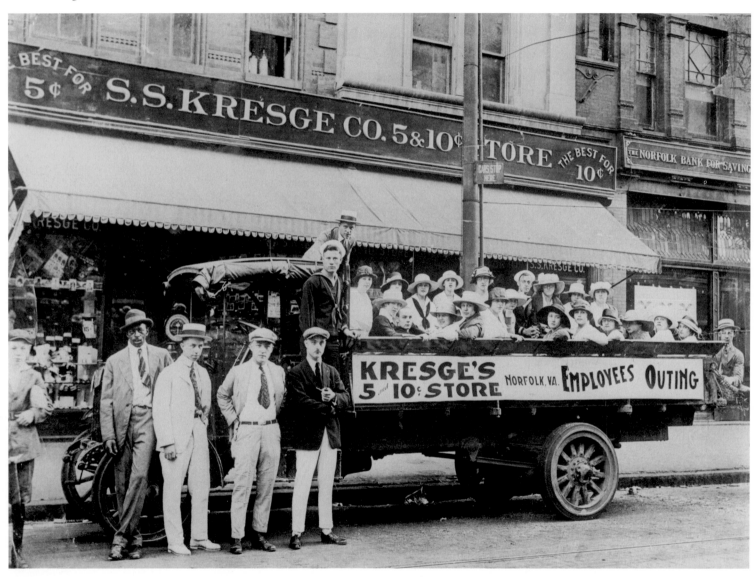

Fire fighters on Plume Street near the Arcade Building, 1911. Norfolk's first fire station was constructed two blocks from here in 1872. The last horse-drawn equipment was taken out of service in Norfolk in 1921.

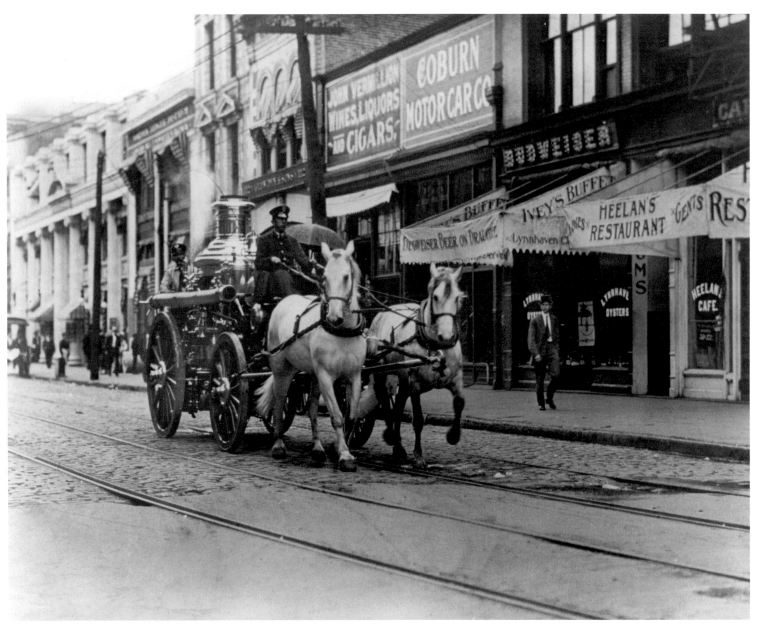

The first tungsten arc lights in Norfolk were put into use on Granby Street between Main and Freemason streets in September 1909. As Plume, Main, Tazewell, and Church streets, and City Hall Avenue, followed in late 1909 and early 1910, the *Virginian-Pilot* forecast that Norfolk would be among the "brightest lighted cities in the world."

A stately lion and whimsical cherubs greet the traveler from atop the elaborate entrance to the Atlantic Hotel on lower Granby Street around 1910. This was the third and final Atlantic Hotel built on the spot, the first two having burned in 1867 and 1902. A group of young boys, working as newsies, are on hand to provide passersby with the latest headlines.

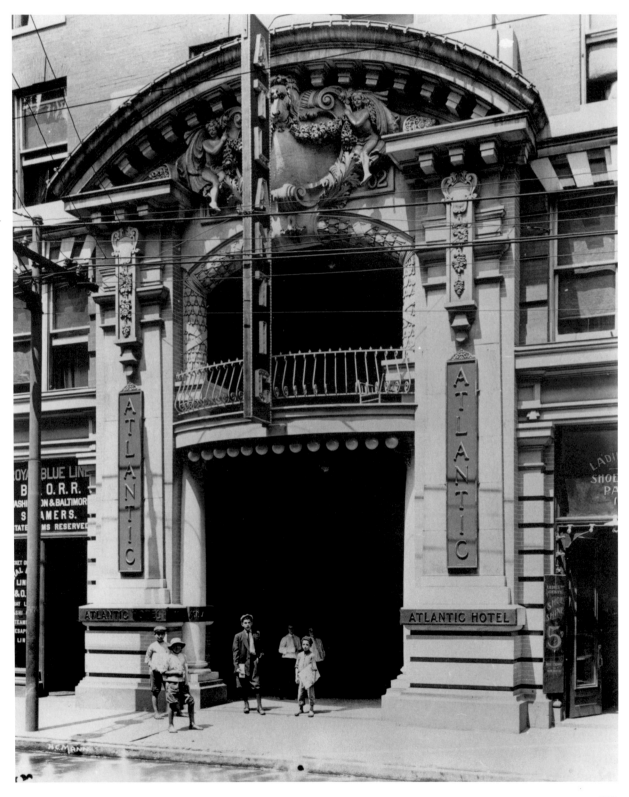

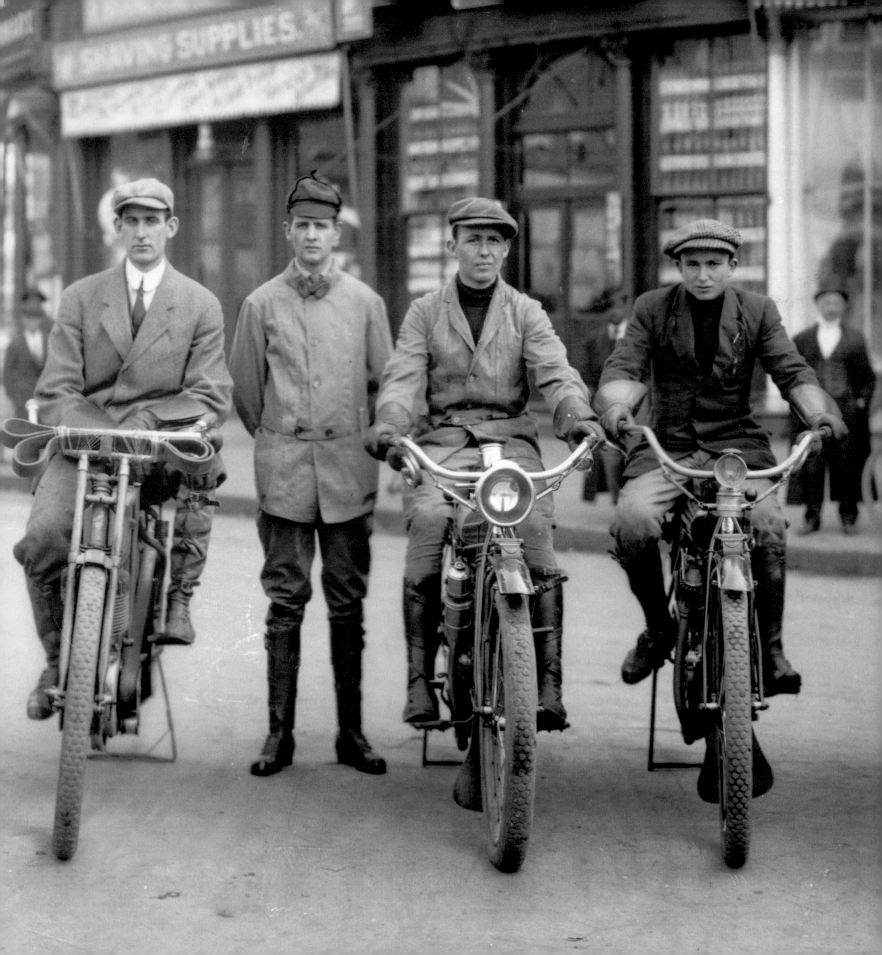

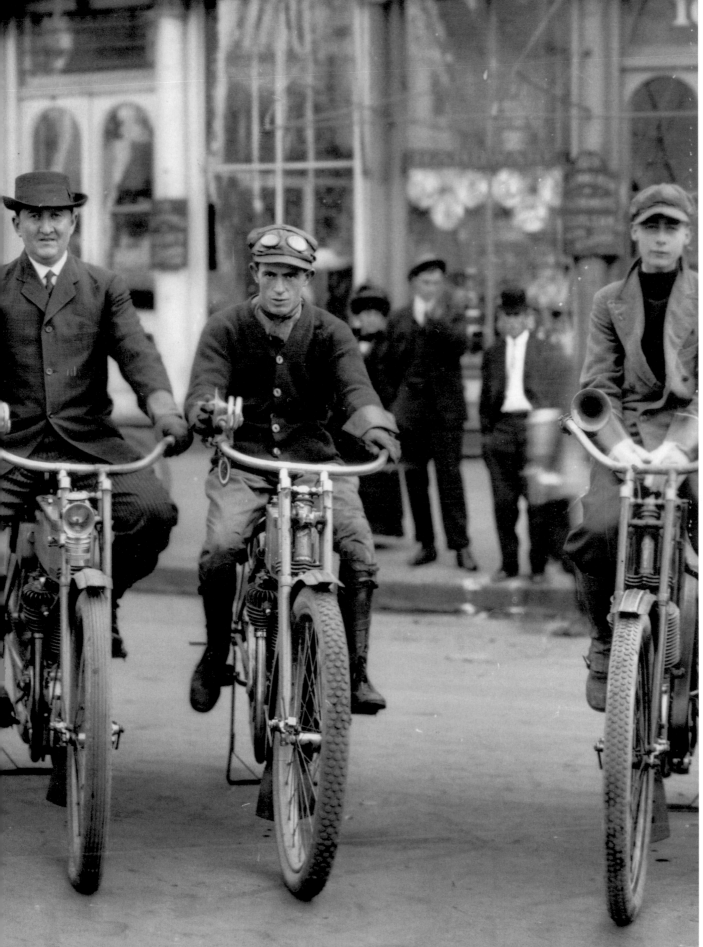

Members of the Twin City Motorcycle Club pose for the camera at Commercial Place around 1913. Norfolk and Portsmouth, our neighbor across the Elizabeth River, were known as the "Twin Cities" for many years.

Norfolk fire fighters pose outside their station around 1914, relaxed for the moment but ready for action should duty call. Perhaps the lad looking on at the right is a prospective future recruit.

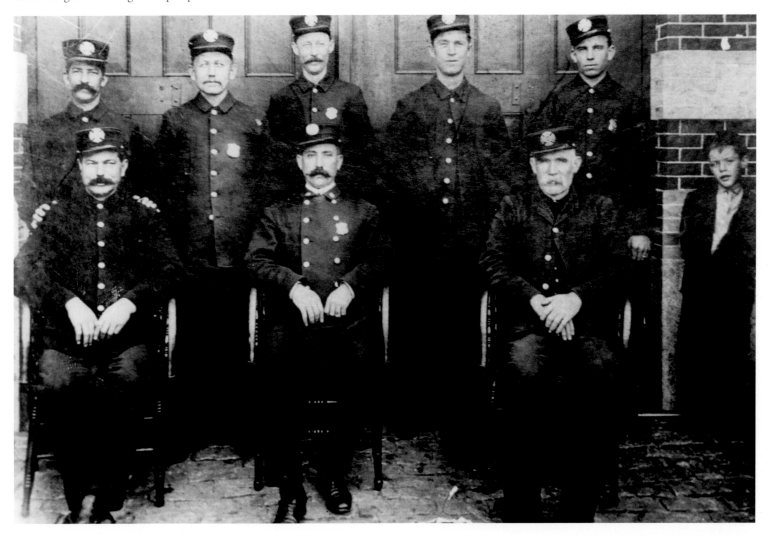

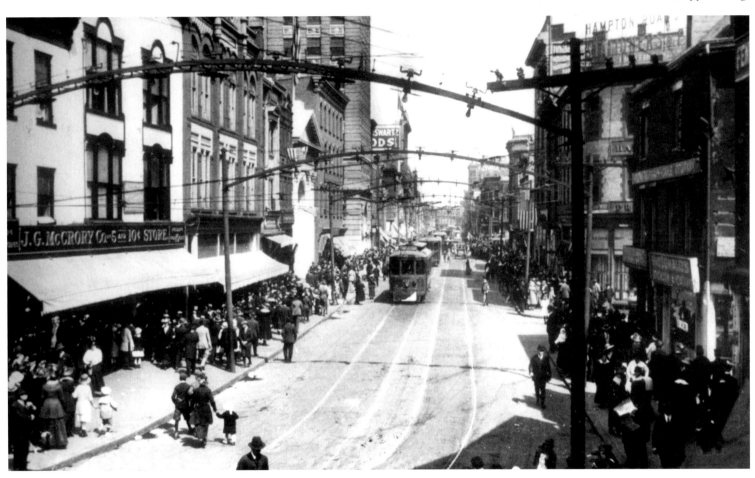

Looking east to the 100 block of East Main Street in 1917, with streetcar number 2112, on the Lamberts Point line, approaching.

The H. D. Van Wyck Branch Library opened at 345 Shirley Avenue on May 15, 1916. It was Norfolk's first branch library, built on land purchased with funds from the estate of New York native Henry Du Bois Van Wyck. Philanthropist Andrew Carnegie provided additional funds to build the library. The building continues to be a part of the Norfolk Public Library system and is the city's oldest structure still being used as a library.

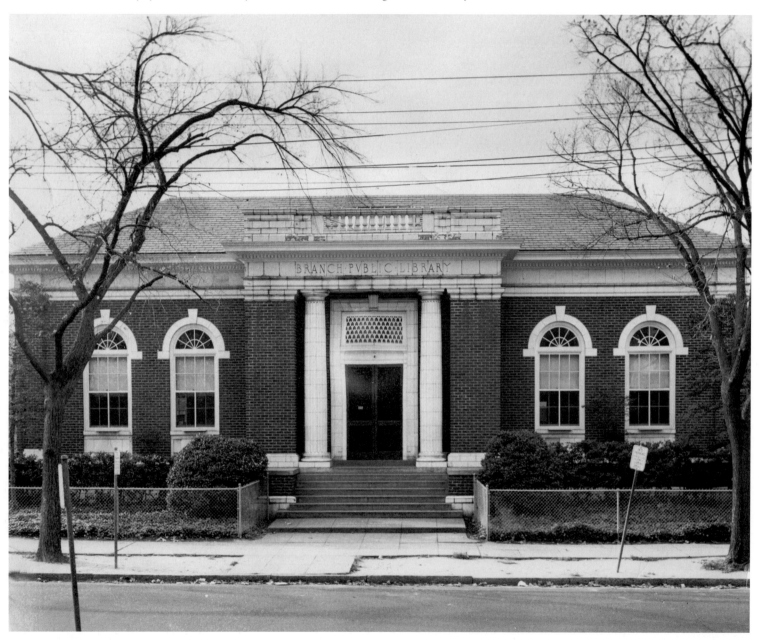

The Monticello Hotel around 1920. The Monticello opened at the northeast corner of City Hall Avenue and Granby Street in 1898. It burned New Year's Day 1918 and was rebuilt a year later with two additional stories. The Monticello was Norfolk's most elegant hotel for many years—its Starlight Ballroom on the top floor was the scene of many a prom and wedding reception. The building was imploded in 1976 to make way for Norfolk's new Federal Building.

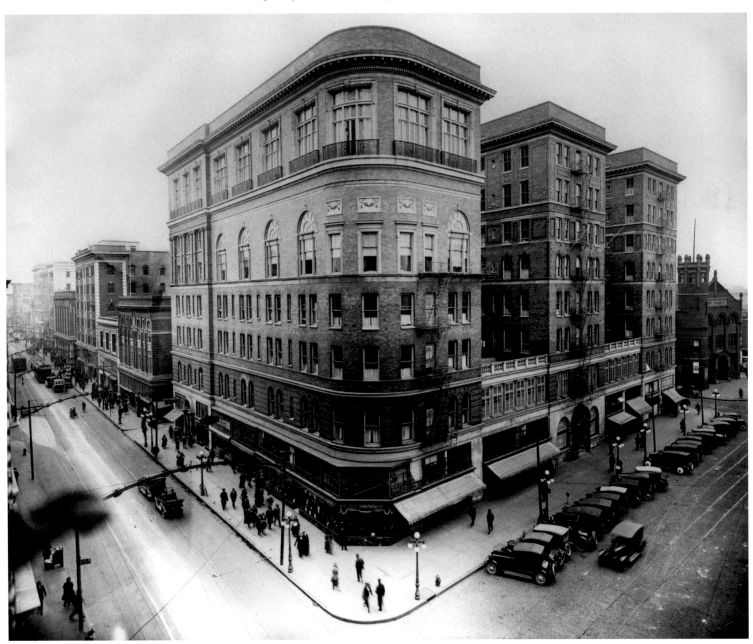

Seen here, the German raiders *Kronprinz Wilhelm* and *Prinz Eitel Frederich* were impounded and their crews of 600 men interned at the Norfolk Navy Yard in April 1915 after being chased into Hampton Roads harbor by French and English warships. Since the United States had not yet entered World War I, the sailors enjoyed liberal leave privileges and became familiar sights in the community.

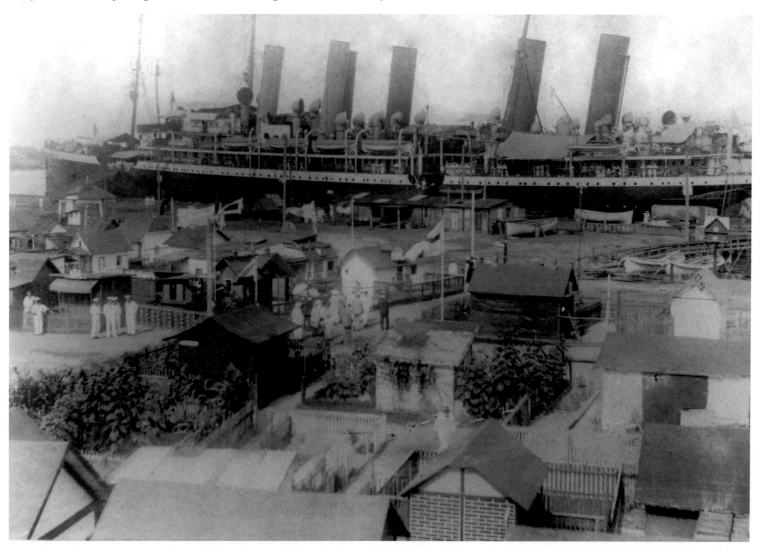

The sailors from the interned ships occupied their time by building a German Village from scrap materials found at the Navy Yard. The village, with its vegetable garden, weekly newspaper, and nearly 50 miniature buildings, attracted thousands of visitors.

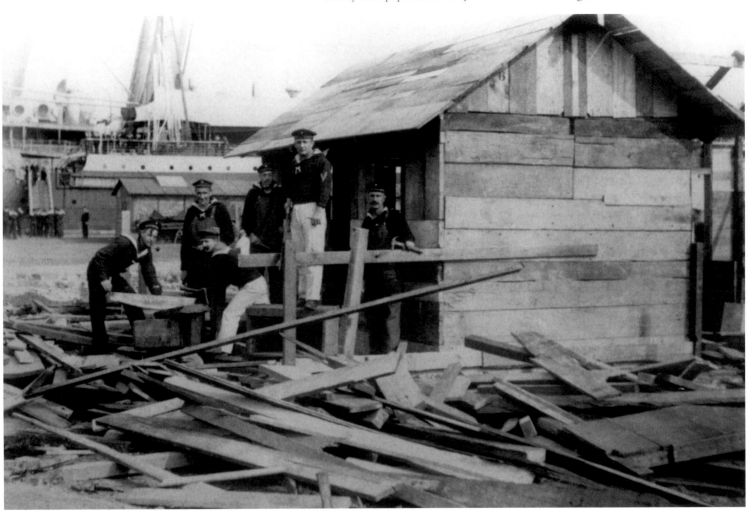

President Woodrow Wilson signed a bill creating a naval base—now Naval Station Norfolk—on the old Jamestown Exposition grounds on June 15, 1917. Wilson, in trademark morning coat and top hat, later visited the base to observe construction taking shape.

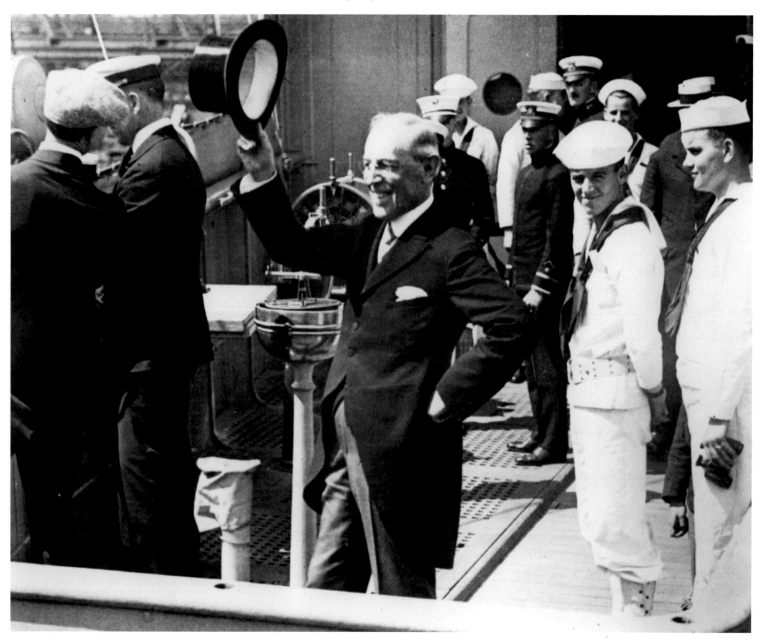

Proceeds from the 10¢ German Village entry fee and the sale of baked goods, postcards, and toys handcrafted by sailors such as these were sent to the German Red Cross. After the U.S. entered the war, the German ships were seized and converted to American troopships. The internees became prisoners of war and were transferred to POW camps in Georgia.

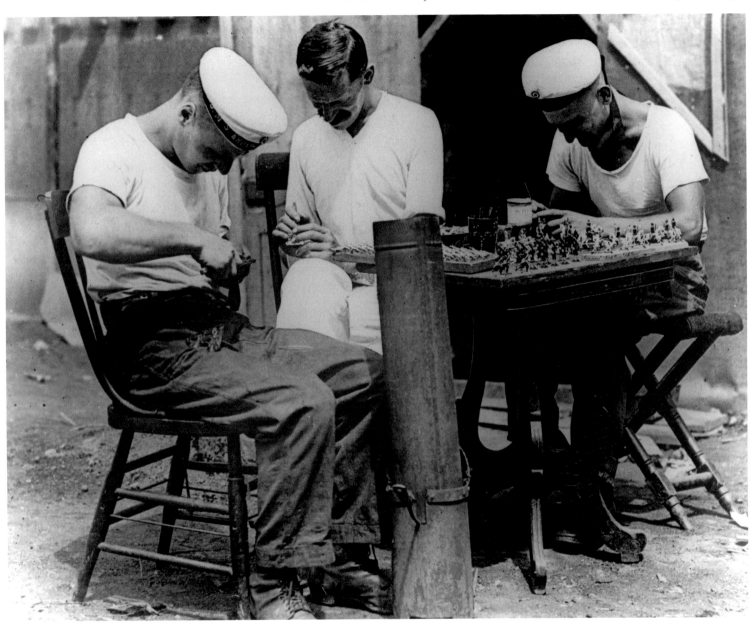

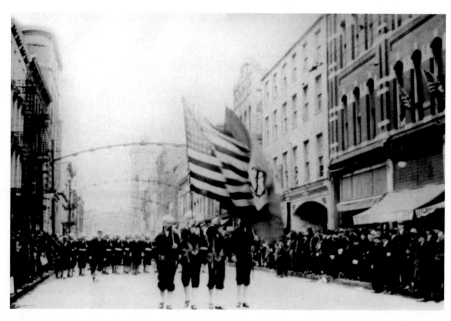

World War I began in Europe in 1914, but the United States was not drawn in for nearly three years. After several attacks on American merchant vessels by German submarines, President Woodrow Wilson asked Congress to declare war on Germany, which it did on April 6, 1917. Here, American sailors parade down Main Street that same April to demonstrate their readiness to serve their country.

It was the Great War. While soldiers and sailors departed to fight for democracy overseas, those on the home front also did what they could to help. Here, in 1918, the Norfolk unit of the National Catholic War Council Women's Auxiliary organizes a sale of Liberty Bonds at the steps of the U.S. Customhouse on Main Street, with the flags of the Allied powers hanging nearby.

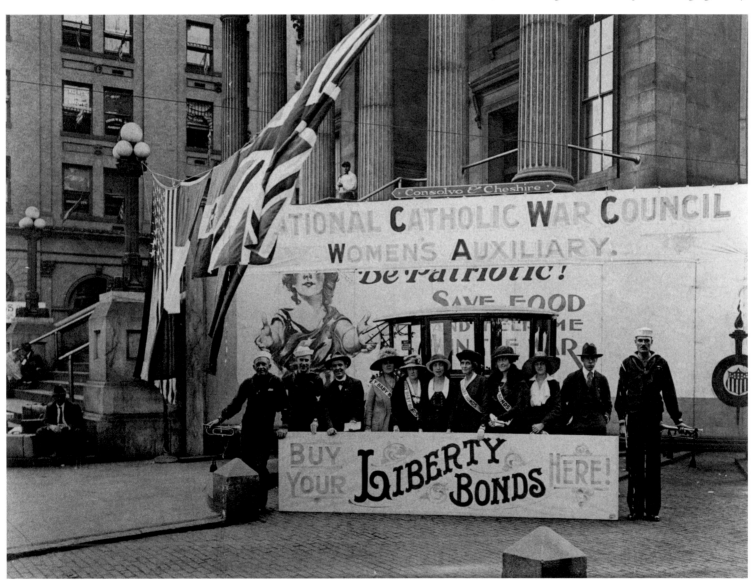

A patriotic parade on East Main Street at Commercial Place in September 1917, five months after the United States Congress declared war on Germany and entered World War I.

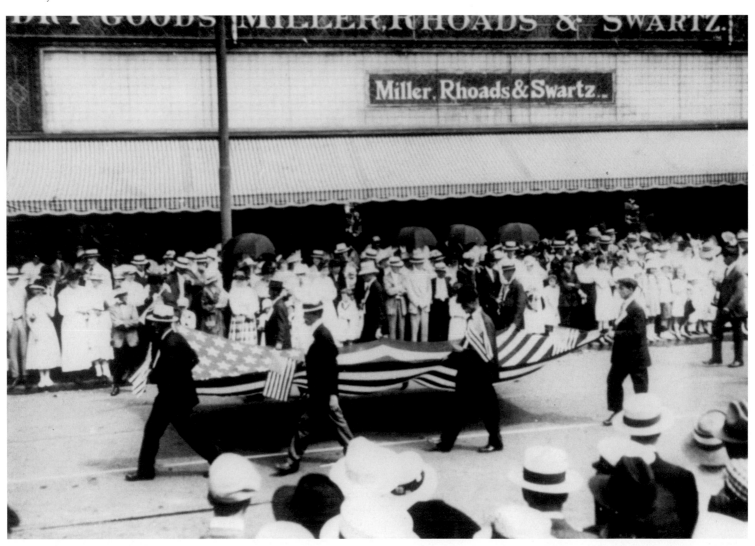

A month before the signing of the Treaty of Versailles, which officially ended World War I, this patriotic parade moved down Main Street. Paraphrasing Lieutenant Colonel John McCrae's war poem "In Flanders Fields," words on the float read: "If ye break faith with them who die/ We cannot sleep/ Though poppies grow on Flanders fields."

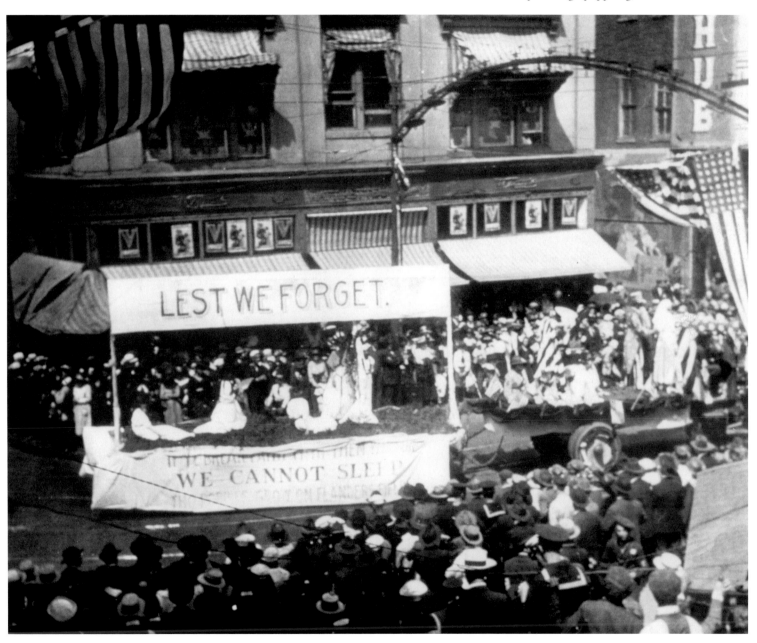

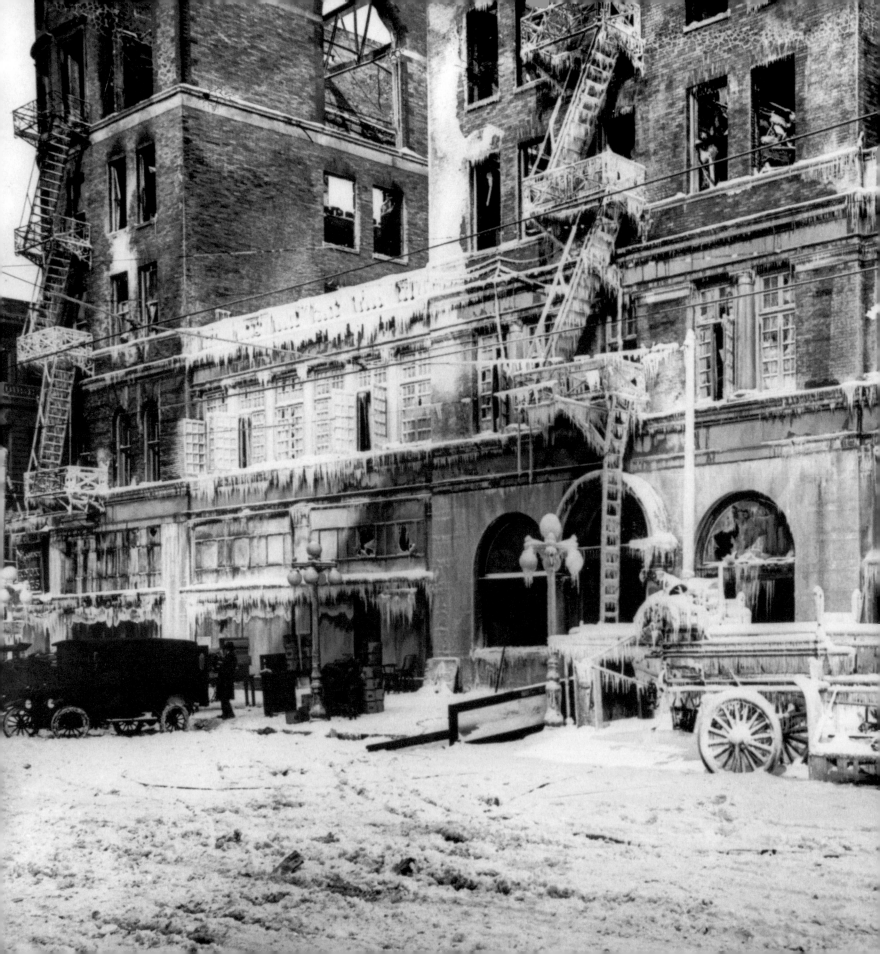

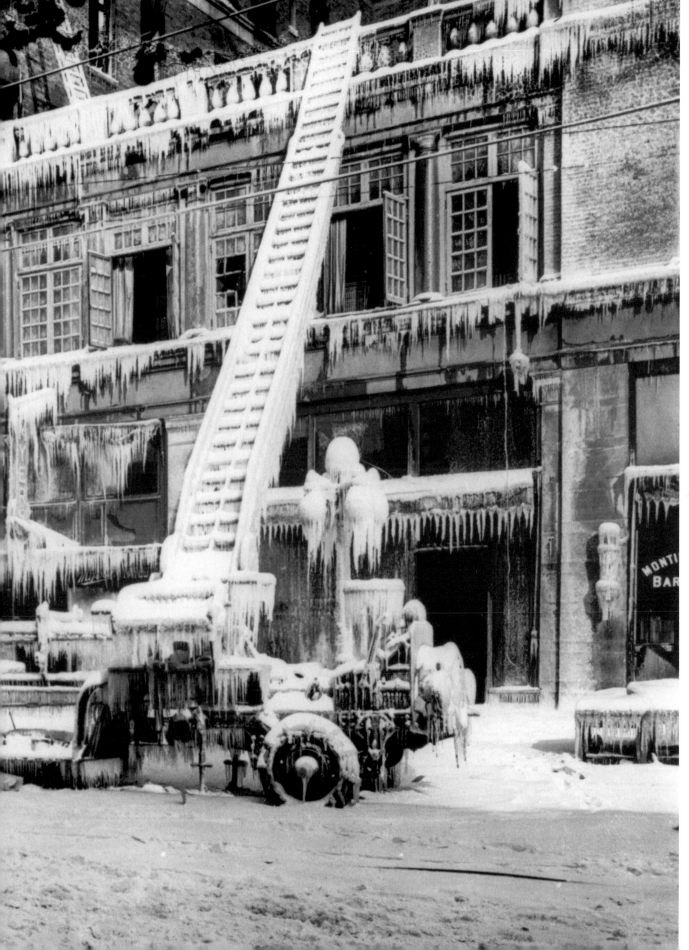

The winter of 1917–1918 was one of the coldest on record in Norfolk. When a fire broke out in the 200 block of Granby Street in the early morning of January 1, 1918, fire fighters rushed to the scene to fight the blaze; however, their efforts were thwarted when the water from their fire hoses froze upon contact with the frigid air, creating a scene of eerie beauty. Four nearby buildings were also destroyed and three fire fighters lost their lives. The Monticello was heavily damaged but was rebuilt the following year with two additional floors and an additional 150 guest rooms. The Monticello was imploded on January 25, 1976, to make way for the new Norfolk Federal Building.

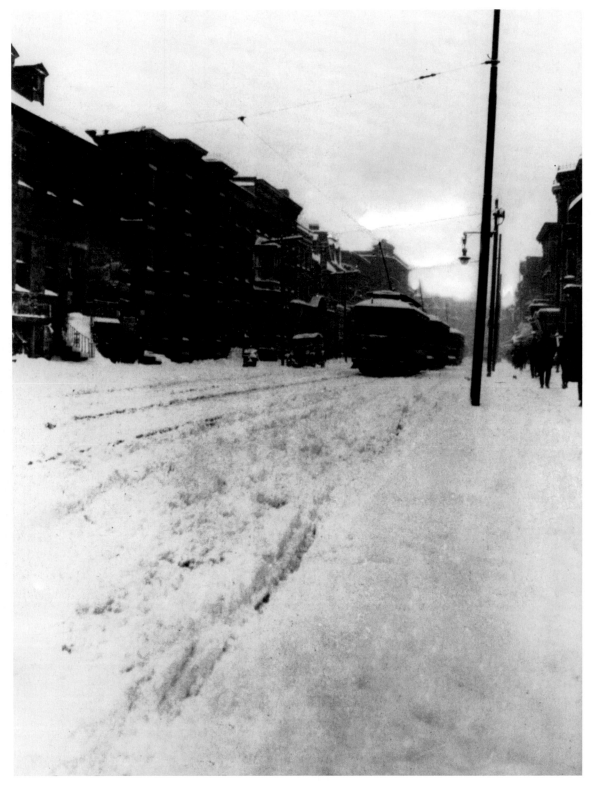

Cars are mired in the snow in the 900 block of East Main Street, and pedestrians follow in the footsteps of others on this frigid day in January 1918, just two days after the Monticello Hotel fire. Only the trolley cars appear to prevail against nature.

The Lorraine Hotel at Granby and Tazewell streets was one of several built to accommodate visitors to the 1907 Jamestown Exposition. Seen here around 1920, it was built on the former property of Littleton Waller Tazewell (1774–1860), one-time Virginia representative, senator and governor. The Colonial Theater, behind the Lorraine, was built around the same time. The Tazewell mansion was not demolished for the new construction, but was dismantled board by board and moved a few miles north to Edgewater, where it stands today.

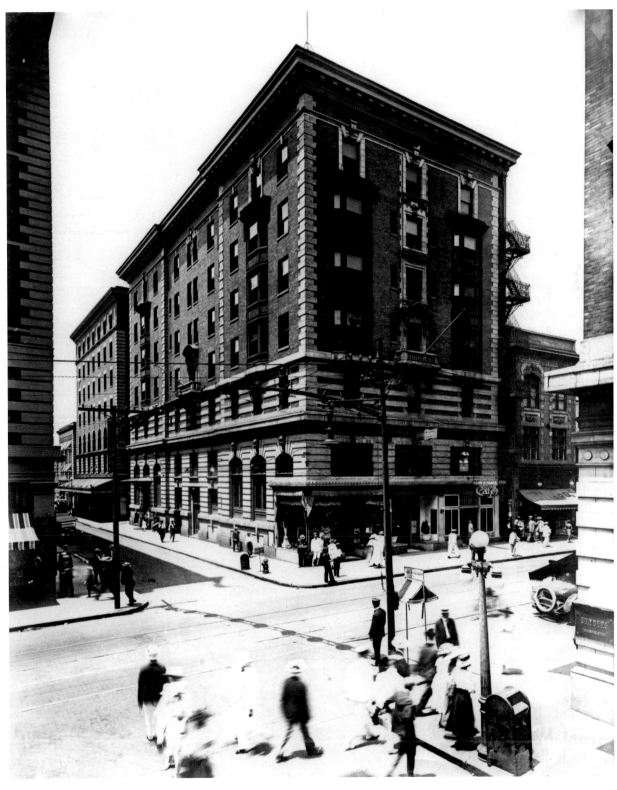

Looking west on Main Street toward the river around 1920, perhaps from atop the Royster Building at Granby Street and City Hall Avenue. The Anheuser-Busch Brewing Company ceased to function as a brewery in Norfolk when Prohibition was introduced in 1920, but served as a cold storage facility for many years. A portion of the complex has been converted into condominiums and still offers a splendid view of the Elizabeth River.

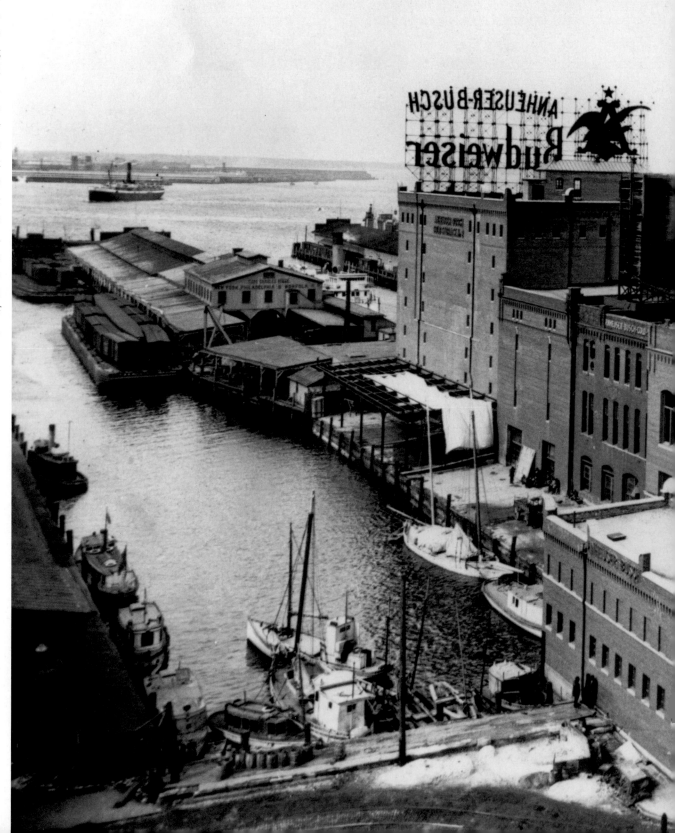

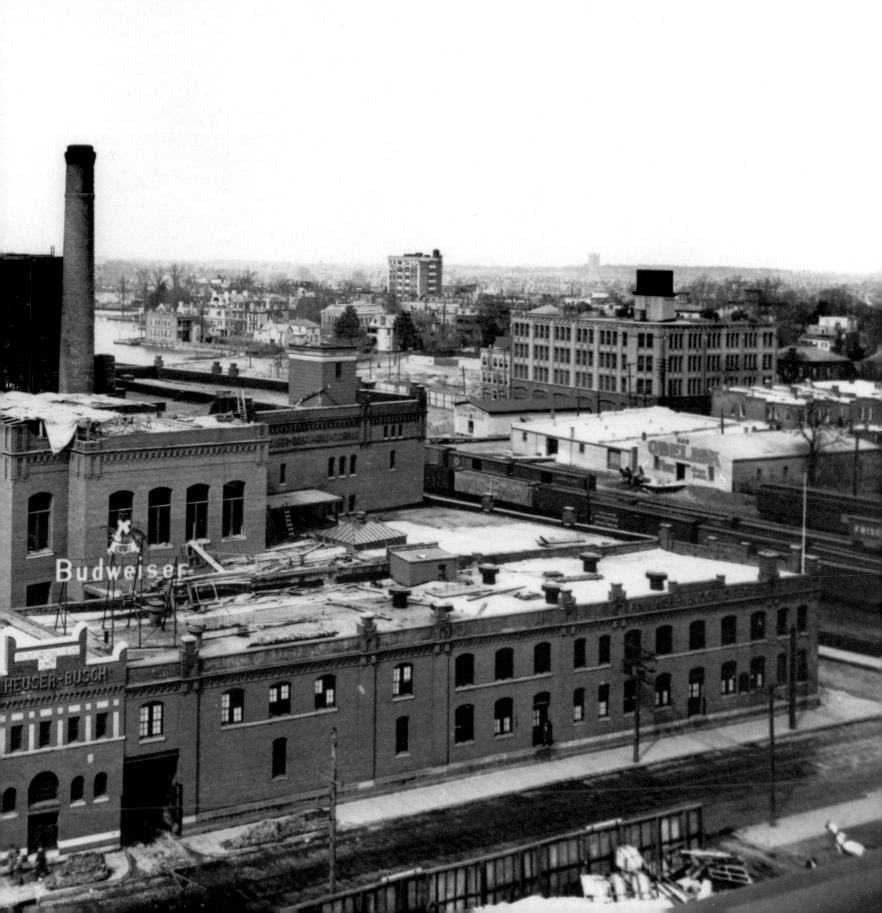

Reliance Electric Company was awarded a license to operate Norfolk radio station WTAR in September 1923. It was the first radio station in Virginia. The first remote broadcasts the following year included the 1924 World Series when, for the very first time, Norfolk baseball fans were able to listen to a play-by-play account of the national pastime, as the Washington Senators defeated the New York Giants four games to three. WTAR became a CBS affiliate in 1929, a year before this station photo was taken.

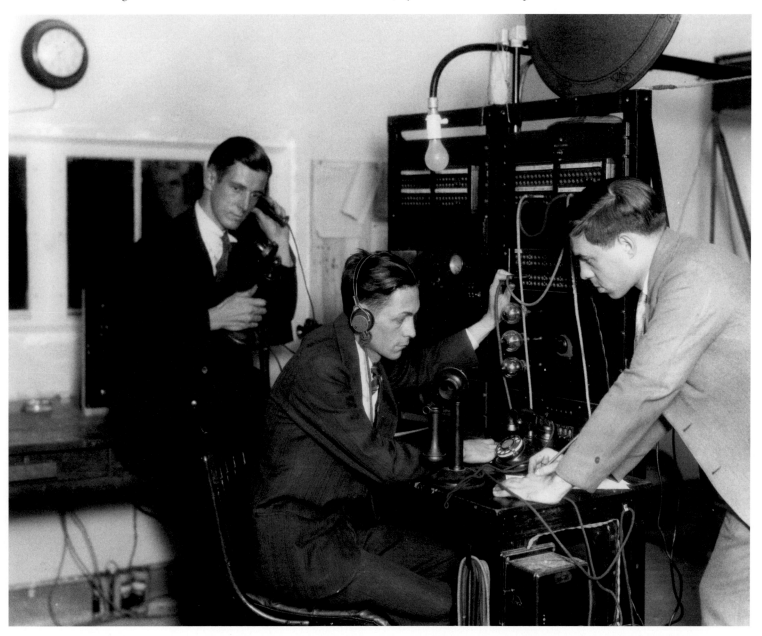

A GROWING CITY AND LIFE ON THE HOME FRONT

(1921–1945)

Norfolk roared into the 1920s with the 1923 annexation of more than 25 square miles of Norfolk County land stretching from the city's northern boundary all the way to the Chesapeake Bay. Much of the new land was populated by communities built along the streetcar tracks laid from downtown Norfolk to the Jamestown Exposition grounds nearly 20 years earlier. Residents of the new suburbs were eager to avail themselves of utilities and services available to city residents. Representatives from Ocean View and Willoughby had petitioned the state for annexation to Norfolk in the early part of 1922. The annexation brought in 25,000 new citizens, making Norfolk the second-largest city in Virginia.

When America went to war, the nation came to Norfolk. A World War II influx of military and civilian personnel from across the country raised the city's population from 144,332 in 1940 to more than 168,000 naval personnel and nearly 200,000 civilians at the end of 1943. Everything from a seat on the trolley to a place to lay one's head was in short supply. Goods of all kinds were rationed, and residents learned to pool their grocery rations for such indulgences as a communal cake or a shared bowl of holiday eggnog. Scrap drives and victory gardens became part of everyday life, with children and adults alike pitching in. Even a dog named Scotty made the news for the sacrifice of his personal fire hydrant to the scrap metal drive.

Allied victory came, but at a price. Of the estimated 8,700 Virginia military personnel who died while serving overseas between 1940 and 1946, nearly 600 were from the city of Norfolk. As confetti rained down and strangers embraced in the streets, gold stars placed in the windows of the families of the dead served as a reminder that not everyone came marching home.

Bridges crisscross rivers and creeks throughout the city. This detail from a 1922 view of the downtown waterfront shows the Berkley Bridge in the foreground and the Norfolk and Western Railway Bridge behind it.

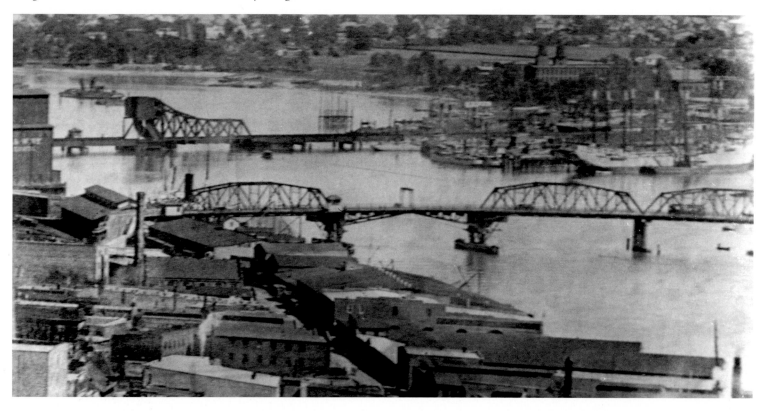

The Ocean View resort was known for its sweet summer breezes, gentle surf, and plenty of good fishing. Here, in 1936, a group displays an impressive catch—even the youngsters caught a few fish!

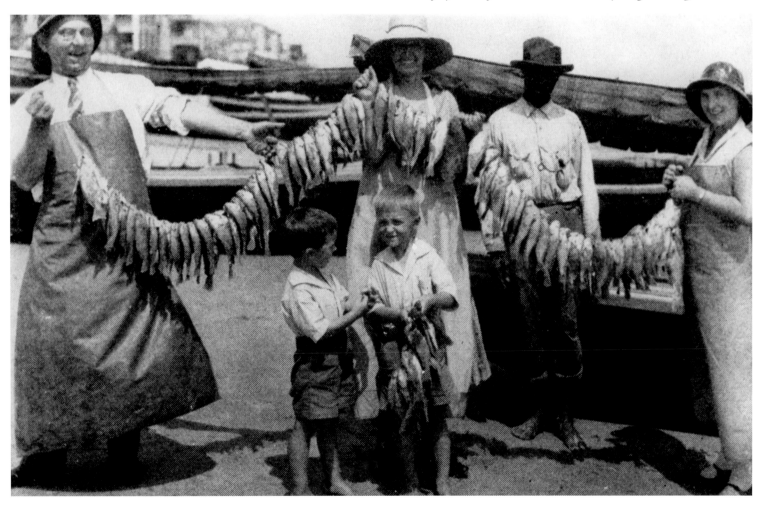

A fire in Berkley that began on the morning of April 14, 1922, left a wreckage trail of more than 300 homes, two churches, and 20 businesses over a ten-block area. The fire marked the end of an era for the Berkley neighborhood, as many families opted to rebuild their homes elsewhere in the growing city.

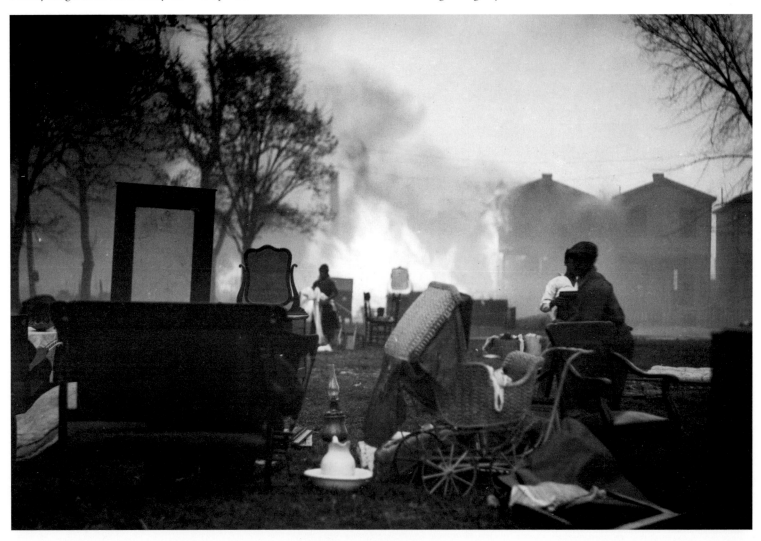

The 1922 Berkley fire began at the Tunis Lumber Company on the Berkley waterfront. Youngsters playing with matches were suspected of starting the blaze by accident, though the alleged culprits were not identified. This scene is at the Tunis docks.

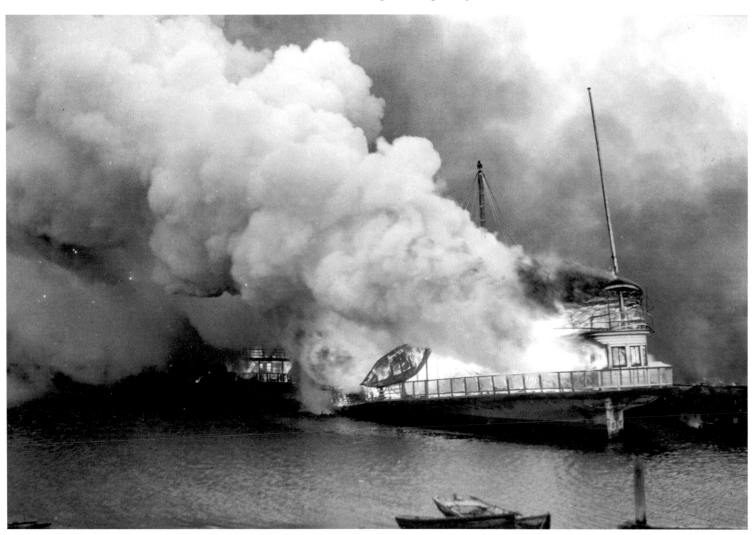

More than 1500 people were left homeless by the Berkley fire. Householders salvaged what they could as the fire approached their homes, and gathered their families and their belongings in makeshift tents. The smiling faces in this group indicate that they were more grateful for their safety than sorrowful for their losses.

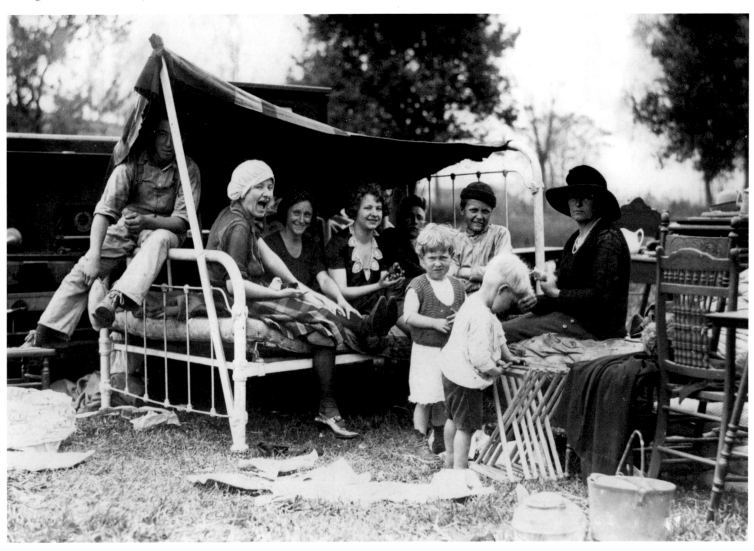

Boy Scouts mass the colors as they march to a Portsmouth playground for the annual Hampton Roads Scouts' Field Day on May 26, 1923. Field Day events were followed by the dedication of Norfolk's new Boy Scout headquarters and scoutmasters' club rooms on College Place.

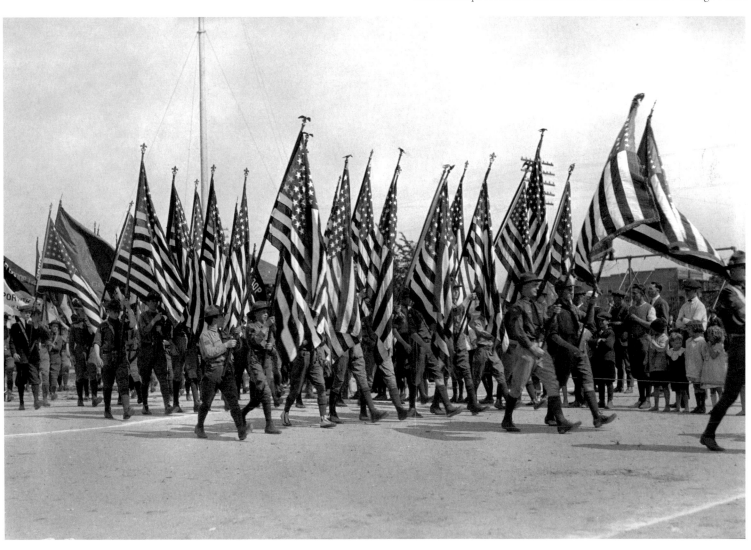

Market Street at Monticello Avenue, 1923.

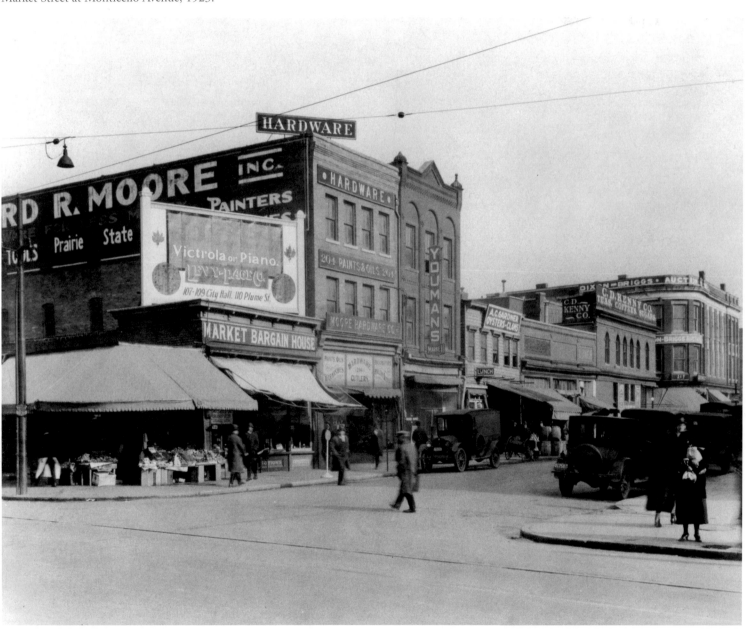

The Norfolk Division of the College of William & Mary, predecessor of today's Old Dominion University, opened in September 1930 in a two-story brick building constructed for Larchmont Elementary School in 1912. In addition to its two-year academic curriculum, the Norfolk Division established teams for football, basketball, baseball, and track, all competing as the "Braves." Thomas Lawrence "Tommy" Scott coached all four sports and taught math at the college from 1930 until he left in 1941 to join the family business. The football program ended the same year, with an overall win-lose-tie record of 62-19-4. Here, Coach Scott illustrates a play to his team.

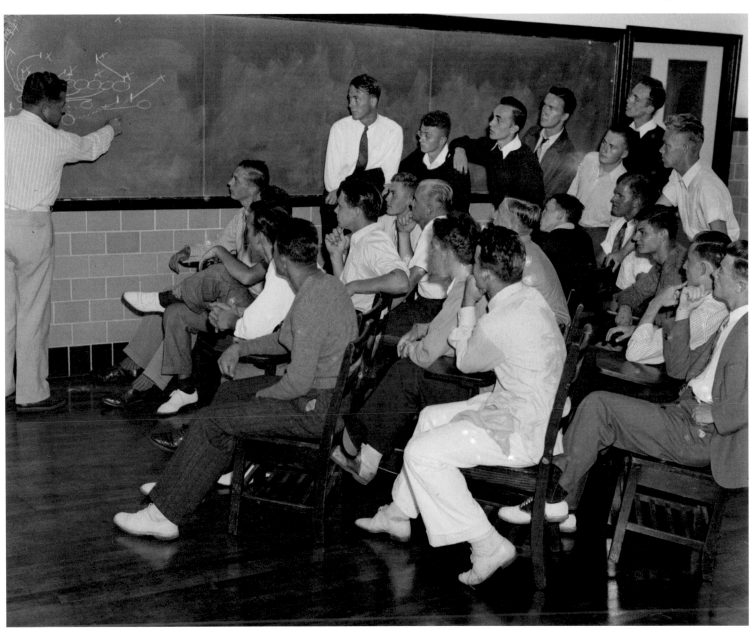

The 413-foot Army airship *Roma* is shown gliding silently above downtown Norfolk in early 1922. The *Roma* would crash at the site of the present Norfolk International Terminals on February 21, 1922, killing 34 of the 49 people on board. A broken altitude control was blamed for sending the airship into a nosedive that caused the hydrogen in its gas bags to explode when the ship came into contact with electrical wires. The *Virginian-Pilot* newspaper remarked the next day that the crash was "air navigation's latest and most tragic plea for helium."

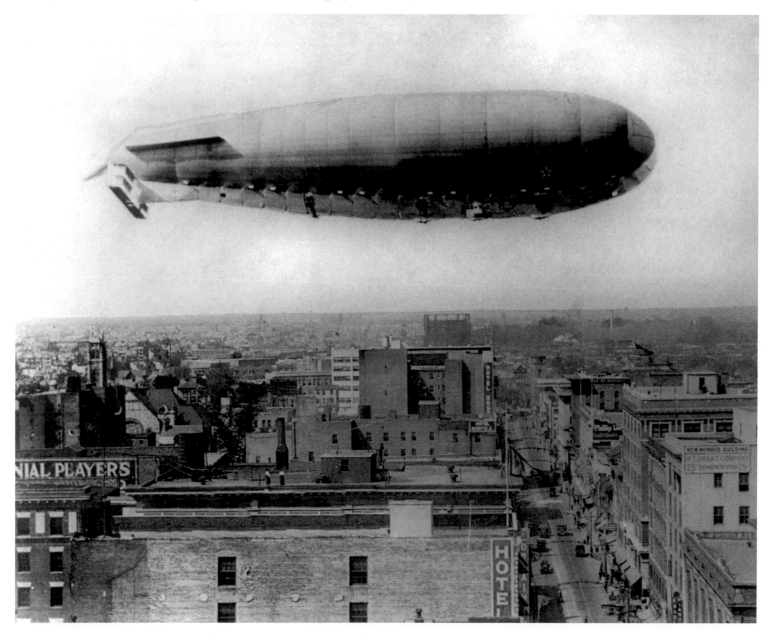

Lon Chaney Sr. and Norma Shearer appear at the Norva Theatre in the 1924 film *He Who Gets Slapped*, while Rice's "smart woman's shop" advertises a January clearance sale in this 1926 image.

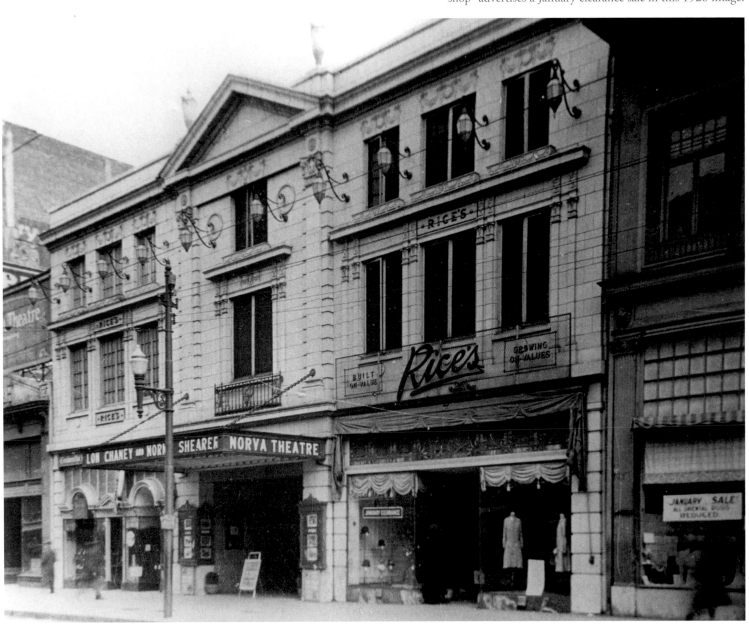

It was a sad day for the bootleggers, and their customers, this day in the middle of Prohibition, around 1926. More than 20 stills were believed to be in operation in the swamplands of northeastern North Carolina along the Alligator River. Unable to penetrate the hidden and treacherous trails through the marshes, federal prohibition agents could hope only to intercept rumrunners such as the *Silver Spray*, shown here, as they attempted to elude the feds on their way from "factory" to customer.

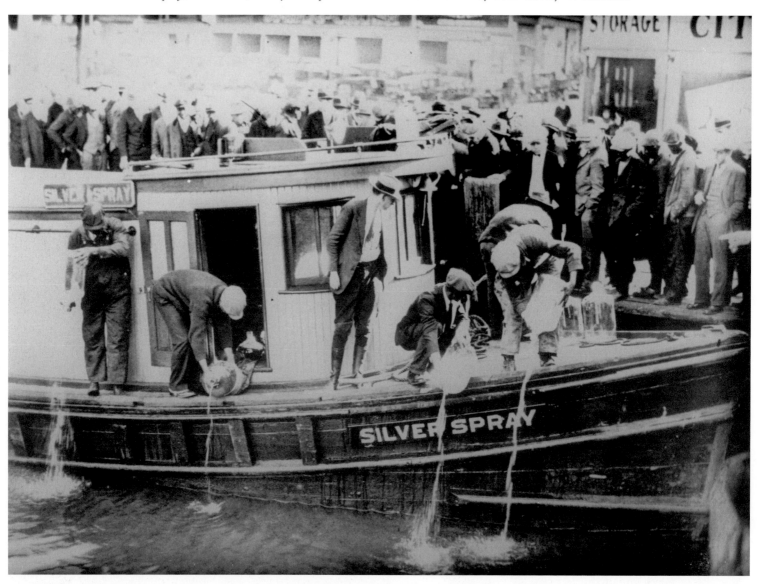

The Spartans and the Cardinals, local amateur teams playing under the auspices of the Norfolk Recreation Bureau, play an early spring game at Norfolk's Lafayette (or City) Park. The commander of the Spartans is at bat, with N. Karangelen of the Cardinals catching. The Cardinals won the game 10-7.

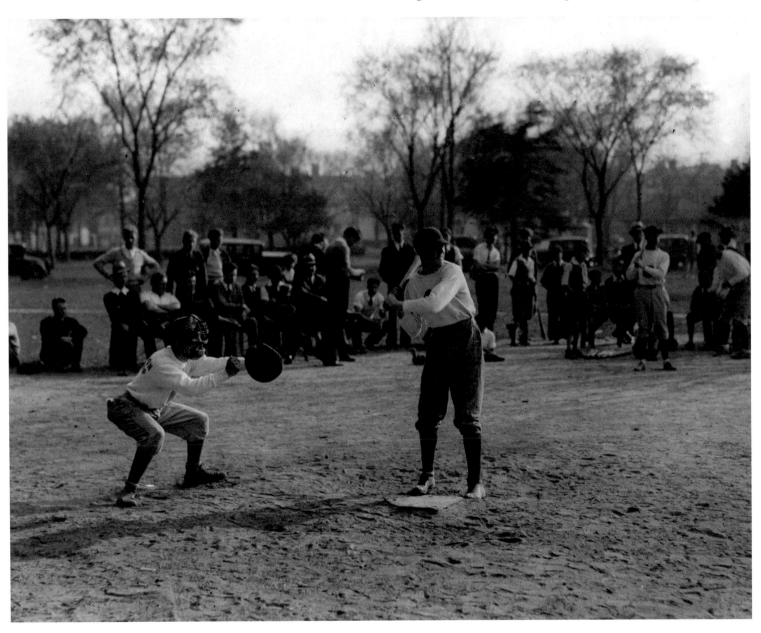

Former World War I pilot Ben Epstein began air taxi service between Norfolk and Richmond from his Granby Street airfield in 1929. Grand Central Air Terminal was constructed the same year and was Norfolk's first commercial airport building, promoted on this airplane in 1930.

Norfolk Police Department's Officer Marshall is on the job, writing a big ticket for a tiny car, March 25, 1932.

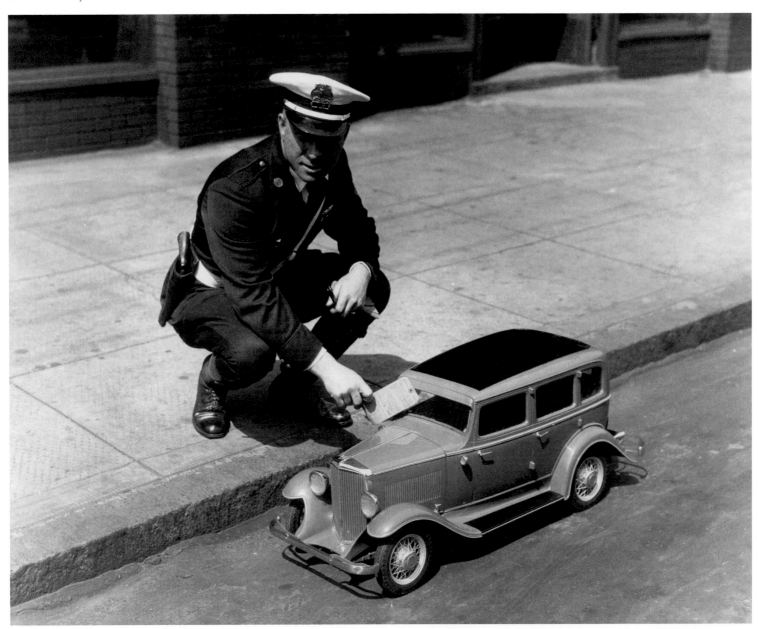

George Herman "Babe" Ruth, the "Sultan of Swat," came to Norfolk with the New York Yankees in June 1934 for the Yankees' first exhibition game with the Norfolk Tars. Here, Ruth shakes a few hands and signs some autographs, ensuring bragging rights for these young fans in the Atlantic City neighborhood.

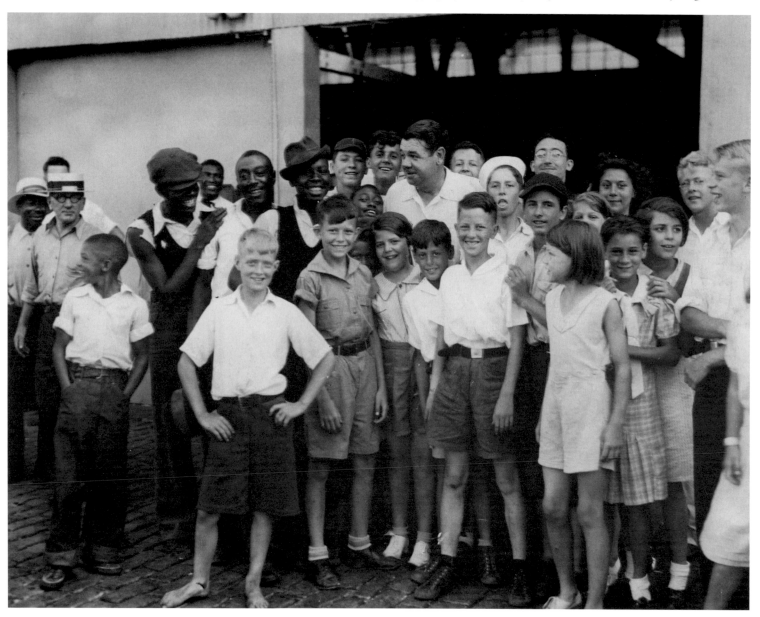

Norfolk *Virginian-Pilot* photographer Charles Borjes is on the other side
of the camera for a change as he poses beside the newspaper's first staff car
in1925. Borjes snapped pictures for the paper from 1913 to 1956.

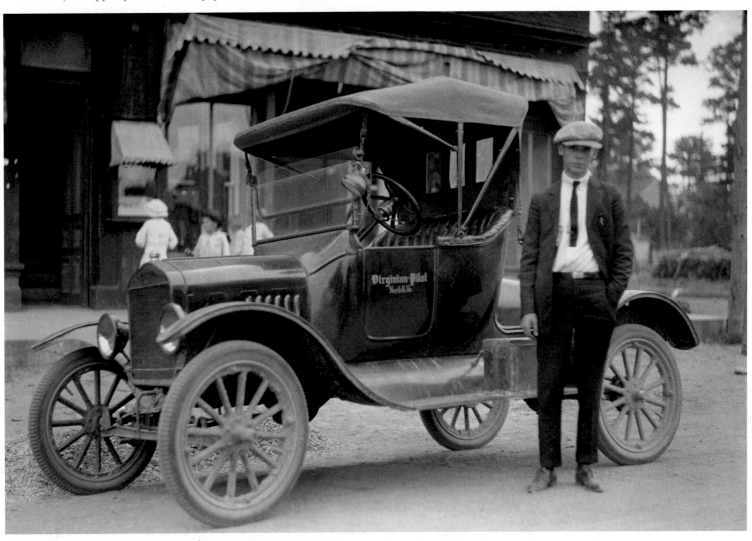

The Southland
Hotel at Granby and
Freemason streets,
around 1930. Built as
the Lynnhaven Hotel
to accommodate
visitors to the 1907
Jamestown Exposition,
the hotel was renamed
the Southland in
the 1940s and the
Commodore Maury
in 1954. American
humorist Mark Twain
stayed here during the
Exposition and again
in 1909.

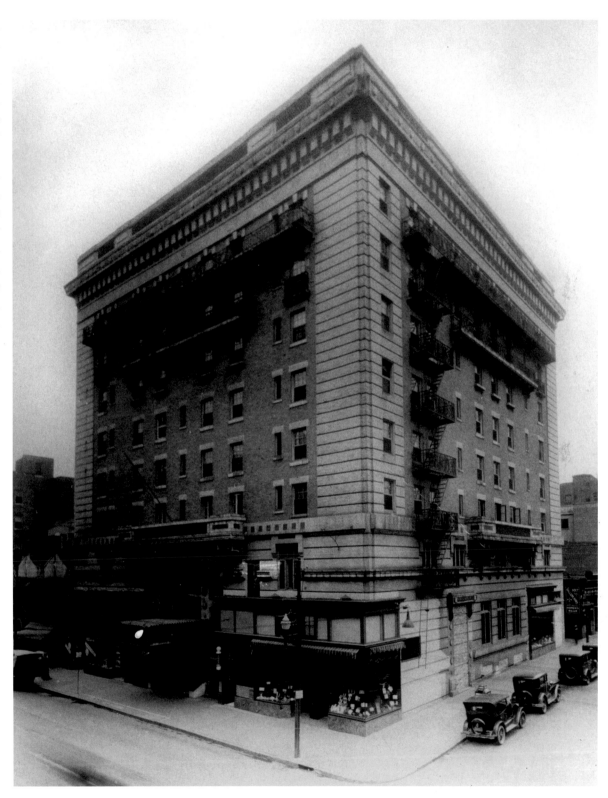

This airborne advertisement at the Ocean View beachfront reminds the ladies in the crowd to make a trip downtown to the Enna Jettick Store on Granby Street, where they would find just the right shoes to make them feel more "energetic."

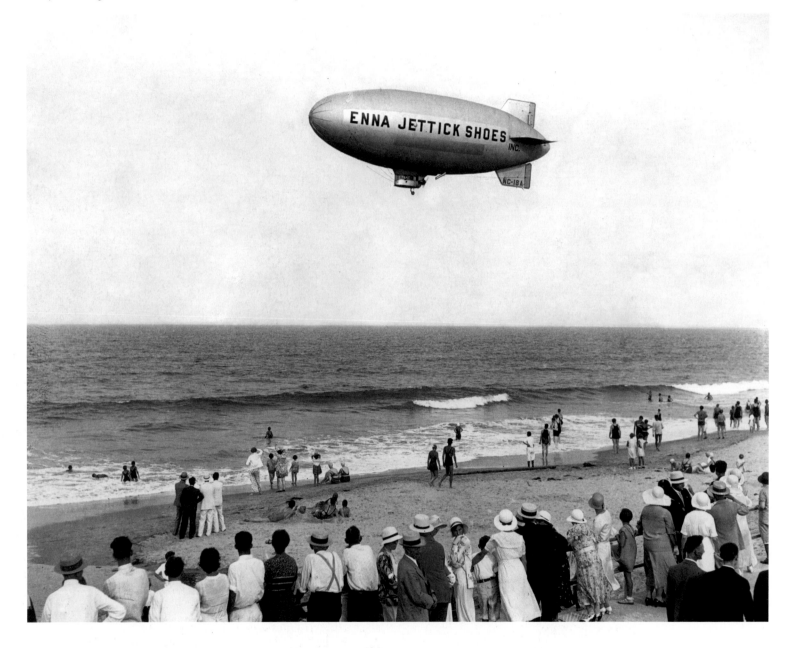

Looking north on downtown Granby Street in 1936. In the days before the suburban shopping centers began to lure customers away from downtown, Granby and Church streets were the primary retail destinations and were always busy with vehicles and pedestrians.

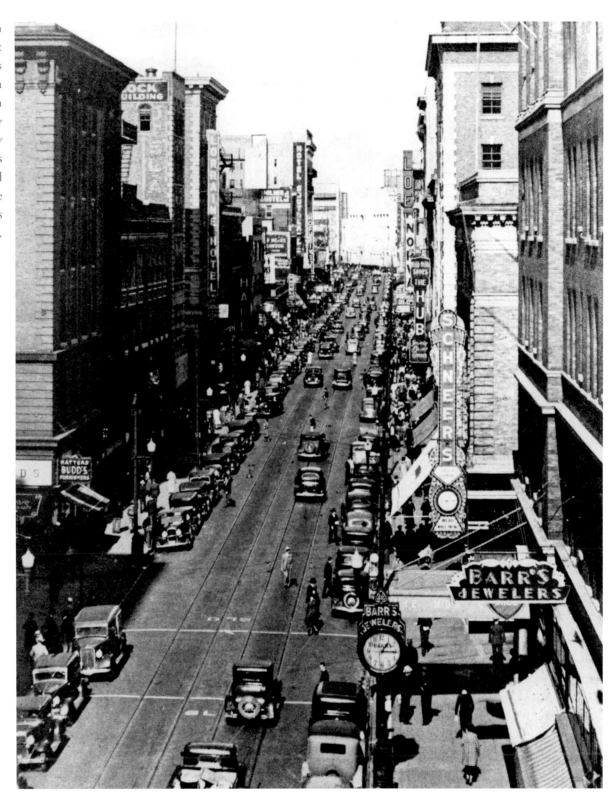

The Norfolk Ford Plant turned out its first Model T on April 20, 1925. Norfolk Mayor S. Heth Tyler, shown here, was given the honor of driving the first car off the assembly line. After more than 80 years of production, the Norfolk plant rolled out its final vehicle, a red F-150 truck, on June 28, 2007.

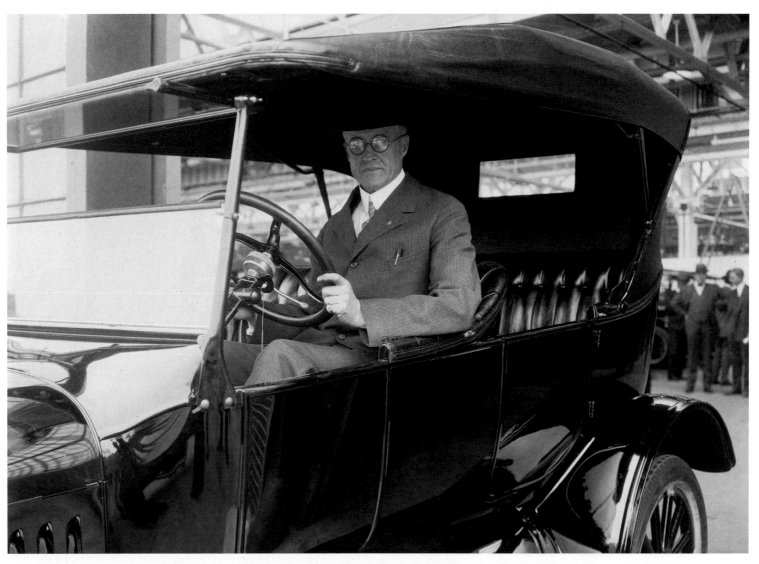

Norfolk's Union Station at the east end of Main Street. Union Station was built between 1911 and 1912 and was designed by the New York architectural firm of Charles A. Reed and Allen H. Stem. The passenger station served the Norfolk and Western; Southern; and Virginian railroads. The popularity of travel by rail had declined by the 1960s. Union Station was abandoned in 1962 and demolished the following year.

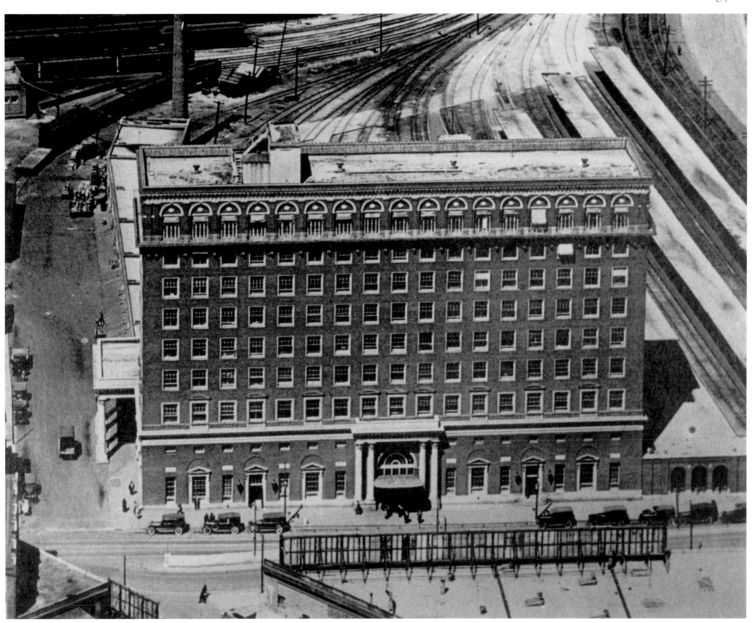

Passengers departing on one of the lines served by Norfolk's Union Station found a lovely place to wait for their trains inside the station, where rows of columns and an elaborate ceiling lent a sense of glamour to an otherwise ordinary journey.

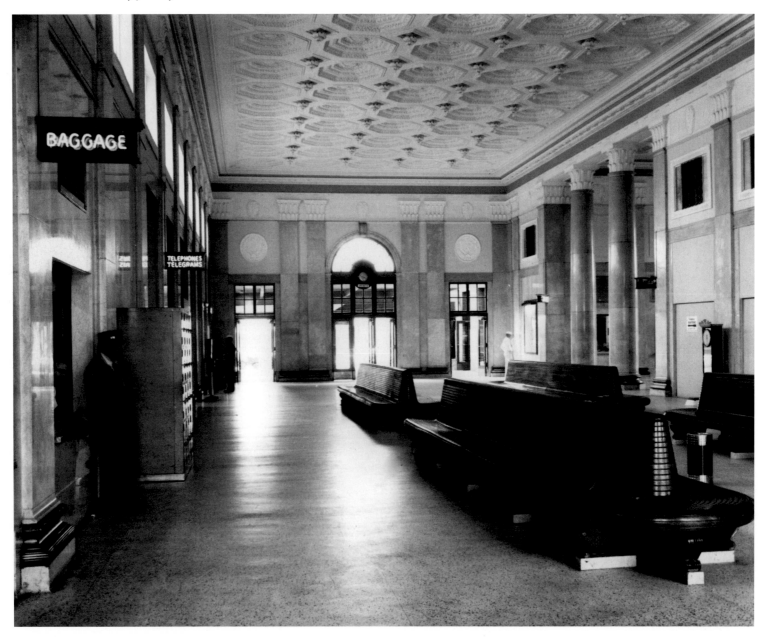

The Norfolk *Ledger-Dispatch* hosted a contest in November 1924 to find a real-life Adam and Eve willing to live off the land in the woods near Cape Henry (now part of First Landing State Park) for a week, to see if a modern couple could survive under the conditions of the original Adam and Eve. Out of the flood of applicants, Robert Day and Loretta Popejoy won the contest. Already engaged, the couple moved up their wedding date and were married in the window of the Hub men's clothing store on Granby Street. When they returned to civilization they were feted at the Wells Theater and received a great array of wedding presents from local merchants.

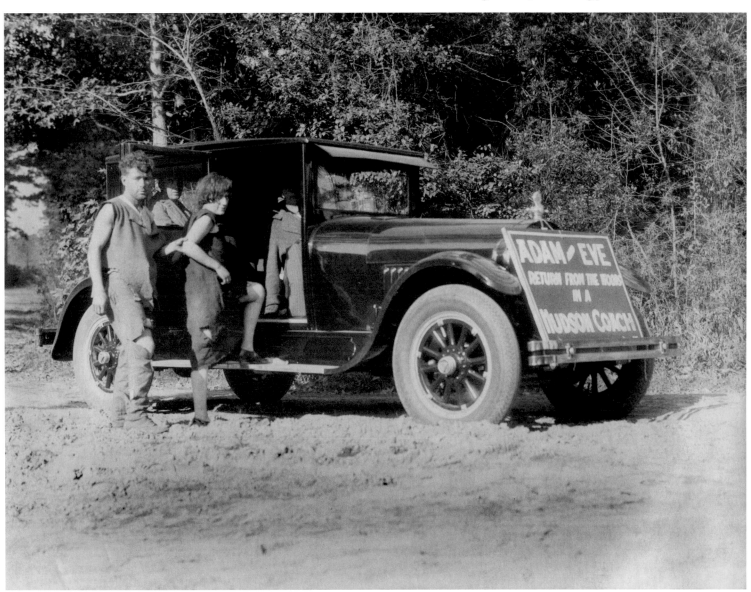

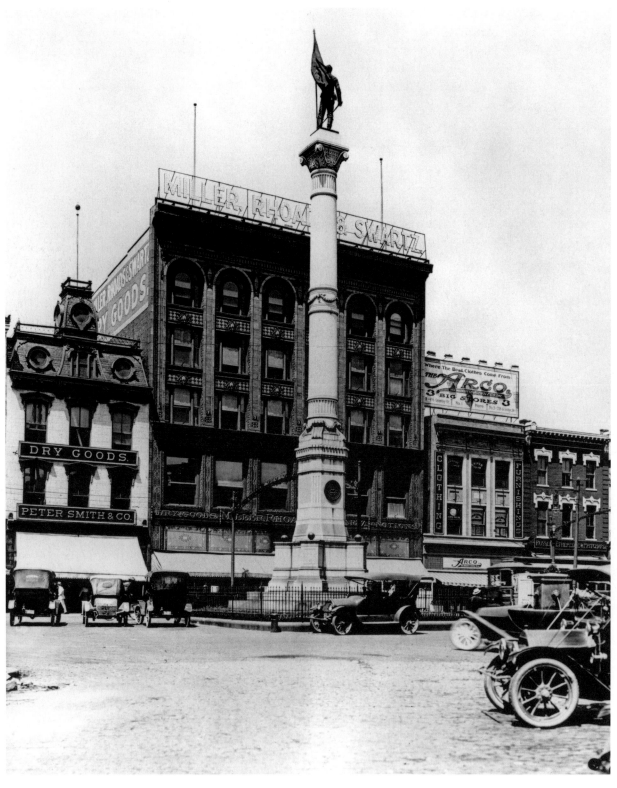

The Confederate Monument towers over this Commercial Place scene. Behind the monument, the Miller, Rhoads & Swartz Department Store was a mainstay for many Norfolk shoppers well into the 1950s. Of particular interest to children was the sound of their shoes on the wooden floor in the older part of the building, and the pneumatic tubes that shot their payments out of sight then brought their change back moments later.

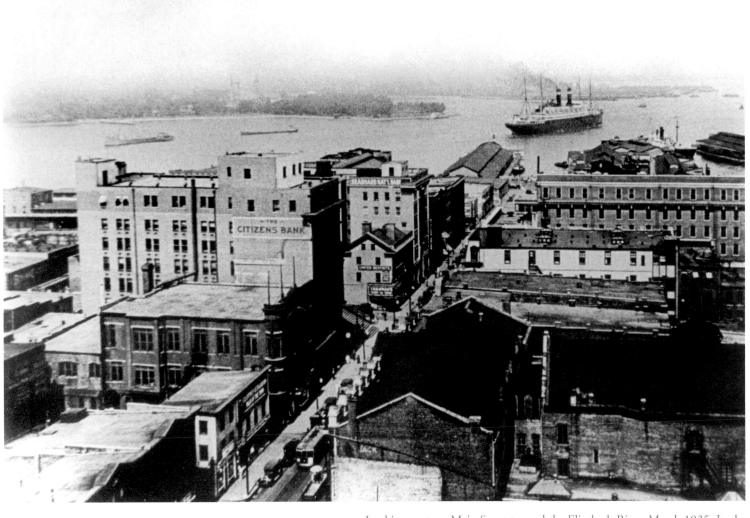

Looking west on Main Street toward the Elizabeth River, March 1935. In the distance, the steamer *George Washington* of the United States Line is leaving the Norfolk Navy Yard under her own steam after being in the Yard for repairs.

Not every story is a happy one. A visitor from Washington, D.C., unfamiliar with Norfolk's downtown streets and waterways, mistakenly drove his car off the end of Plume Street and into the river on a dark night in early October 1930. Sadly, he did not survive.

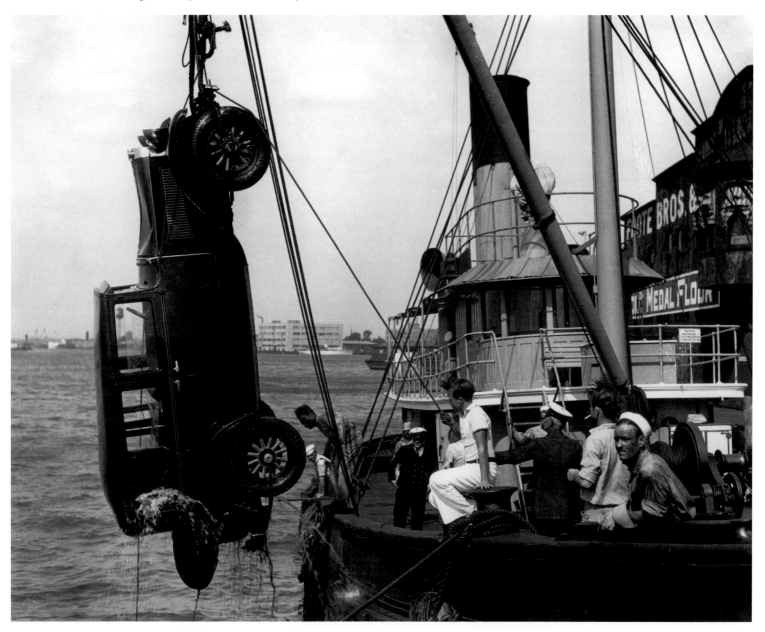

This aerial shot of a deserted Ocean View Beach offers a bird's-eye view of the roller coaster and amusement park, with the famed Spanish-style Nansemond Hotel at its far end, and the outline of Willoughby Spit curving away in the distance.

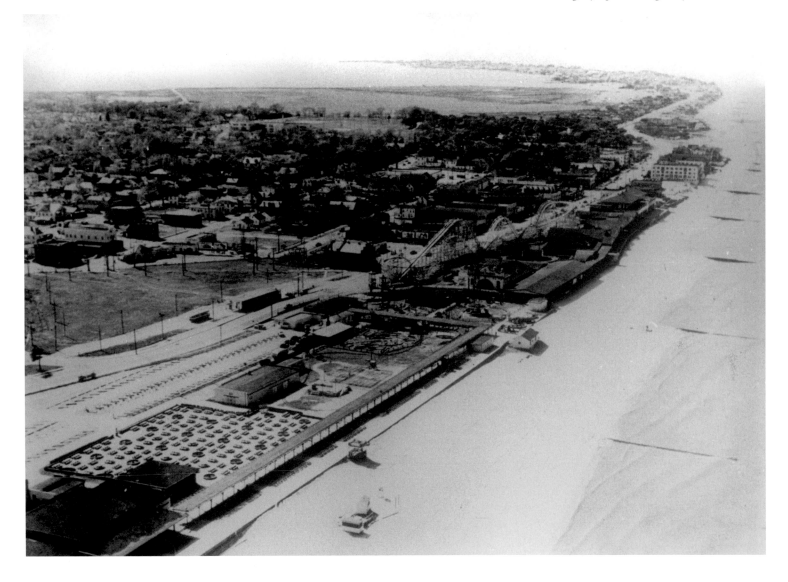

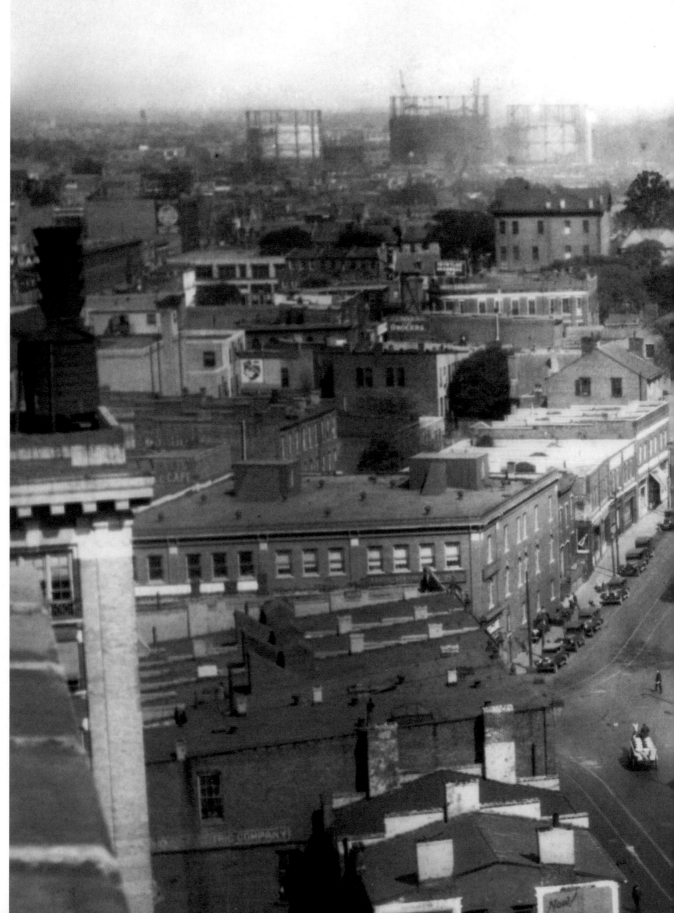

Looking north on Bank Street from Main, around 1931. Much of this vista would yield to redevelopment in the 1950s. Two landmarks recognizable on the modern skyline are the rounded dome of the 1850 Norfolk City Hall and Courthouse (today's MacArthur Memorial) upper right, and the darkened spire of the 1848 Freemason Street Baptist Church, punctuating the horizon to the right of center. Both buildings were the work of nineteenth-century architect Thomas U. Walter.

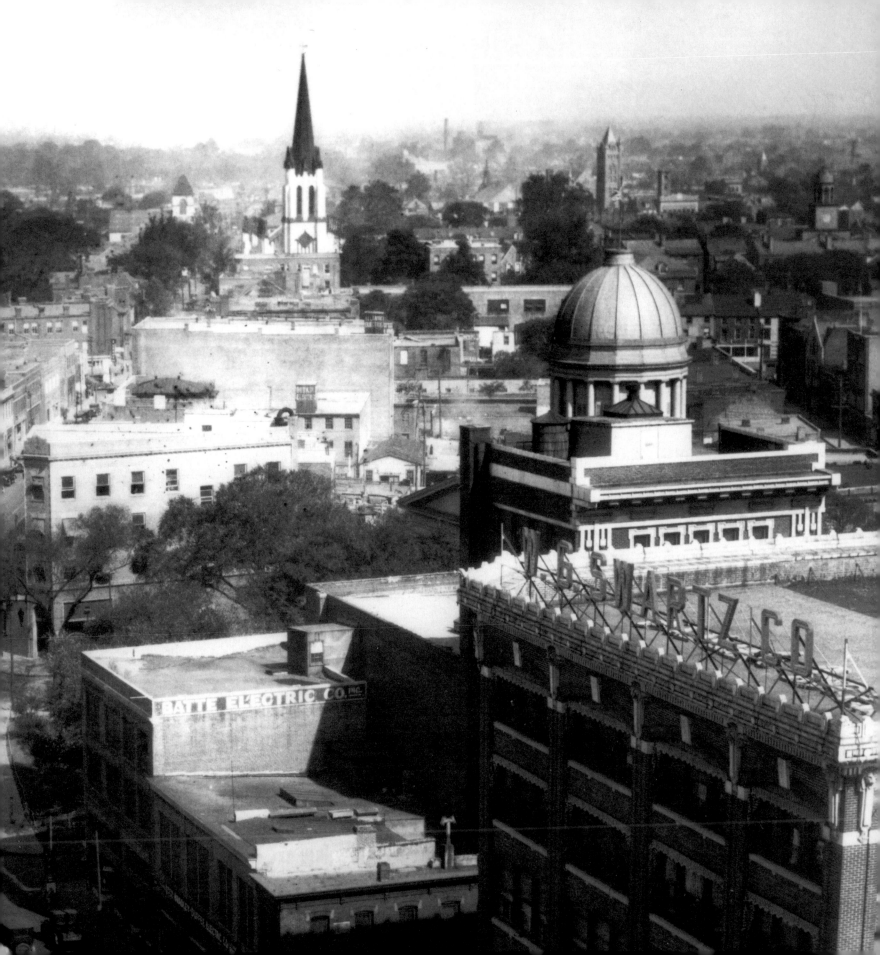

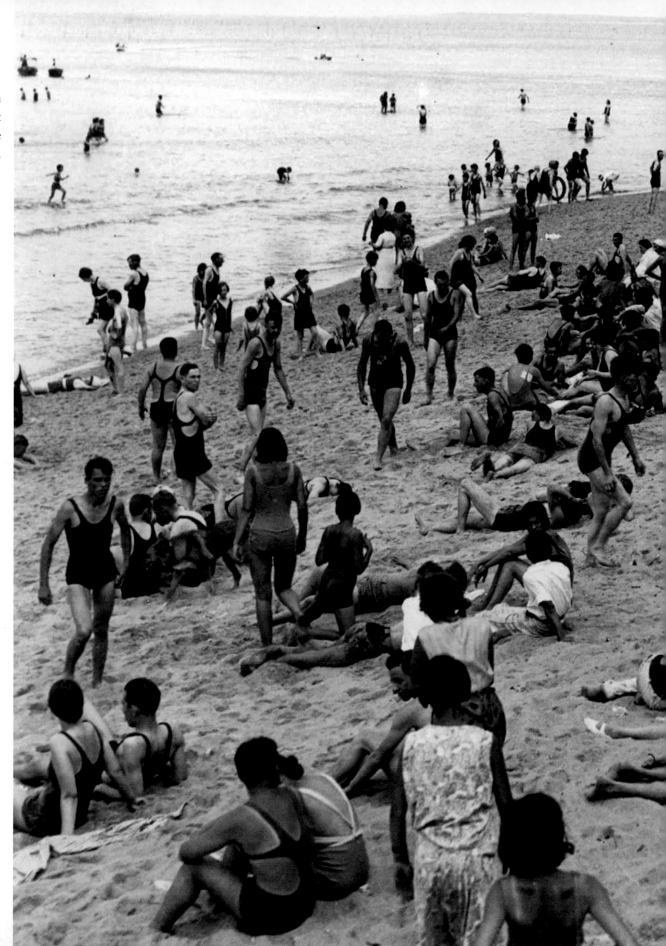

Bathers and sun worshipers enjoy a day at Ocean View Beach on the Fourth of July 1931.

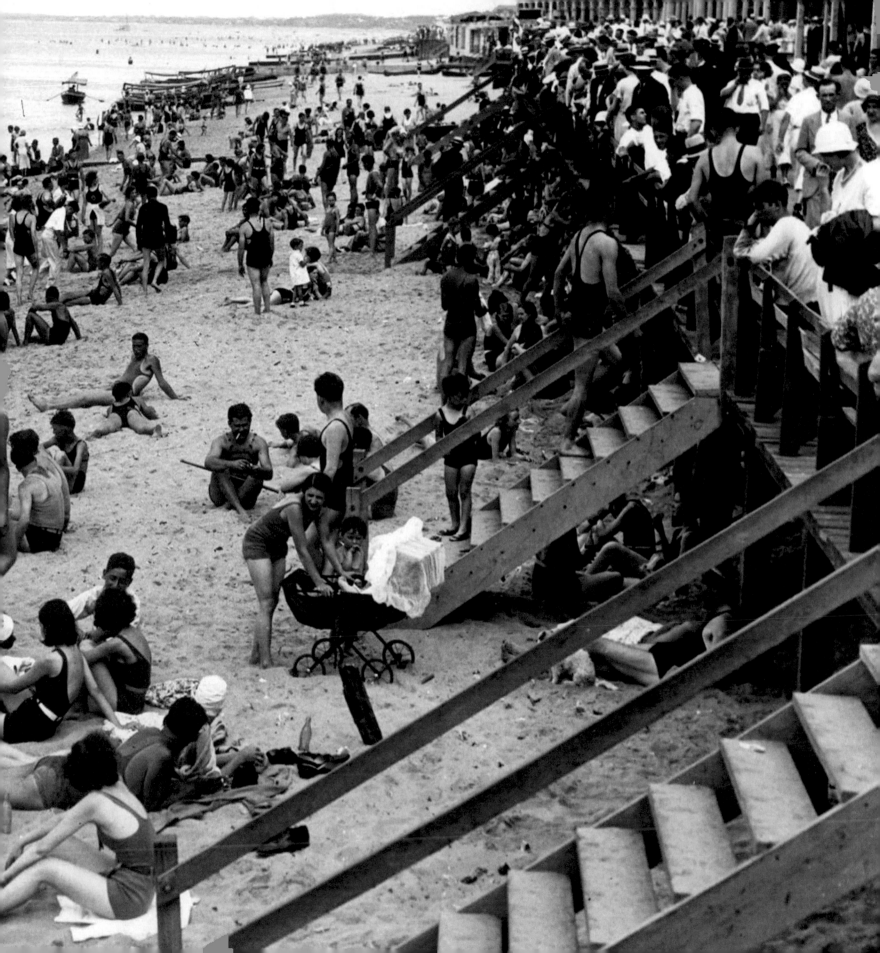

This wooden drawbridge served the citizens of the Campostella suburb until the area was annexed into the city of Norfolk in 1923. It was replaced by a two-lane concrete span in the latter part of 1923, but the congestion of traffic necessitated the construction in 1935 of a four-lane concrete and steel structure. The draw span from the 1923 bridge was dismantled and shipped to Pulaski County to replace the New River ferry. Today's six-lane span opened in 1987.

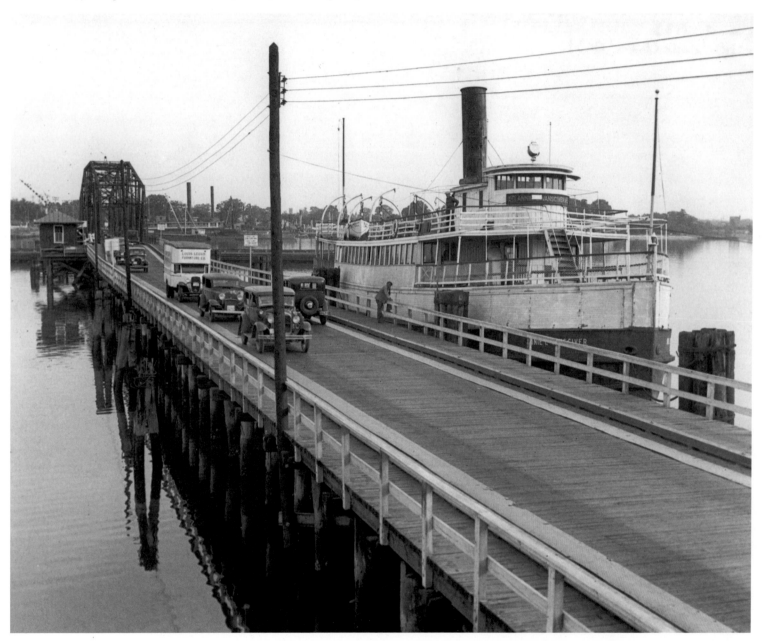

On the day of his inauguration, at the height of the Great Depression, thirty-second United States President Franklin D. Roosevelt announced a nationwide, ten-day bank holiday, to begin on March 4, 1933. Here, customers line up at the Norfolk National Bank of Commerce & Trusts on the day that the bank reopened.

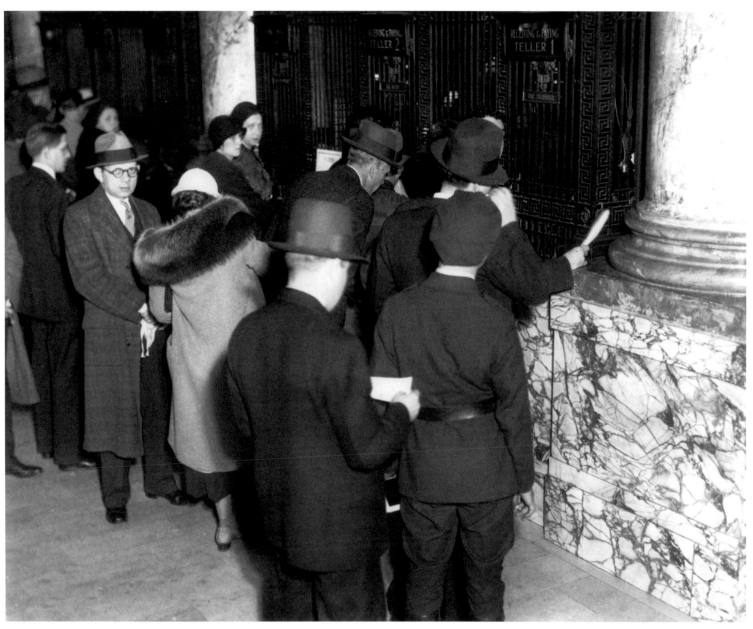

The hurricane-prone East Coast has seen its share of storms, but 1933 is still remembered in Norfolk as the year of the "Big One." Hurricanes in August and September 1933 brought wind speeds as high as 88 miles per hour, extensive damage at Ocean View, and 18 deaths. Here, floodwaters fill the street outside the Monticello Hotel, August 23.

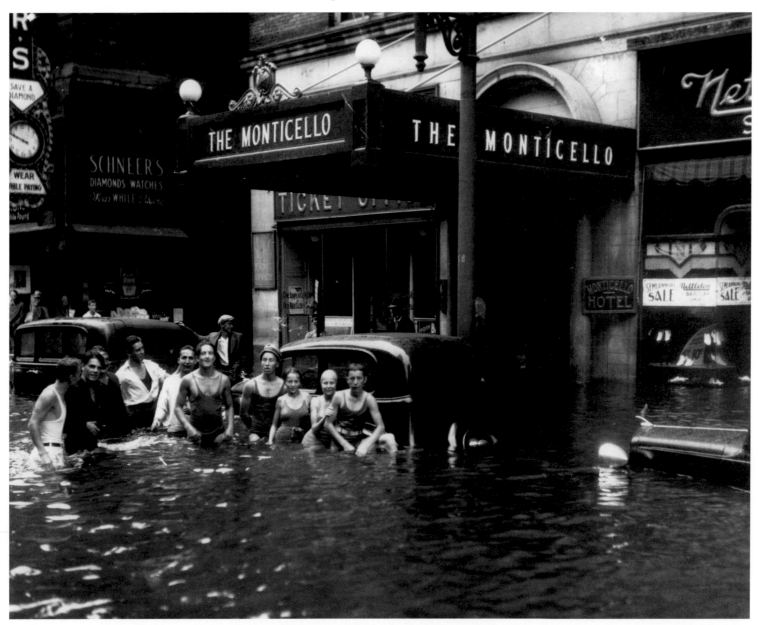

During the August 1933 hurricane, waterfront homes at Ocean View were knocked off their supports by the force of the wind and water, sustaining heavy damage. The boardwalk at the amusement park was also destroyed.

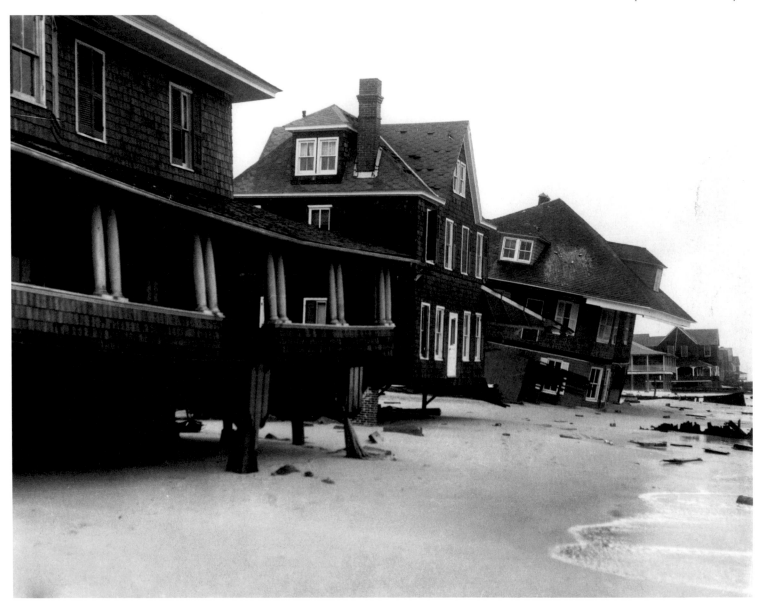

A family evacuates its Ocean View home after the hurricane, taking only
what they are able to carry in—and on—the family car.

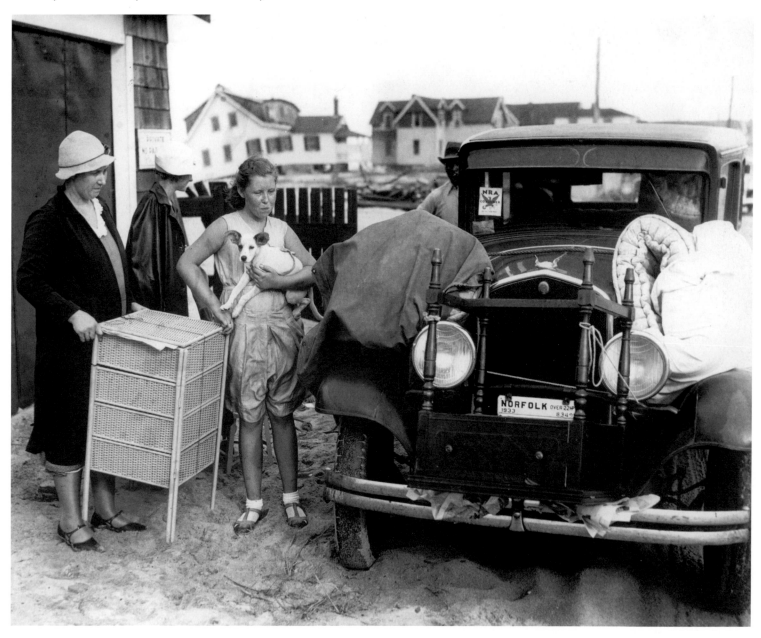

A Norfolk police officer shows off the department's brand-new emergency vehicle, used as both an ambulance and a paddy wagon, in 1933.

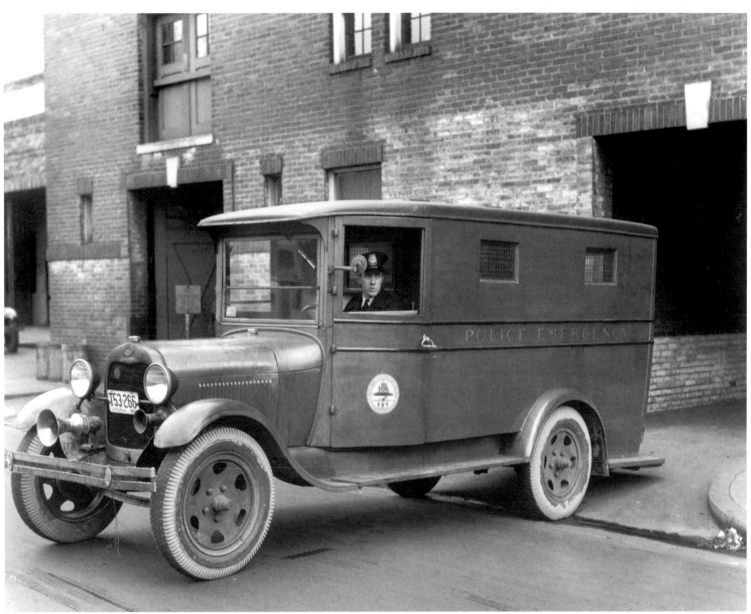

Boaters take advantage of the lingering high water on Granby Street after the August 1933 hurricane to put their boats in; meanwhile, their counterparts on Plume Street engaged in what they dubbed the "first annual Plume Street Regatta." After the storm passed, Norfolk took to the streets in boats and bathing suits to survey the aftereffects and be thankful that the worst was over.

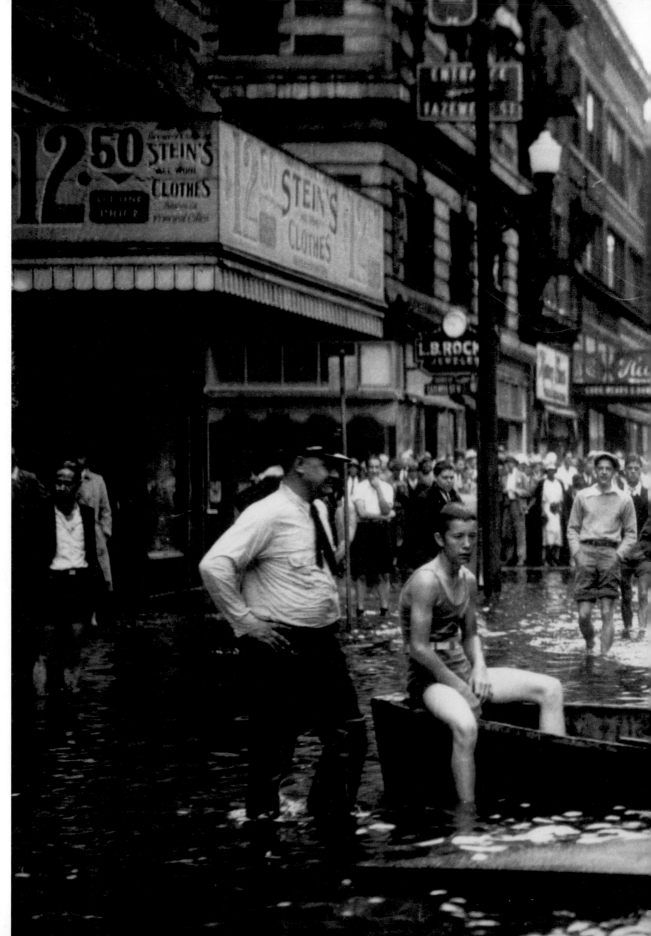

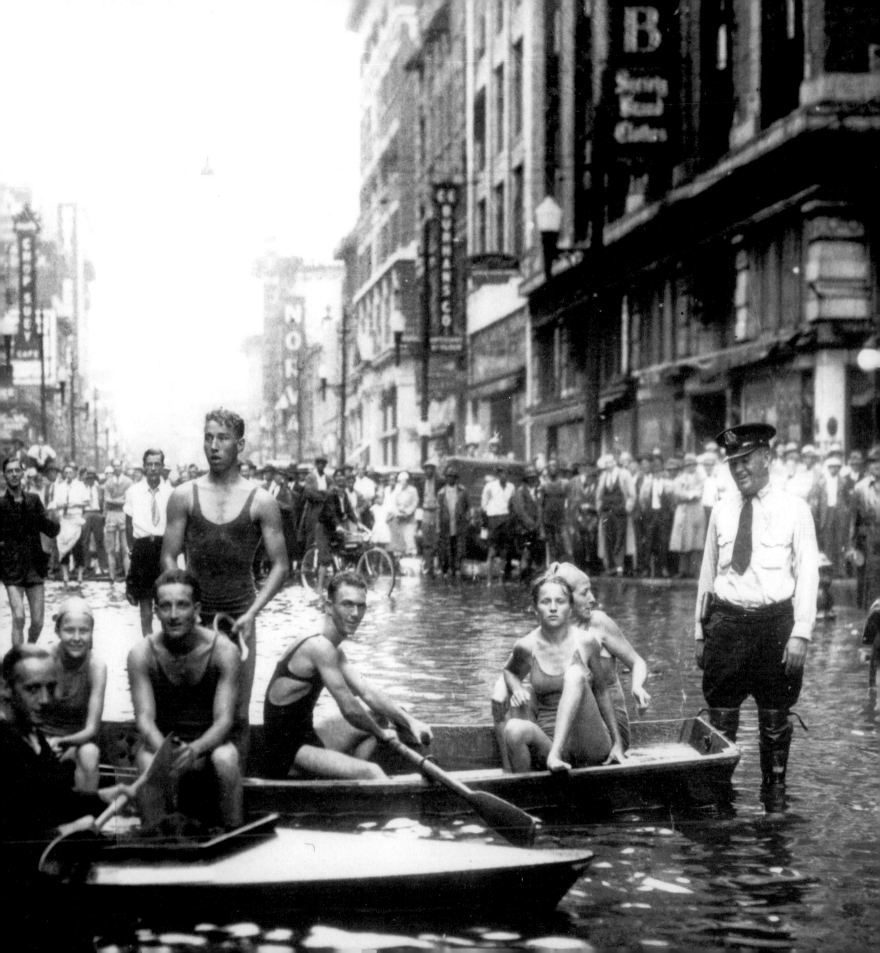

Interior of the Norfolk City Market, which occupied a spot on Monticello Avenue at City Hall Avenue for more than 30 years. The motto carved above the entrance proclaimed the purpose of the market: "That pure food may be kept in the best manner and sold at a fair price."

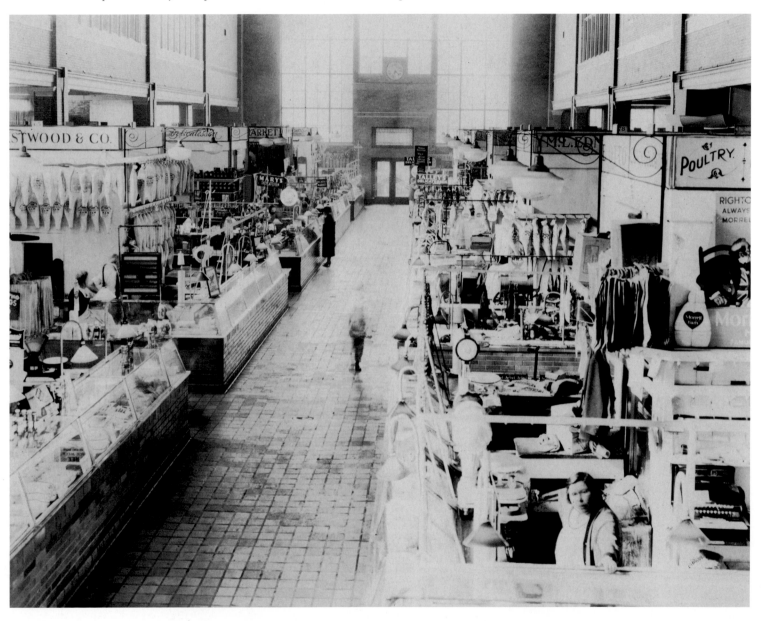

The James Adams Floating Theater, seen here in 1932, operated in the North Carolina Sound and the Chesapeake Bay from 1914 to 1941. Edna Ferber spent a week on the boat in 1924 while gathering material and conducting research for her 1926 novel *Show Boat*, later adapted for musical theater.

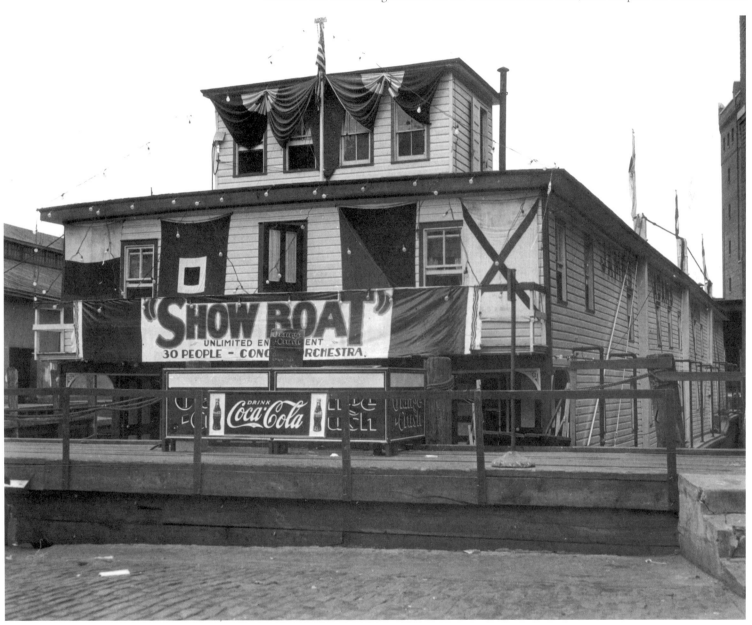

The Twenty-First Street Business Men's Association used the occasion of the installation of their new street lights—said to be the brightest in the state—to throw this October 1940 street party, which they dubbed the Great White Way Jubilee. Some $40,000 in prizes—including three automobiles and 50 Smithfield hams—were given away, and there was free food and drink for all. The street was closed to traffic and turned into a blocks-long ballroom with several bands and a honky-tonk piano player to make feet fly. Perhaps the greatest curiosity of all amid the spectacle was the new escalator—Norfolk's first—put into operation at the Center Shops the day of the event. The escalator could convey 5,000 people an hour from the first floor to the second.

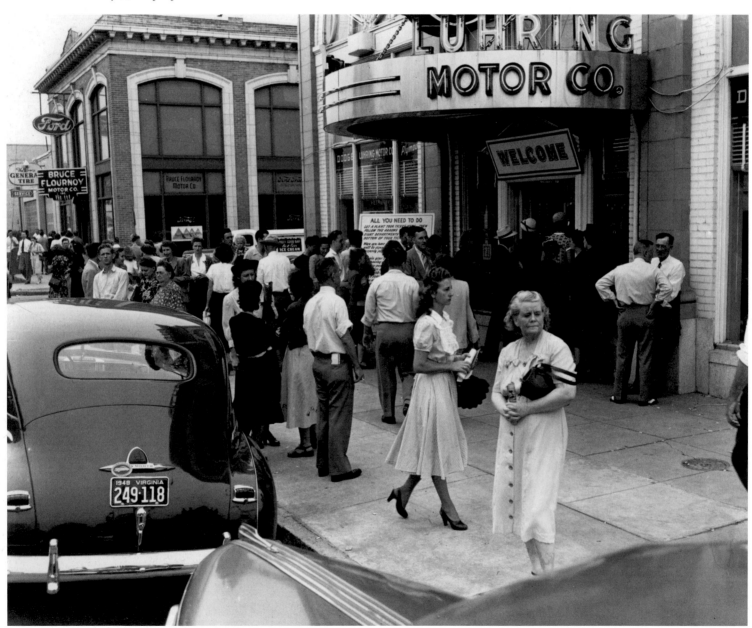

The Norfolk Division, College of William & Mary–Virginia Polytechnic Institute opened a new swimming pool in the summer of 1937 and hosted free "learn to swim" lessons to local children. The program was sponsored by the YMCA, YWCA, Norfolk School Board, and Navy YMCA. Generations of Norfolk children learned to swim in that pool.

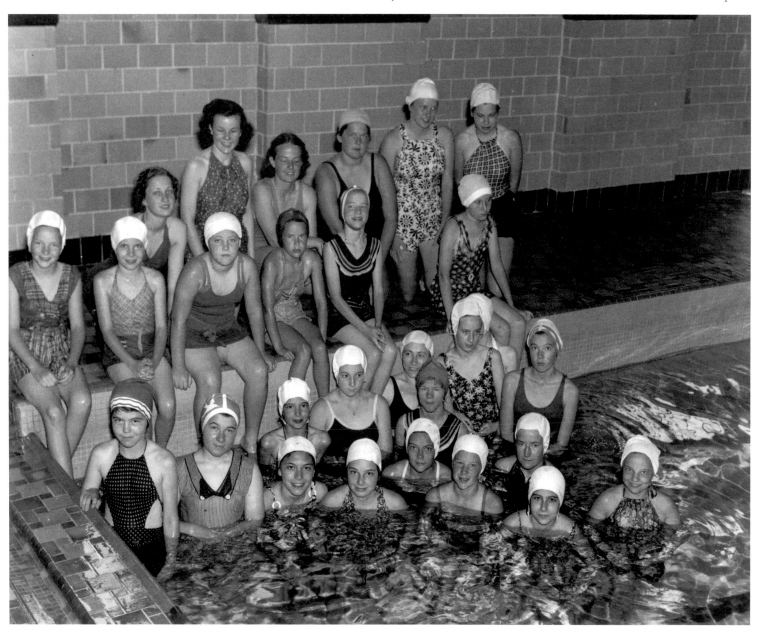

Before there was a Greyhound or a Trailways station, bus companies such as the Carolina Coach Company, Peninsula Lines, and Norfolk Southern Bus Corporation, their buses shown here in 1935, carried passengers across the state or across state lines from their shared depot at the City Market Building on Market Street.

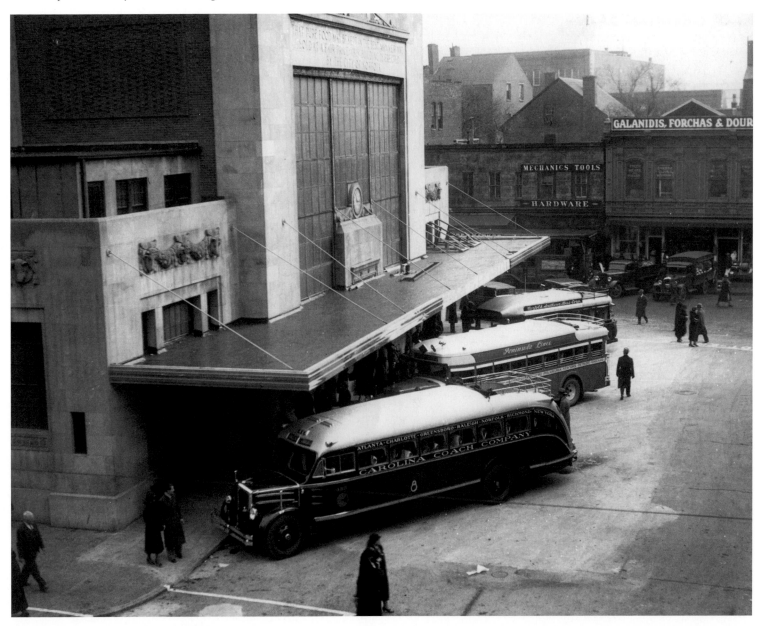

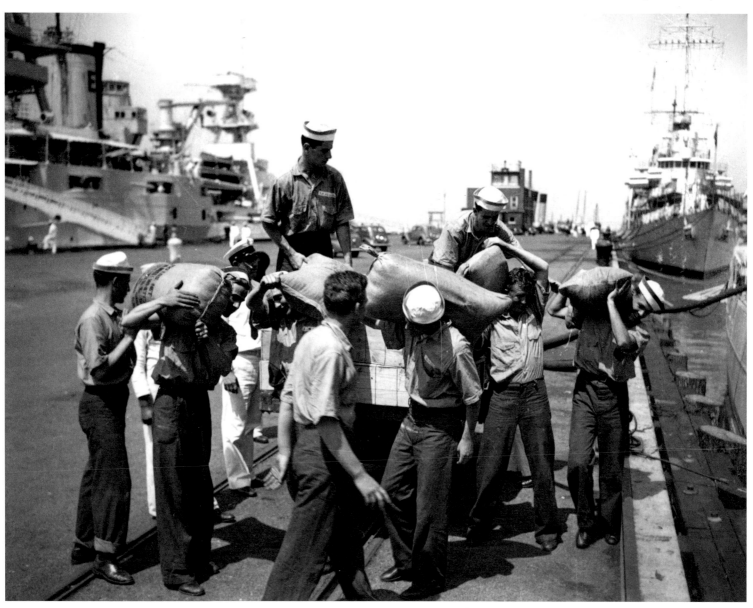

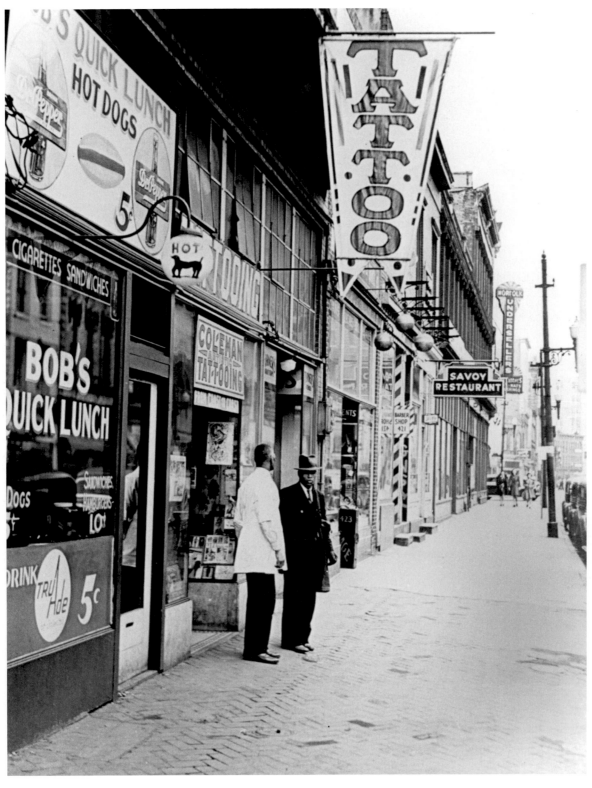

Prominent along East Main Street was the sign marking the location of Daniel "Cappy" Coleman's place of business. Coleman was a Norfolk tattoo artist famous with sailors and merchant seamen around the world and, covered with tattoos himself, was a walking advertisement for his trade. This image was taken by Farm Security Administration photographer John Vachon in March 1941. Photographers for the FSA and Office of War Administration recorded thousands of images of daily life in America during the Great Depression and World War II.

Norfolk had several short-lived air cargo and passenger terminals, beginning in 1926. In 1938, the city purchased the Truxton Golf Course east of the city limits and built the Norfolk Municipal Airport, where these officials gathered on opening day. It was the predecessor of today's Norfolk International Airport.

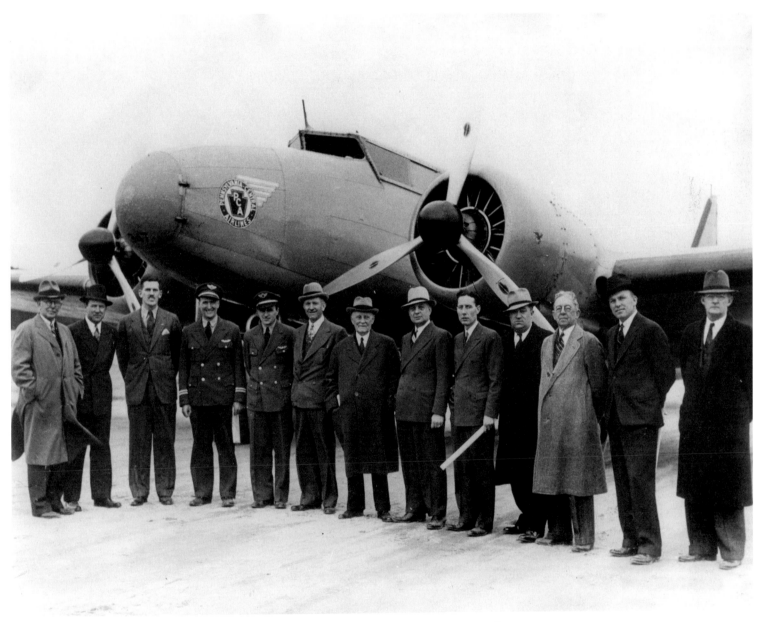

In this city of rivers, a network of bridges accommodate the drivers, and a series of drawbridges accommodate traffic of another kind, such as the Wood Towing Company tug *Atlas*, shown passing under the Berkley Bridge in 1935.

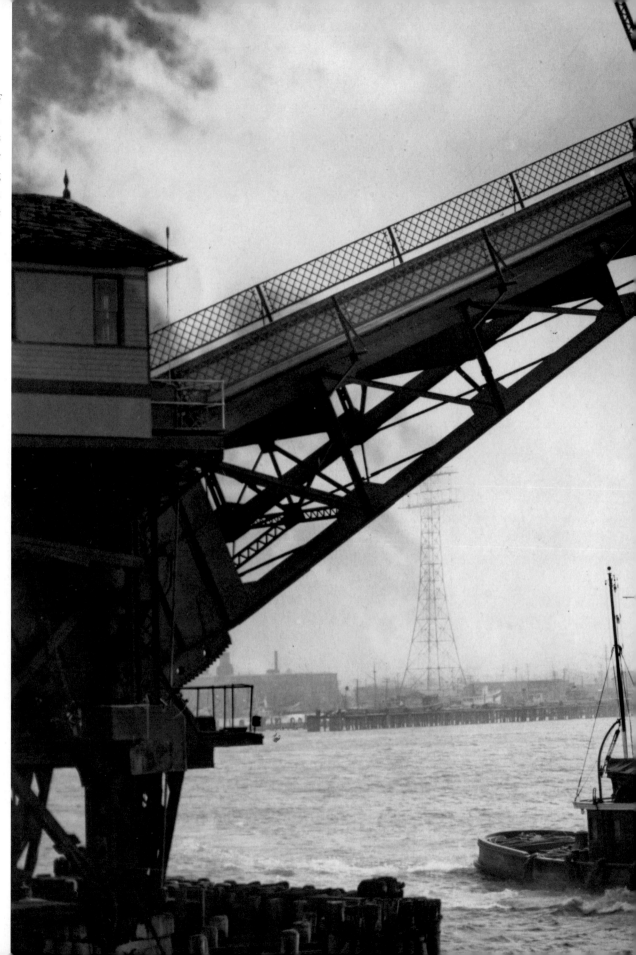

140

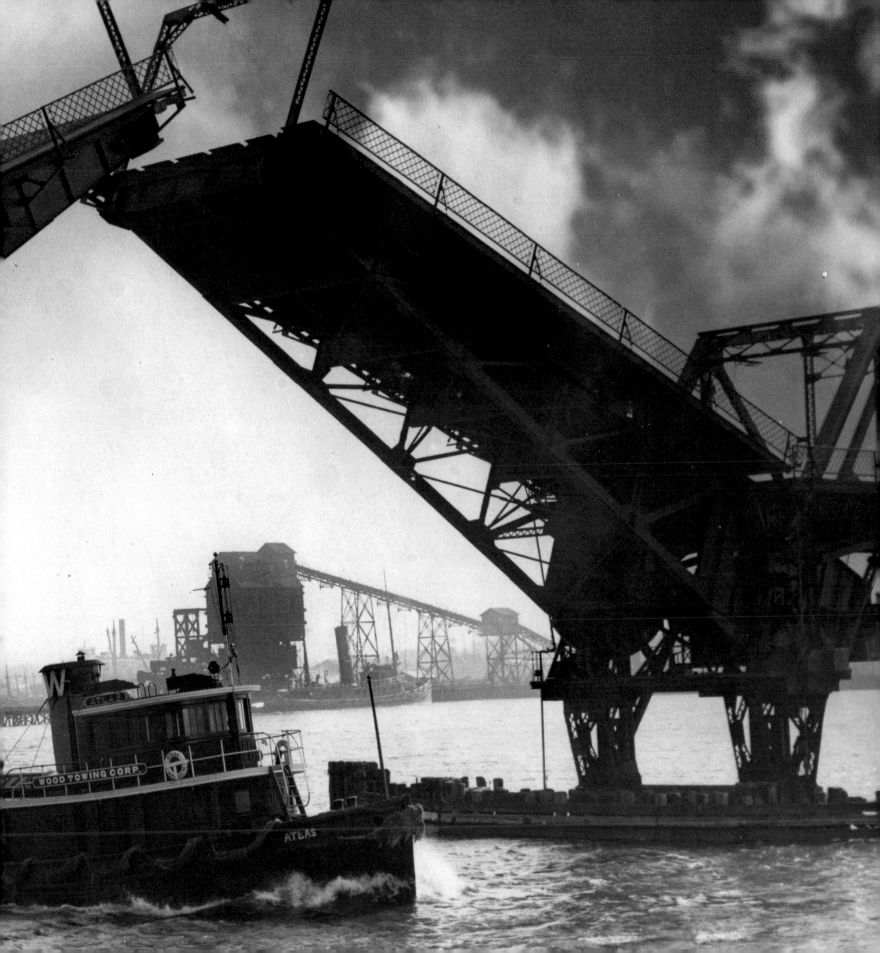

The Norfolk Tars baseball team was formed in 1896 and played until the summer of 1955. New York Yankees owner Jacob Ruppert reorganized the Tars as a farm team of the Yankees in 1934. The Tars played at several fields during their years in Norfolk, including High Rock Park, shown here after a 1944 fire. Norfolk dentist Eddie Myers funded the rebuilding of the park, which was later renamed Myers Field in his honor.

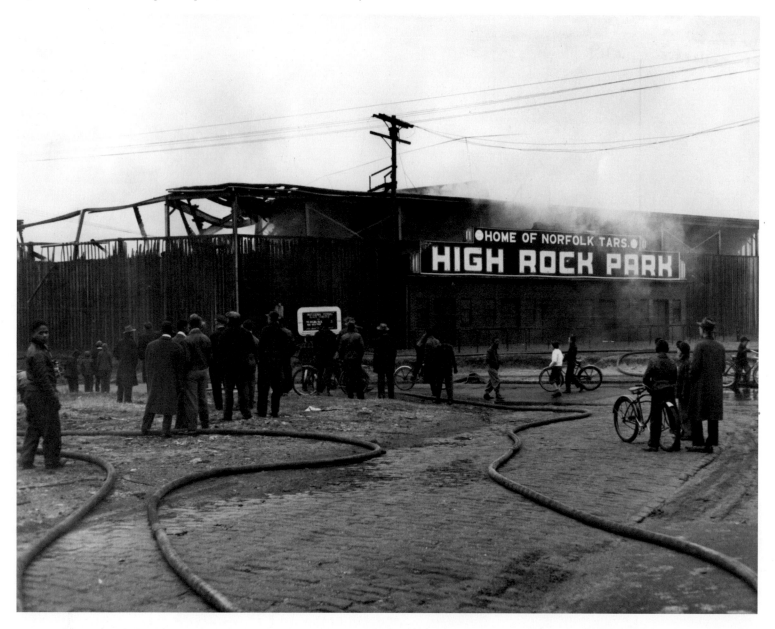

Citizens on the home front provided many services during World War II. Some, such as the trio shown here at their station on the Government Reservation at Ocean View in September 1942, served as "spotters," watching for enemy aircraft and reporting back to the U.S. Army Air Corps.

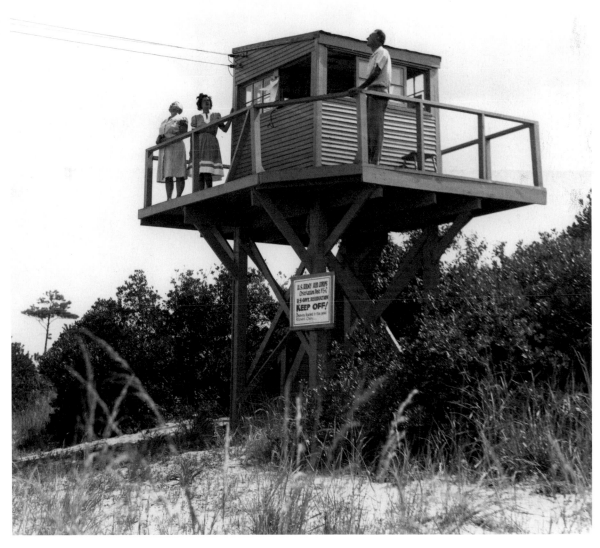

Waving good-bye to ship. U.S. Navy dependents have stood pierside in Norfolk to wave good-bye to their sailors for more than 300 years, but every time is much like the first—one final hug, tears wiped away, and a prayer for a safe return home.

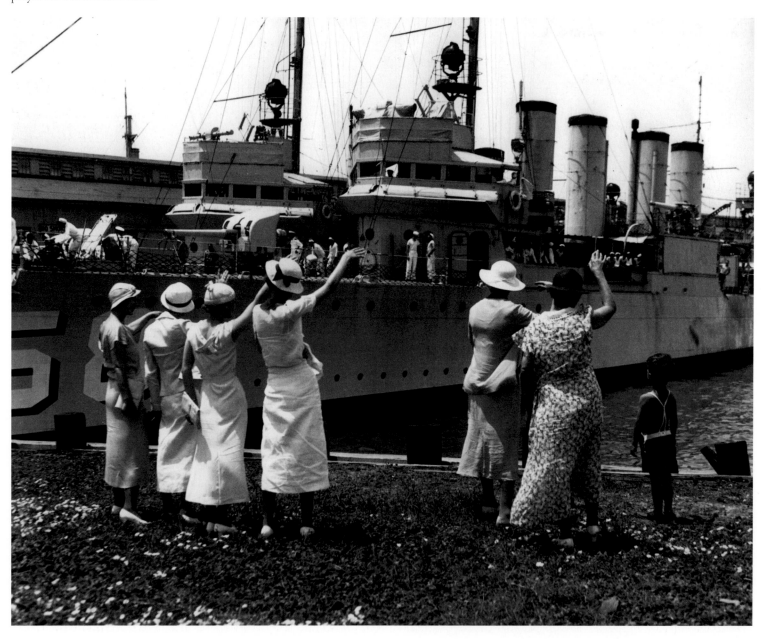

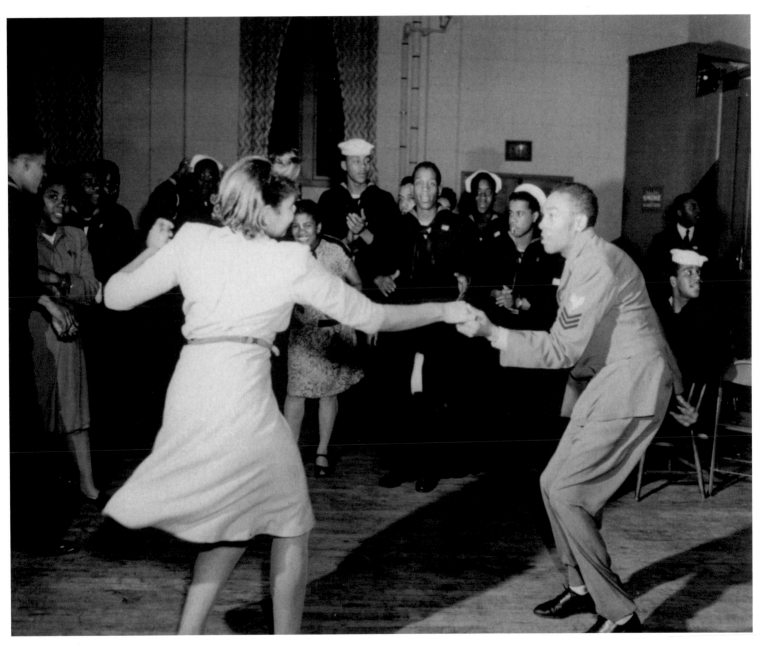

Sailors swing out at the Smith Street USO during World War II. The Smith Street USO, for African American service personnel, opened in March 1942.

Norfolk concrete contractor J. U. Addenbrook's Sons delivered this pile of sand to a vacant lot at the corner of Hampton Boulevard and Westover Avenue for neighbors to use in homemade bomb shelters in February 1942.

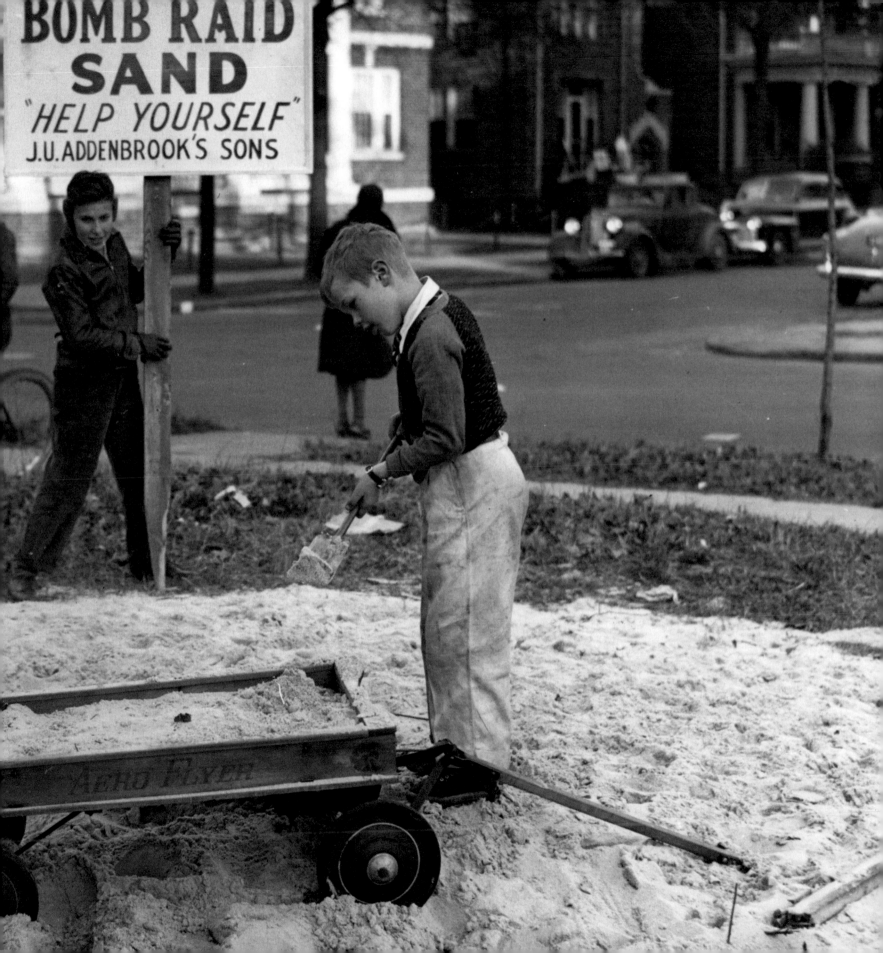

Norfolk residents of all ages—and species—worked together on the home front during World War II, collecting material such as scrap metal and rubber, as in this 1942 scrap metal drive. The material would then be converted by the government into weapons and other items for U.S. soldiers on the battlefront overseas.

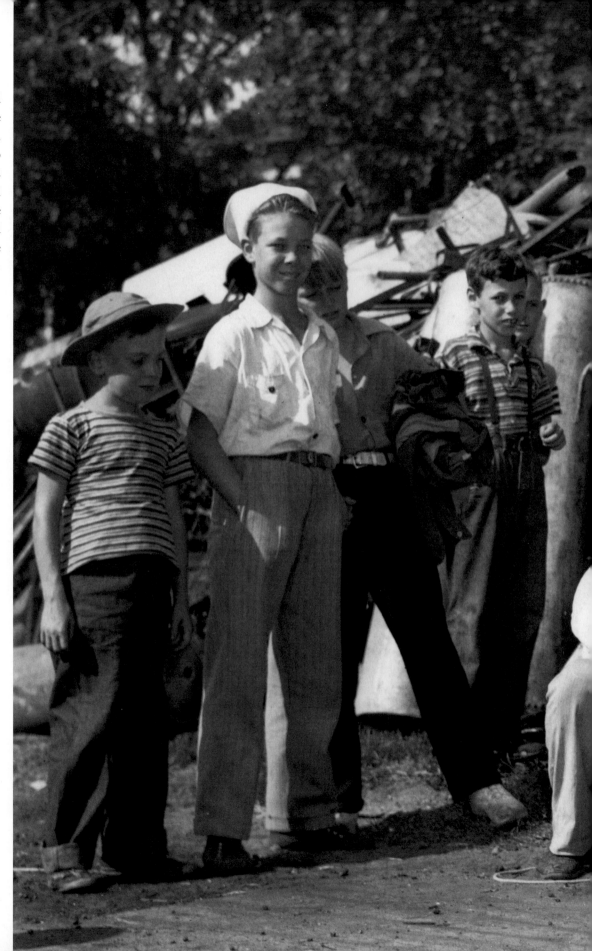

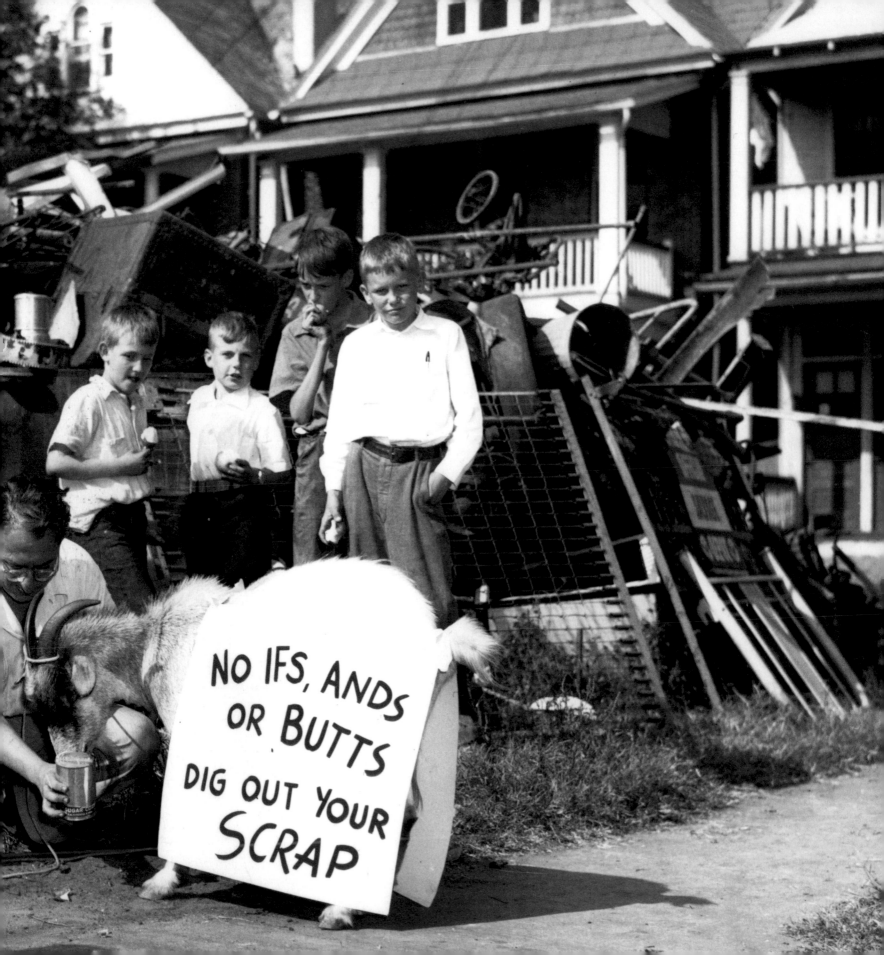

Preparedness on the home front. Here, Ensign V. Taliaferro Boatwright and an assistant instruct a group of Norfolk women on the correct use of a gas mask, around 1943.

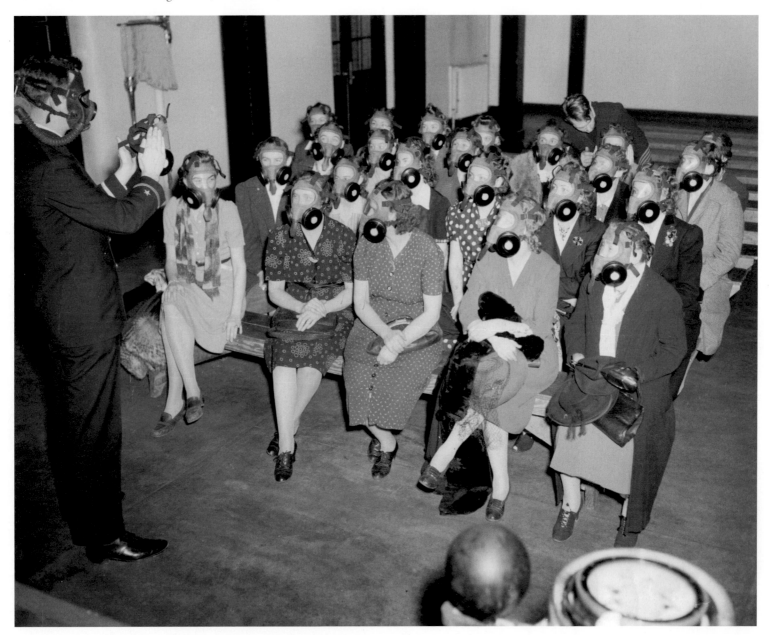

An experimental victory garden at Lafayette Elementary School in 1943 was soon expanded into a citywide effort. Here, youngsters from Bayview Elementary School work on a victory garden behind their school in Norfolk's Ocean View section. Each of the school's eleven classes had its own plot, leading to some friendly competition and the assurance that these farmers would gladly eat their vegetables when their crops were ready to be served in the school cafeteria in June.

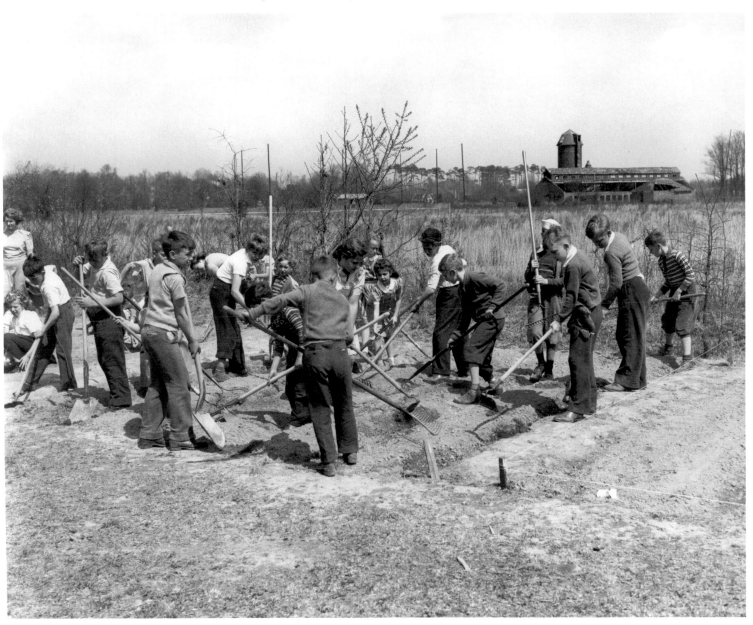

All in a day's work—"Big Ben" pulls a fishing boat loaded with the day's catch through the shallow surf and onto the Ocean View beach, July 14, 1944.

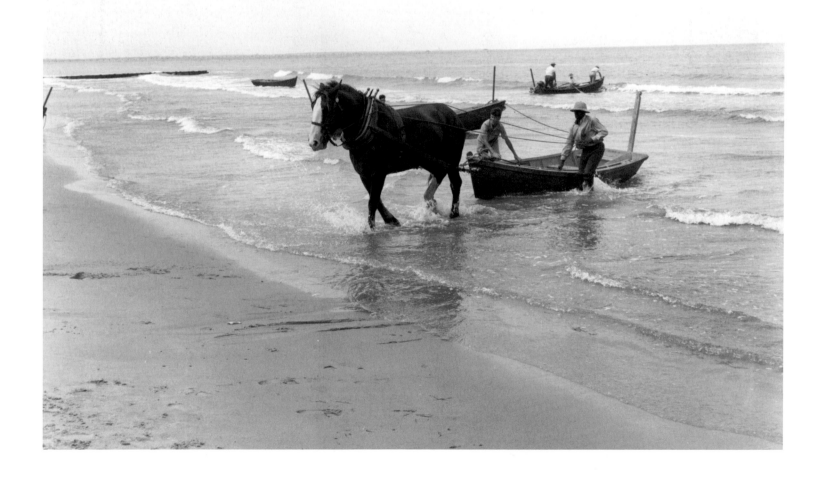

This 1943 Mercedes-Benz, said to be the personal car of Hermann Goering, is displayed in the Selden Arcade in December 1945.

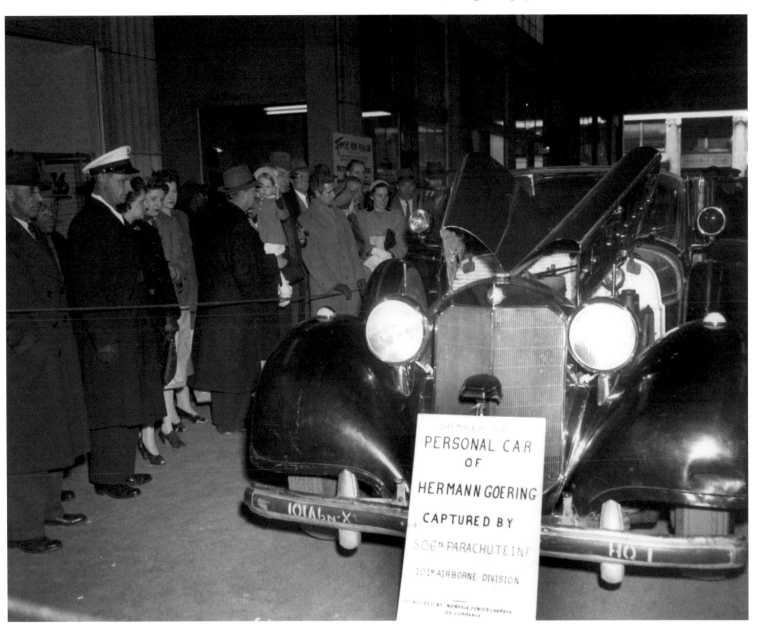

PERSONAL CAR
OF
HERMANN GOERING
CAPTURED BY
506th PARACHUTE INF.
101st AIRBORNE DIVISION

Stores, businesses, restaurants, and theaters across the nation closed on the afternoon of Saturday, April 14, 1945, to observe funeral services for thirty-second United States President Franklin D. Roosevelt and to mourn his death two days earlier. In Norfolk, thousands of hastily printed signs appeared in store windows, such as this one on the window of the Acropolis Restaurant on 35th Street.

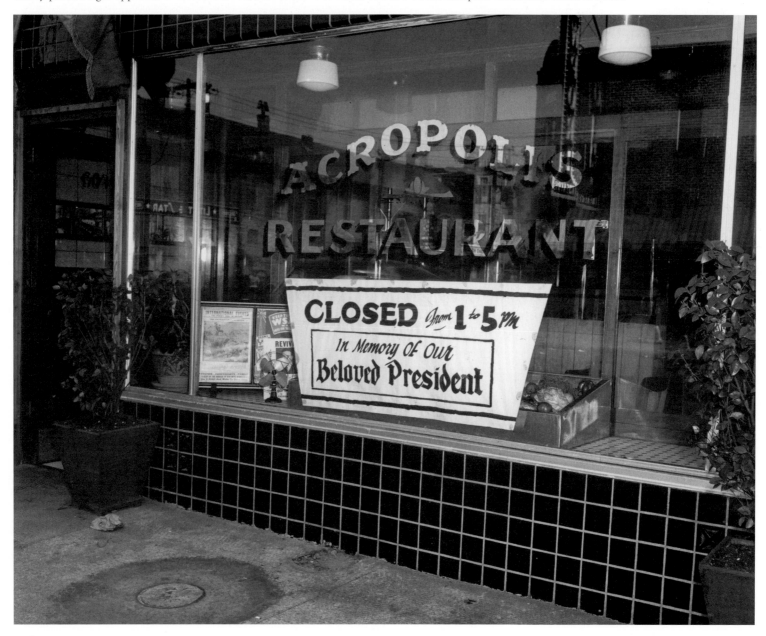

There was jubilation among the Allied nations when victory over Japan was announced, heralding the end of World War II. Hearing the news, August 15, 1945, Norfolk citizens rushed downtown to take part in a frenzy of horn-blowing, street-dancing, confetti-raining euphoria.

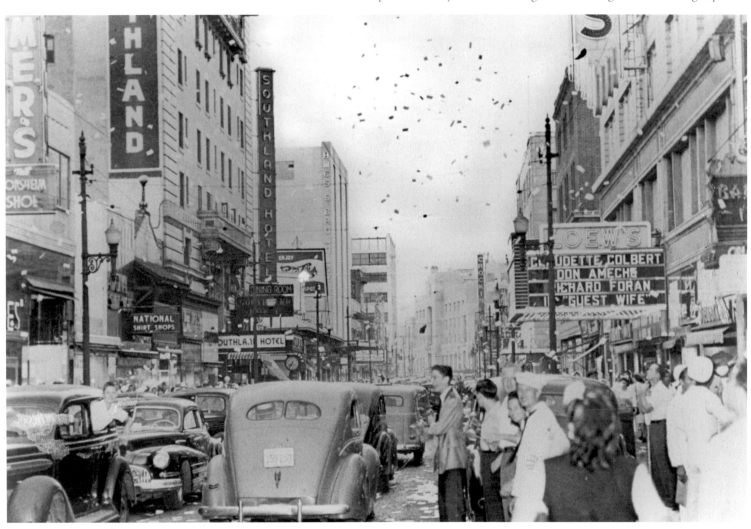

Latvian native Elias Codd (ca. 1897–1967) arrived in Norfolk in 1910 at the age of 13 and joined the grocery trade. His sales of stamps and war bonds from his delicatessen on Princess Anne Road during World War II exceeded three million dollars. Behind his counter here in 1948, Codd continued to sell bonds into the 1960s.

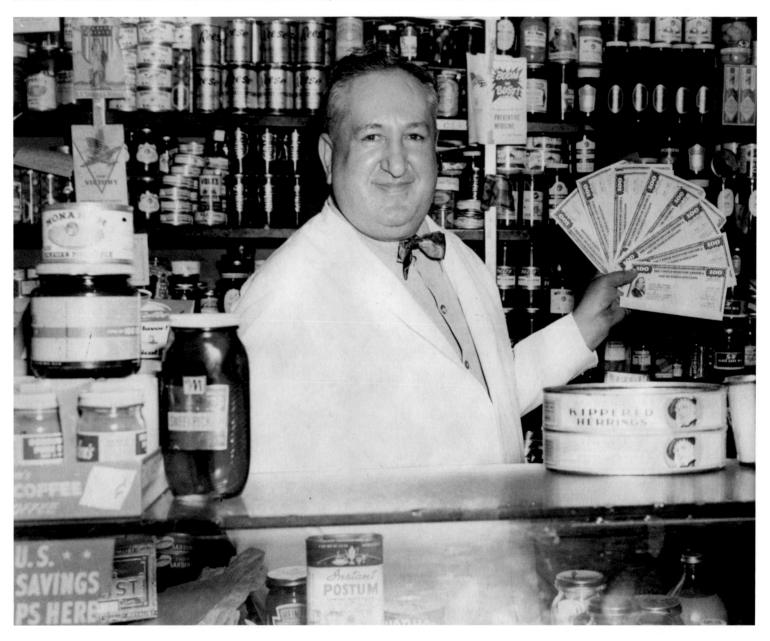

LOOKING TO THE FUTURE

(1946–1979)

In the days of relative prosperity following the Second World War, Herbert Hoover's prediction of a "car in every garage" came close to reality, and brand new suburbs in the county east of Norfolk lured homebuyers with the prospect of patios, split-level living, and roomy garages for all those cars. Norfolk's population explosion, driven by the influx of military and civilian personnel during the war years, did not abate at war's end. Norfolk continued to grow. Annexations in 1955 and 1959 brought the city to its present boundaries. Its population was now the largest in Virginia and the 38th-largest in the nation.

The Norfolk Housing Authority, formed in 1940 to address the problem of substandard housing, stepped back to reassess its purpose. Changing its name to Norfolk Redevelopment & Housing Authority, the agency broadened its mission from that of merely ensuring adequate housing for its citizens to drafting a plan to cut out acres of decay and substandard conditions in the older part of the city, chiefly downtown—a plan that would transform the worn-out infrastructure into a modern city that addressed the needs for housing, a growing medical center, and better access to the financial district. Decrepit housing was replaced with new construction. The taverns and tattoo parlors of East Main Street made way for towering banks and office buildings, and the ground cleared for today's Sentara Norfolk General Hospital enabled it to grow into the most complete medical complex in the region.

One possessed of a crystal ball might have correctly predicted a bright future for this port city founded on 50 marshy acres three centuries earlier, but even without the gift of prophecy, the words of the Norfolk *Virginian-Pilot* in 1960 still ring true today: "Norfolk citizens are creating a city with a bright new character."

Many Norfolk grocers, such as Charles Johnson, manager of the Aubrey V. Grimes meat stall at the City Market, continued to feel the pinch caused by food shortages as much as a year after the end of World War II. Grocery ads in the fall of 1946 were heavy with specials on produce and dairy products and an occasional bit of seafood and poultry; but no red meat could be found for sale.

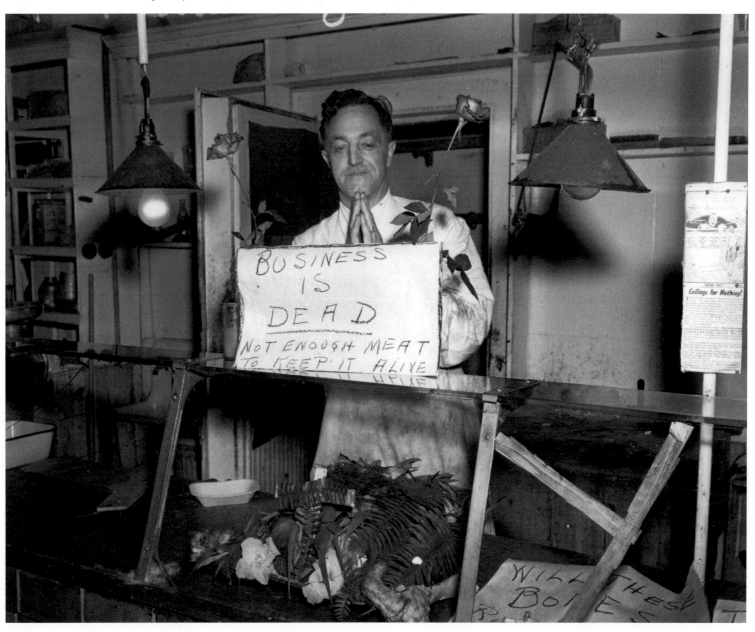

Thirty-third United States President Harry S. Truman's visit to the Norfolk Naval Base in September 1947 was brief but attended to with all the pomp and circumstance due America's commander in chief. The man from Missouri and his family had just returned to Norfolk aboard, aptly, the USS *Missouri*, which had taken them on a visit to Rio de Janeiro. As the president was piped off the battleship and walked the hundred yards or so to be piped aboard the presidential yacht *Williamsburg*, the national anthem was played and a 21-gun salute was fired; also on hand, families of the crew of the "Big Mo" gathered to welcome their own sailors home.

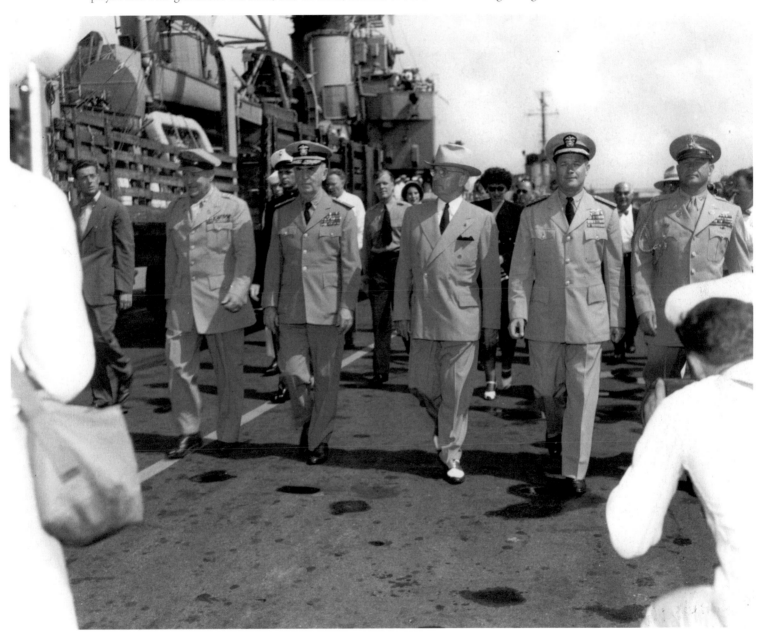

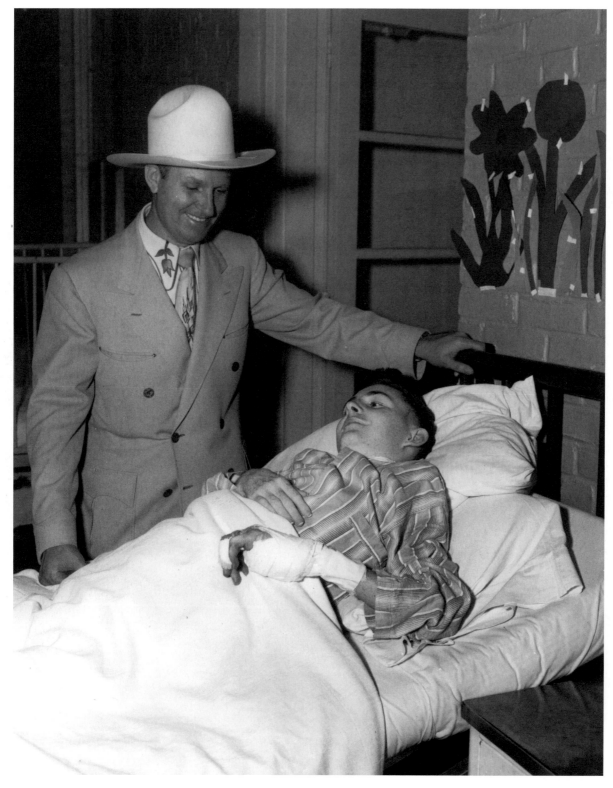

Gene Autry, of Hollywood "singing cowboy" fame, was in Norfolk in the spring of 1948 to speak to the Norfolk Sports Club at Bell's Restaurant. While in Norfolk, he took time to visit a young fan in the hospital.

A favorite way for a young lad to spend a summer afternoon—it's "All Aboard" the tots' train at Ocean View Amusement Park in 1948. One youngster appears to have his eye on the conductor's job.

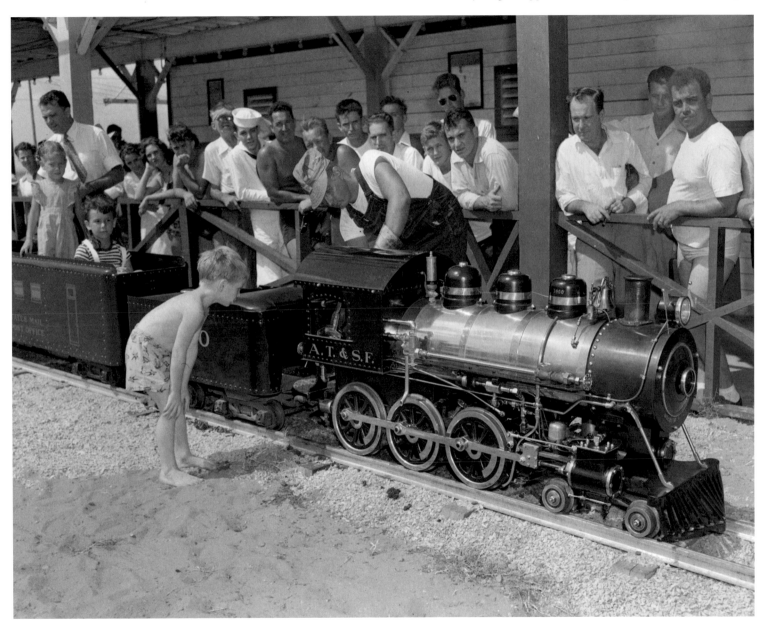

Norfolk's Battling Palms at their home field, Norfolk Community Field near Booker T. Washington High School, in 1952. The Palms were one of the most popular and longest-running African American baseball teams in the South, playing ball from the 1920s until 1955.

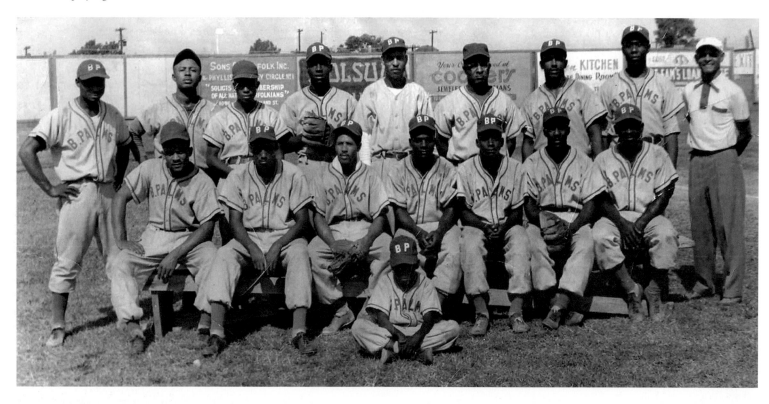

Daylight saving time was introduced to the United States in 1918 and was observed year-round nationwide during World Wars I and II. In other years, it was a local option, often found to be more of a nuisance than a blessing as some communities observed it while their neighbors did not. In a 1952 referendum, Norfolk, Portsmouth, South Norfolk, and Princess Anne County voted to observe. Norfolk County remained on standard time until July, inspiring at least one county resident who worked in the city to wear two wristwatches. In 1953 we elected to stay on standard time by more than 2400 votes.

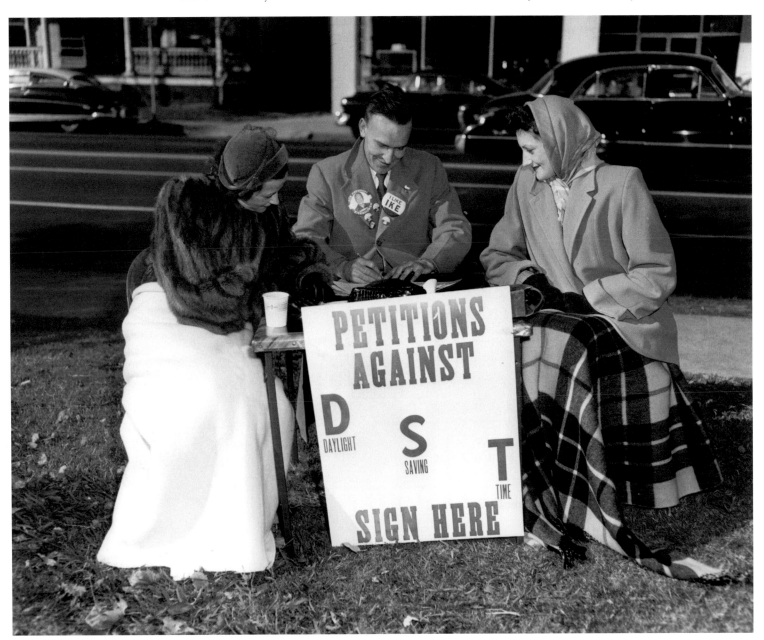

Admiral Richard Byrd (1888–1957) led several expeditions to Antarctica between 1928 and 1955. For his second expedition, Byrd procured this long-range, twin-engine Curtiss Wright Condor seaplane, photographed here in 1933, which he named the *William Horlick* after one of the supporters of the expedition. In January 1947, the Norfolk Public Library loaned 12 books to one of Admiral Byrd's expeditions. The admiral took the books to the South Pole and there established a "branch library."

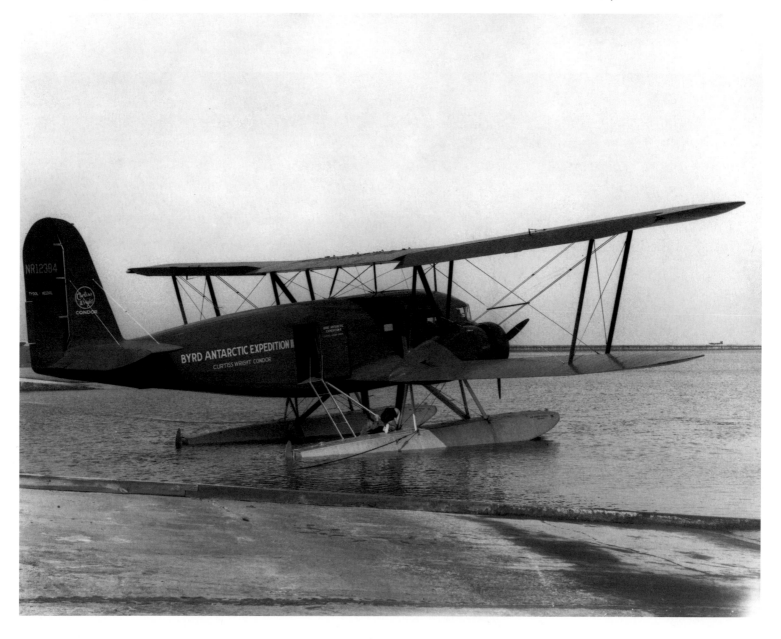

Seen here in 1949, the Victoria Hotel was constructed on East Main Street around 1906 to house visitors to the 1907 Jamestown Exposition. The Rathskellar, located in the Victoria's basement, was a popular restaurant and watering hole for many years.

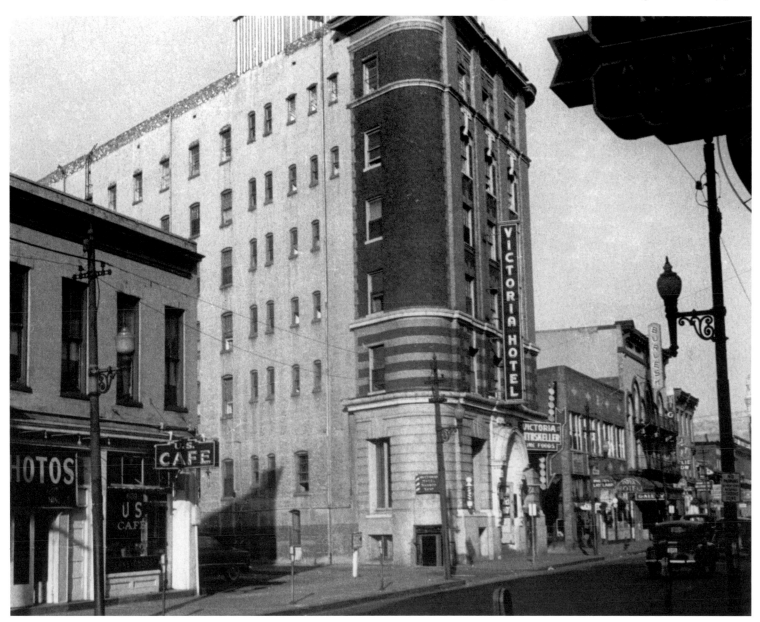

Gus Nestor's Grill at the corner of Church Street and Olney Road was a popular gathering spot in 1949, as it was for many years.

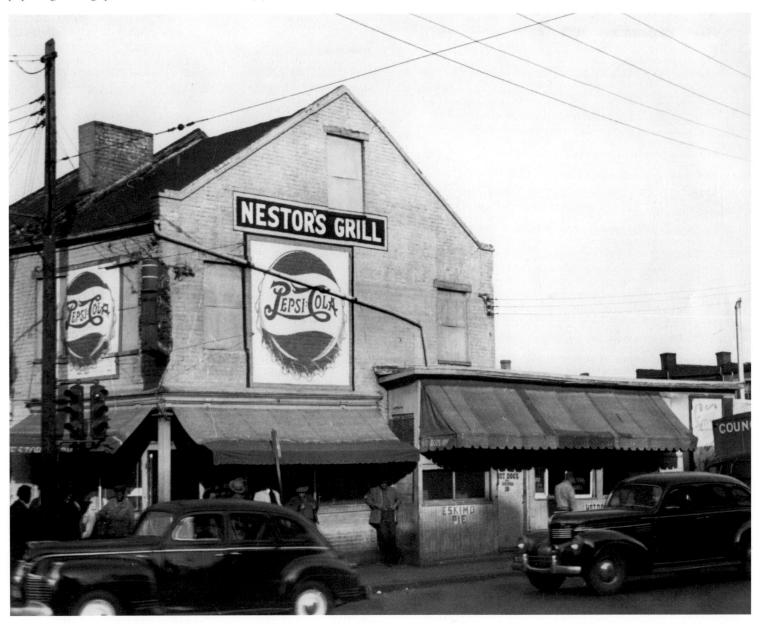

Boarding the streetcar in front of the Granby Street entrance to the Monticello Hotel, 1940s, for the long ride out to Ocean View and Willoughby. Norfolk began to phase out its fleet of streetcars in 1935 in favor of buses, but brought the streetcars back during World War II, when an enormous influx of military and civilian defense workers and their families stretched every amenity—including transportation—to the bursting point.

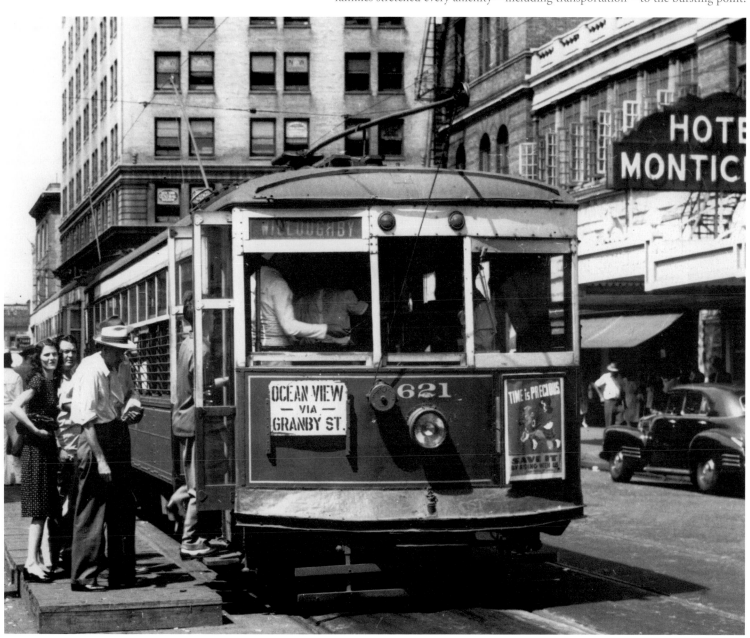

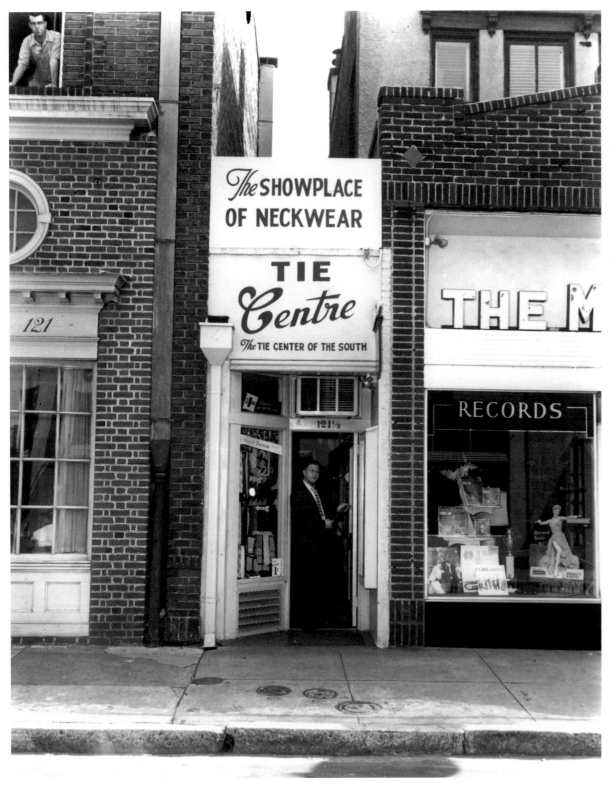

The Tie Centre, wedged between two "grown-up" buildings at 121½ College Place in 1955, was less than five feet wide and sold nothing but gentlemen's neckties. The specialty shop was the brainchild of Morris Narkier. Narrow ties were the fashion when the store opened—according to Narkier, "any tie over three and one-quarter inches in width definitely is old hat."

Officers William Lewis and Vernon Cooke walk the beat in 1946. Lewis and Cooke were among Norfolk's earliest African American police officers. The first, Horace Carlyle Case and Thomas Davis Weaver—sworn onto the Norfolk force November 7, 1945—were the first black police officers in the state of Virginia.

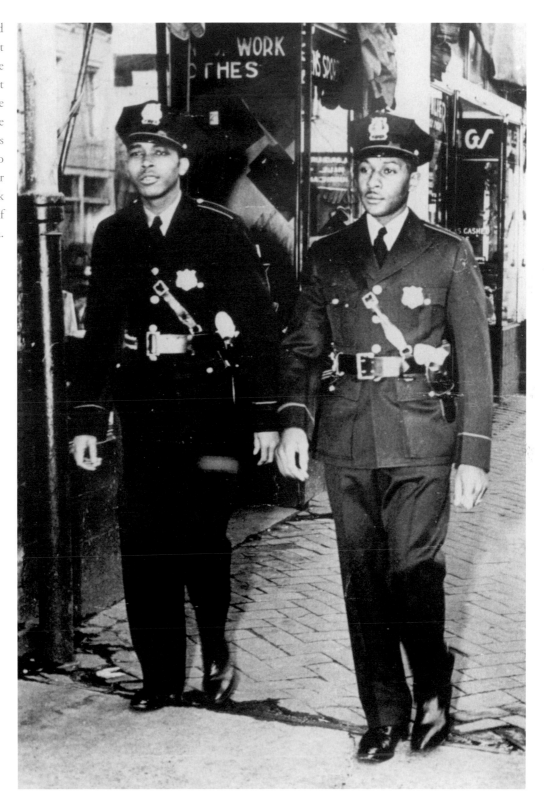

Australian merchant seaman Elwynn Hepple lost his life on the night of May 16, 1948, when he jumped into the chilly waters of Hampton Roads to rescue two local women from a capsized pleasure boat. Hepple was buried at Forest Lawn Cemetery in a plot provided free of charge by the city of Norfolk. The Civitan Club of Norfolk erected this monument to the seaman on October 30, 1948, and established the Elwynn Hepple Award for Valor, given as appropriate to those whose acts of bravery have far exceeded the norm.

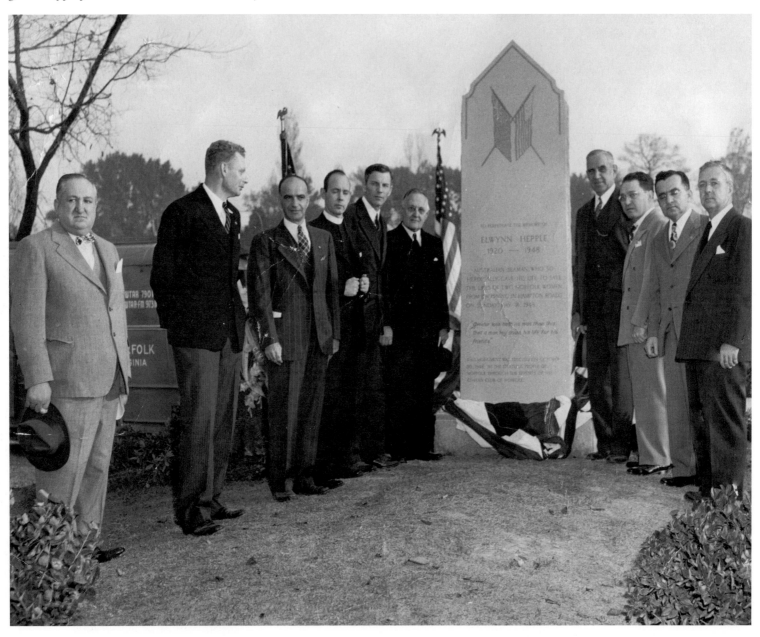

The portion of East Main Street between Commercial Place and Church Street (now St. Paul's Boulevard) was notorious with servicemen all over the world until well after World War II. The few short blocks were packed elbow to elbow with taverns, pawn shops, tattoo parlors, shooting galleries, and burlesque theaters, as seen in this image from 1948.

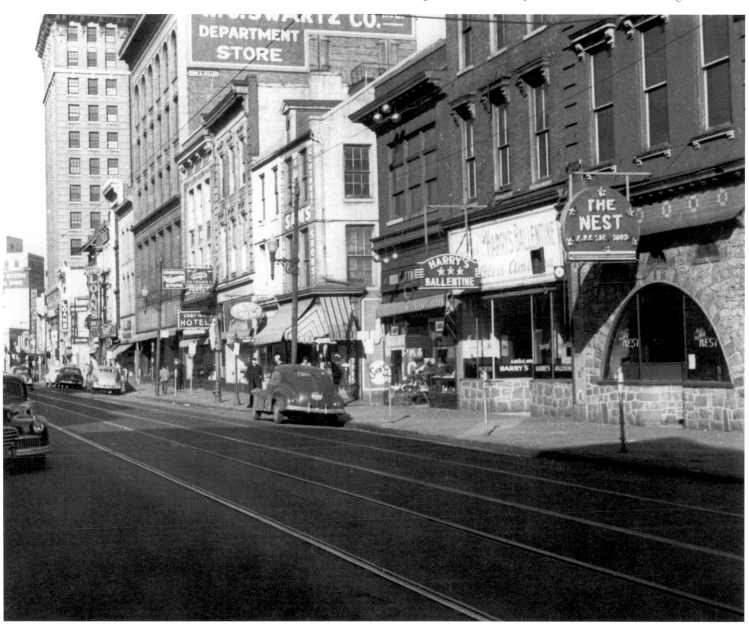

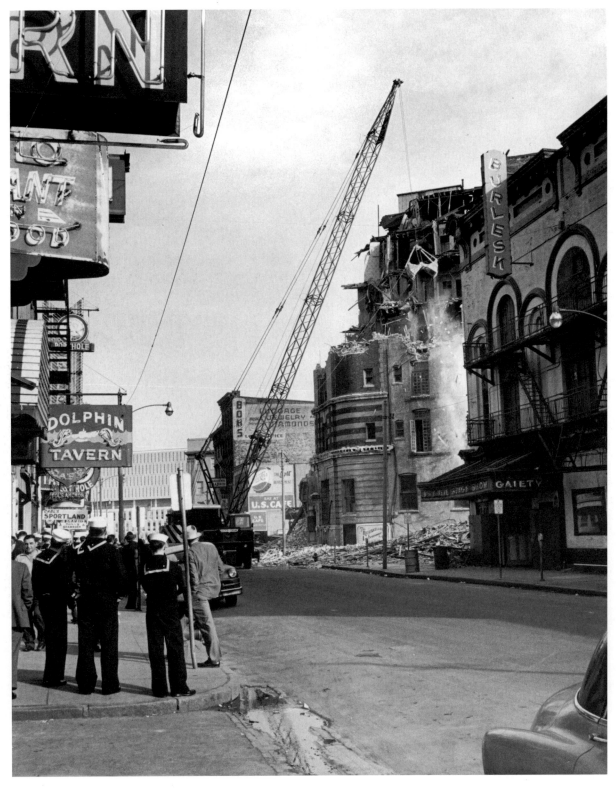

Locals and enlisted men watch as the Victoria Hotel comes down in the name of redevelopment. The onlookers may be thinking of happy times spent in the hotel's basement restaurant, the Rathskellar, or in the audience at the nearby Gaiety burlesque house.

Main Street at Nebraska Street in May 1959, showing the former Gladstone Hotel. The Union Mission occupied the Gladstone from 1919 until the building was razed during the redevelopment of downtown Norfolk in the early 1960s.

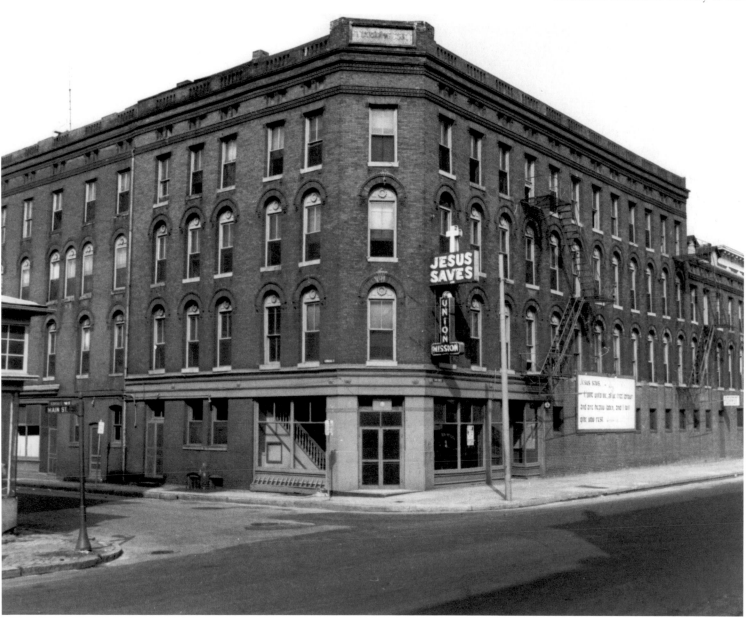

Childhood—when your heart's desire may be just a mailbox away. These youngsters are posting their wish list to the Jolly Old Elf in a special letter box provided by Norfolk's Recreation Bureau. Then it's home to bed to dream of sugar plums and reindeer dancing on the rooftop.

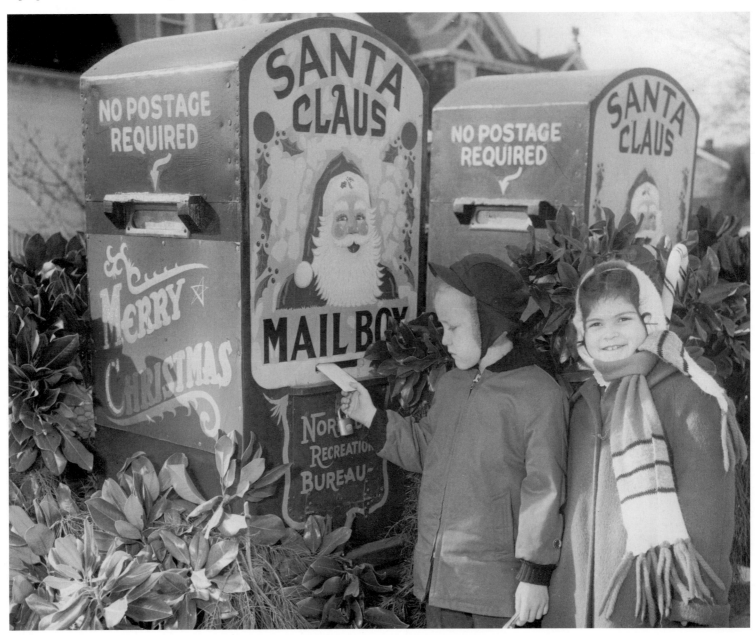

WTAR (now WTKR) was Norfolk's pioneer television broadcasting station when it began to air CBS programming on Channel 4 in 1950. Consumers flocked to the Municipal Arena, where vendors vied to be the one to sell each a first television set.

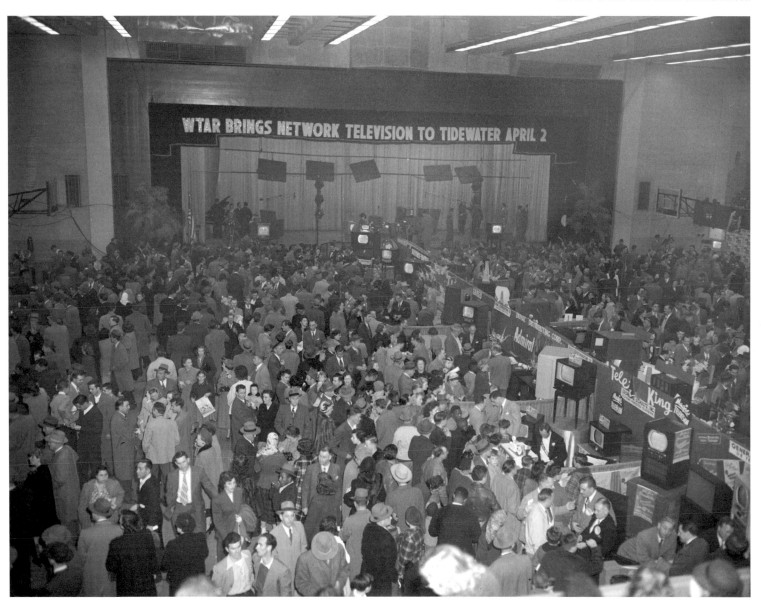

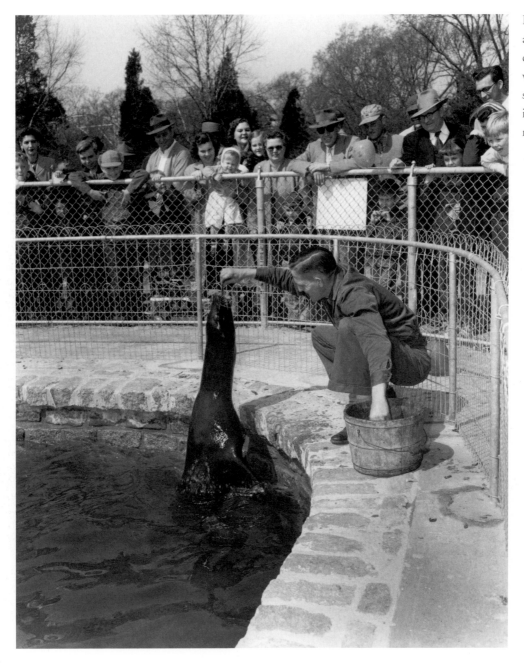

It's lunchtime for sea lions at the Norfolk Zoo and an expectant crowd gathers to watch the animals put on a show, clapping and barking in anticipation of a nice meal of fresh fish.

These pint-sized skippers take to the briny in the kiddie boat concession at Ocean View Park, July 1950.

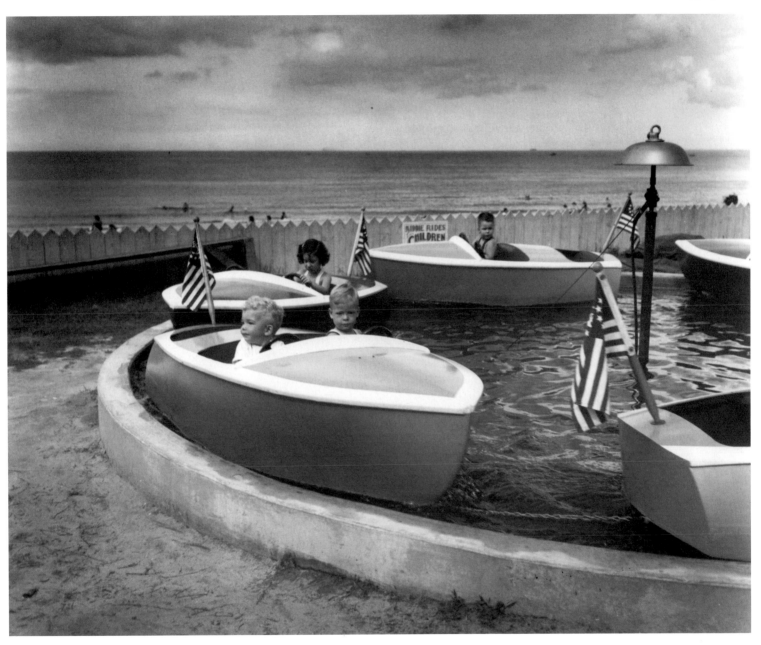

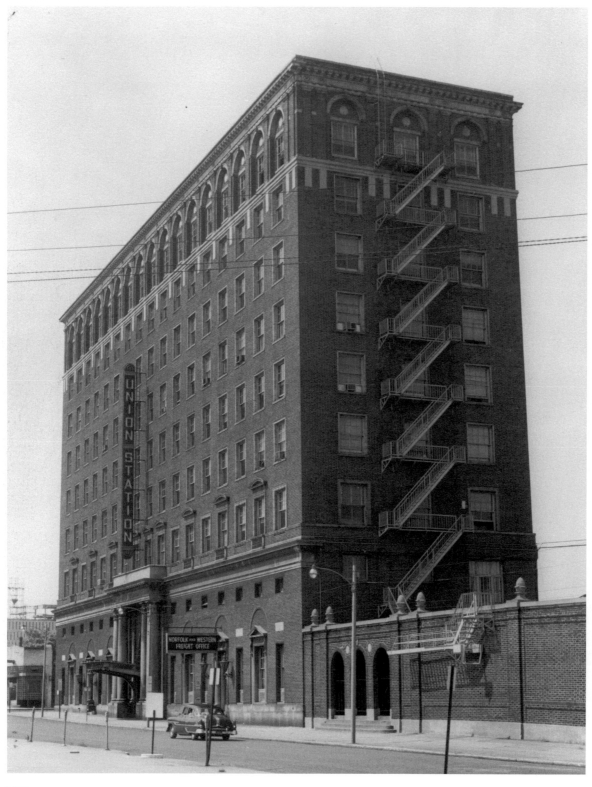

Still active here in 1960, the Union Station on East Main Street served passengers traveling on the Norfolk and Western Railroad from 1912 until the building was demolished in 1963.

178

The year is 1959, and vestiges of East Main Street's heyday linger in the corner tavern, the Krazy Kat Lounge, and the empty beer kegs set out for replenishment in front of the Midway. In a few years it would all be gone.

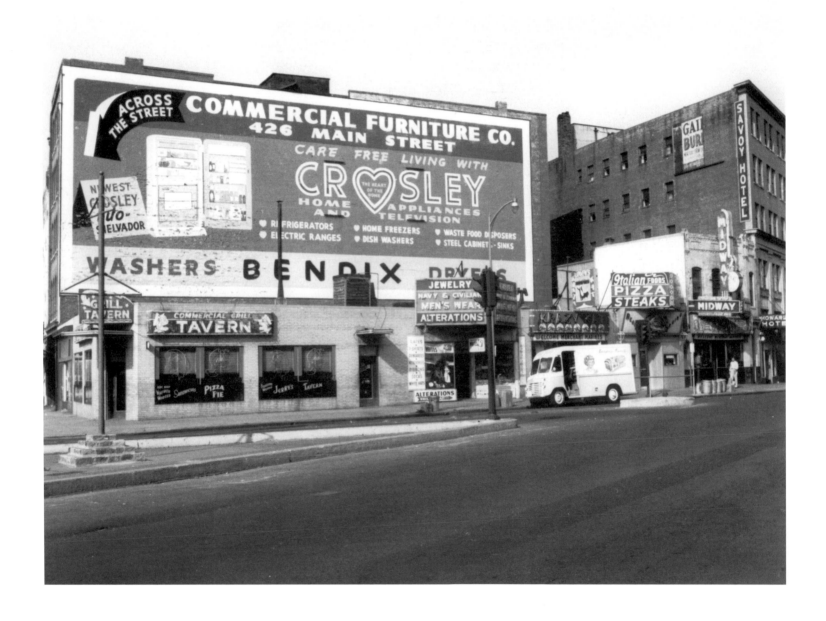

Grandy Park goes home with the trophy, presented by a ponytailed Miss Playground, in the 1956 Pushmobile Derby sponsored by the Norfolk Recreation Bureau. The teams numbered 16 and 6 won the Consolation Prize and the Booby Prize, respectively.

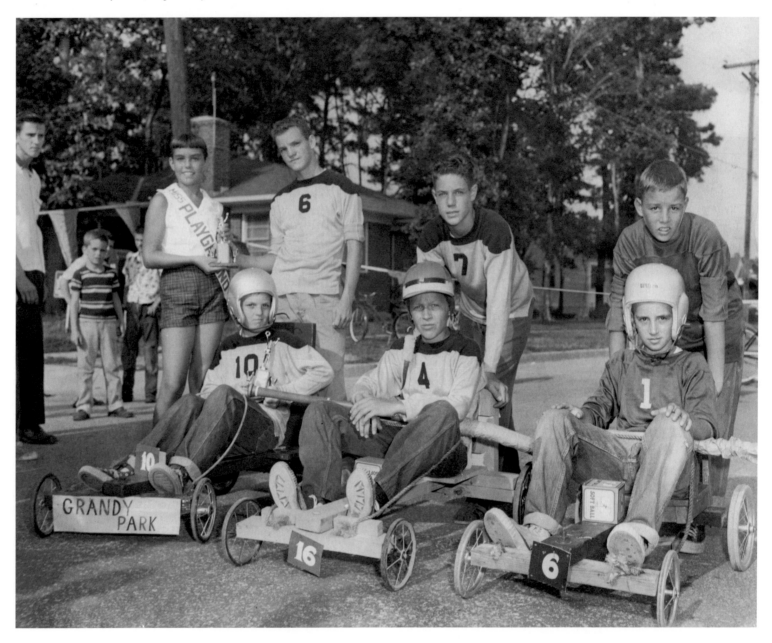

George H. Schomaker opened his popular Schoe's Restaurant at 114 E. 21st Street in 1947. The food was good at the busy, popular drive-in, but the main attraction was the waitstaff, who served meals at carside while wearing roller skates.

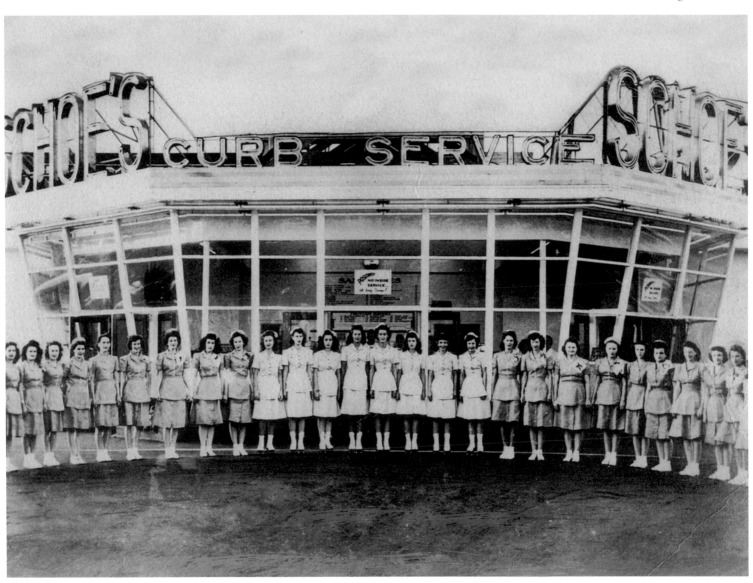

The annual Oyster Bowl football game, sponsored by the local Shriners, raised money for the care and treatment of disabled children under the slogan "Strong Legs Run That Weak Legs May Walk." The parade, with its marching bands, majorettes, floats, clowns, and Shriners weaving in and out on undersized vehicles, was a favorite pregame event, as here in 1963.

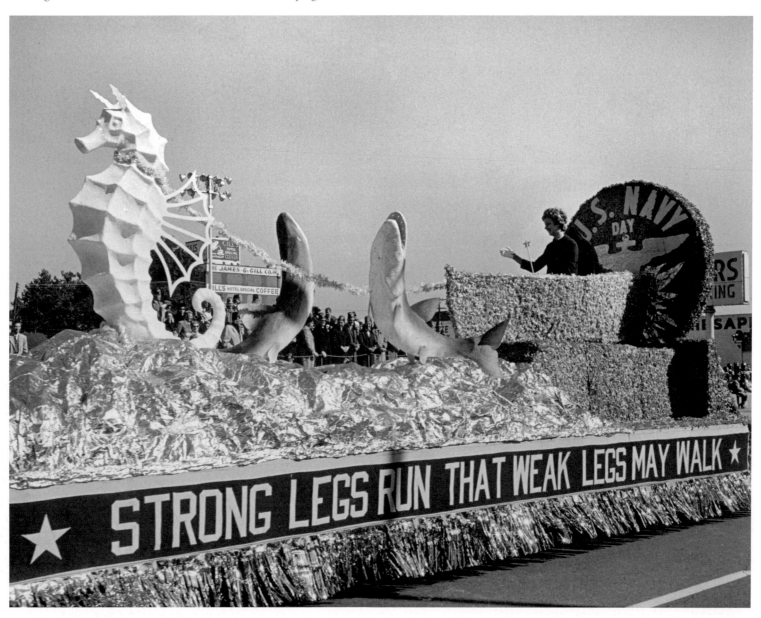

A view of the rides at Ocean View Park from the shade of the picnic pavilion. The Ferris wheel can be seen in the near distance. The tower in front of the Ferris wheel supports the Rocket Ship, a descendant of the Circle Swing, which was Ocean View Park's first electric ride, installed in 1906.

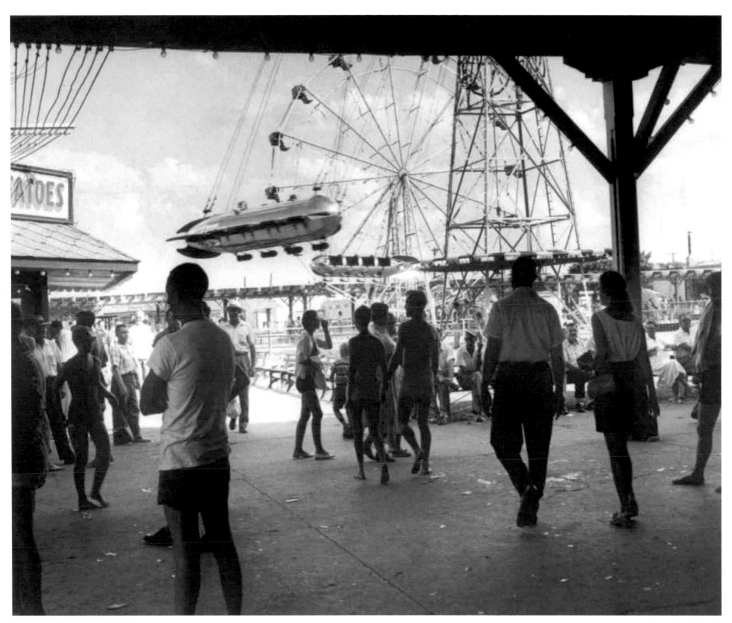

Round and round and round you go, stirring up nothing but fun on the teacup ride at Ocean View Park. In just a few years these young men will probably learn that the teacup ride is also an excellent opportunity to give your best girl a hug as the whirling cup slides her in your direction. All in good fun.

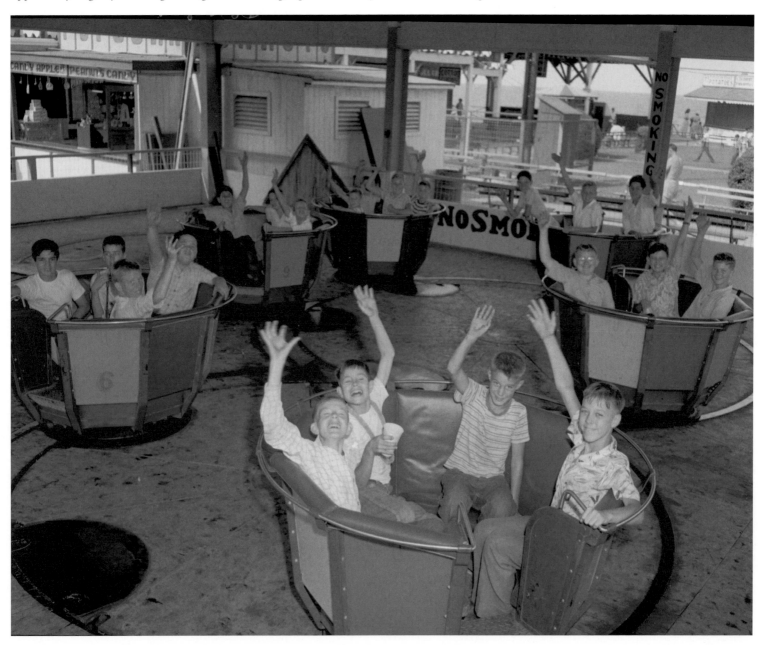

This snapshot, probably taken outside of Arthur's Drug Store on Church Street around 1965, could have been a scene of coming of age anywhere in America. A soda shop, your best girlfriends, a secret to share a laugh over—and a memory to last a lifetime.

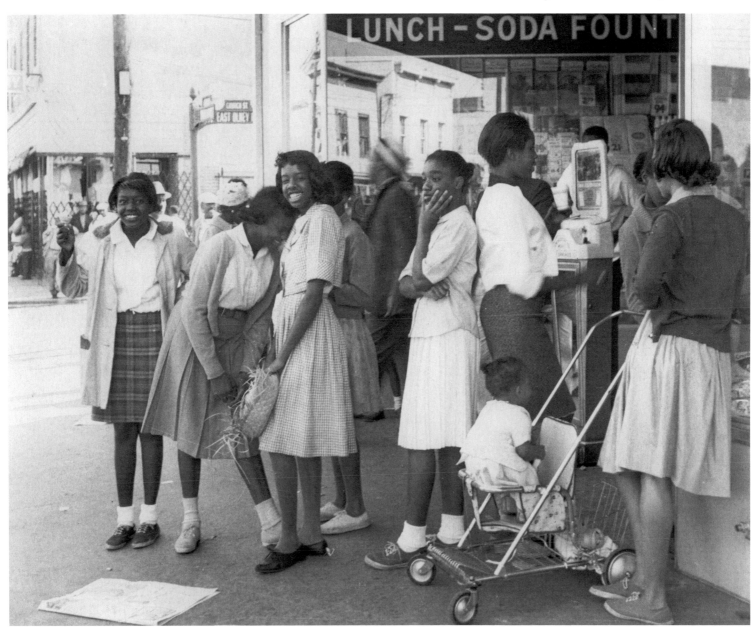

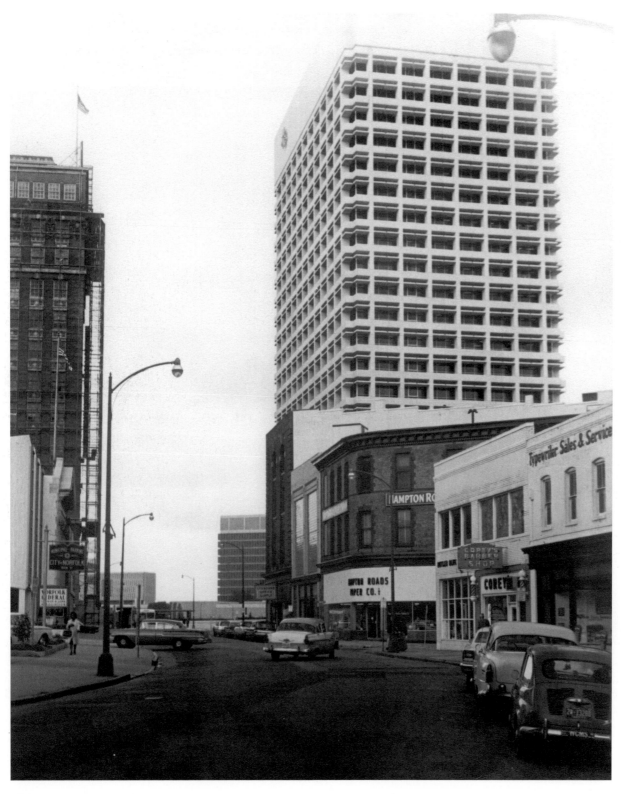

Looking east on Main Street near Commerce Street in April 1968. The brand new Virginia National Bank Building, to the right, towers over its predecessor, the old National Bank of Commerce, directly across the street. At 13 stories, the National Bank of Commerce was Norfolk's tallest building until the late 1950s. The 23-story VNB building left the Bank of Commerce in the dust and remained Norfolk's tallest building into the late 1980s.

Norfolk initiated the International Azalea Festival in 1954 to honor a NATO nation annually in April, when Norfolk is abloom with azaleas. Bonnie Ruth Buchanan, the daughter of U.S. State Department Chief of Protocol Wiley Buchanan, served as Queen Azalea VI. Here she waves from her perch on the back of a Thunderbird convertible during the 1959 festival parade on Granby Street.

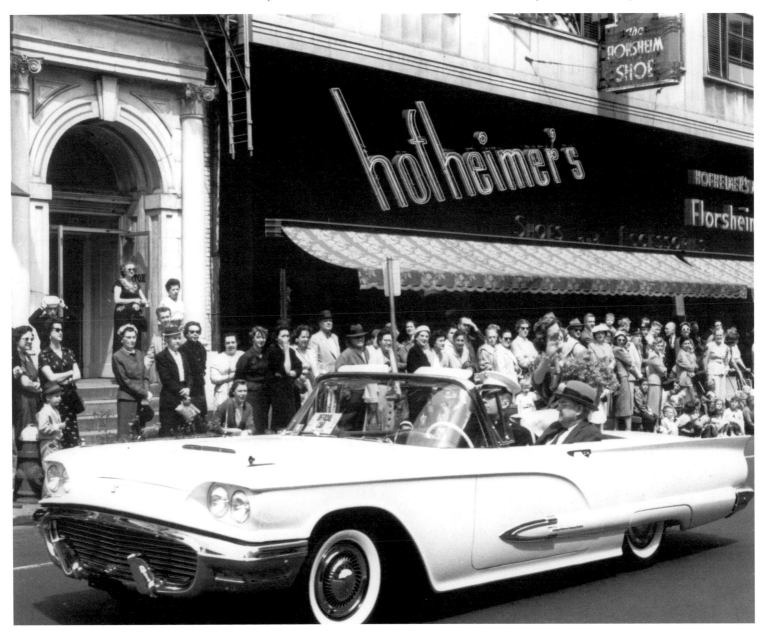

The Azalea Festival Parade, with an American Indian on horseback, progresses down Granby Street, April 16, 1959.

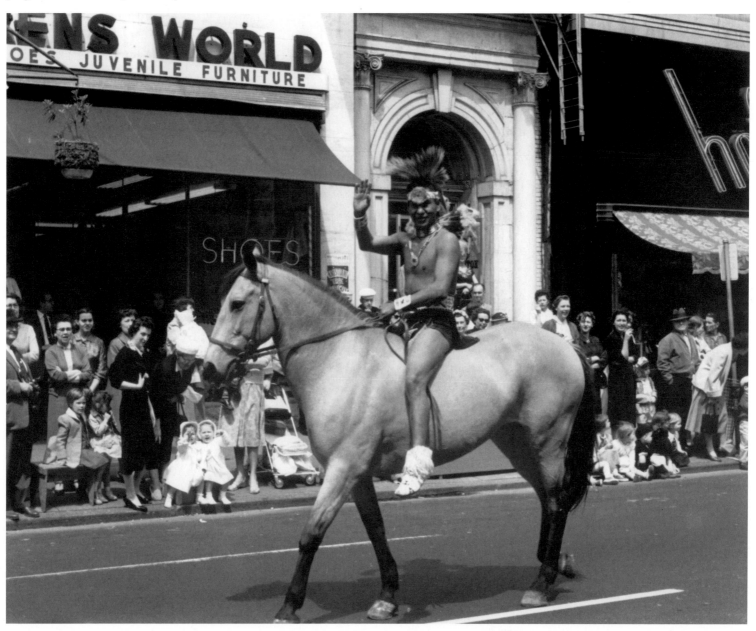

A mission for slaves was begun by the Cumberland Street Methodist Episcopal Church around 1840. The congregation grew, and by 1863 there were more than 800 members. The church became a part of the African Methodist Episcopal Church the same year. The present church was built on Bute Street in 1888 and included the first pipe organ in an African American church in Virginia.

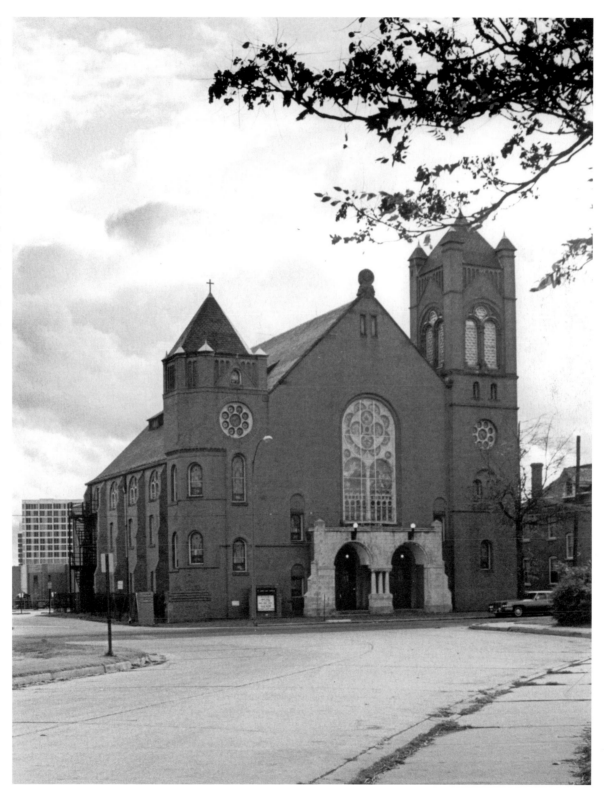

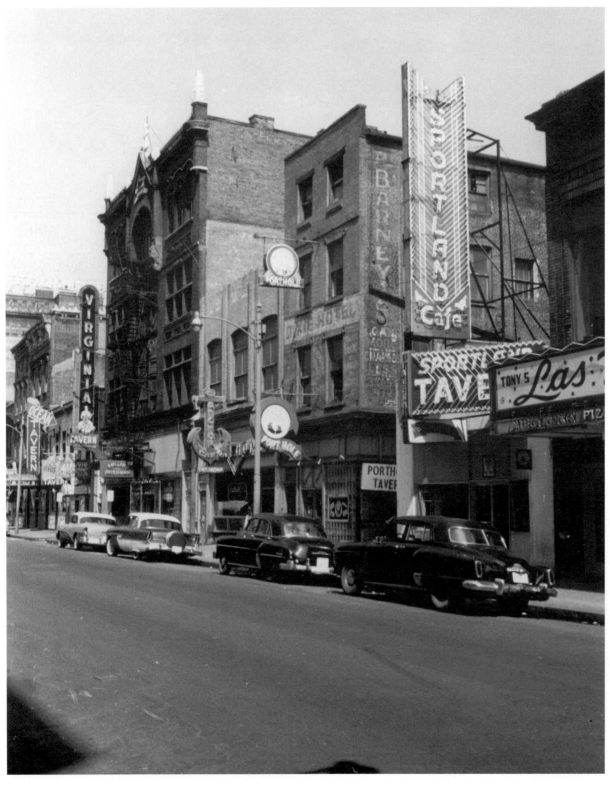

A view of the 400 block of East Main Street in 1959, shortly before the world-renowned taverns and dance halls met with the wrecker's ball during the city's third phase of redevelopment. The last remaining establishments closed on New Year's Eve 1961. Work started on the city's new office-and-financial district the following year.

Gone but not forgotten. Ocean View's wooden "Leap the Dips," aka "Rocket," aka "Southern Belle" roller coaster thrilled and terrified riders with its creaking frame and heart-stopping plunges. After the park closed, the roller coaster had one final hurrah as the star of the 1979 made-for-TV disaster movie *Death of Ocean View Park*. When it came time for the coaster to topple, on June, 29, 1979, it refused to budge, withstanding three unsuccessful charges of explosives before being brought down by a bulldozer from local contractor E. T. Gresham.

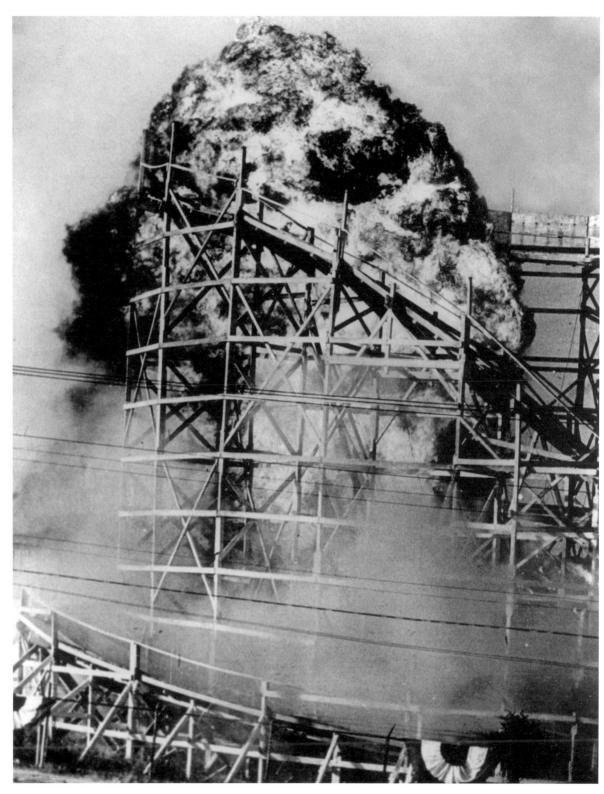

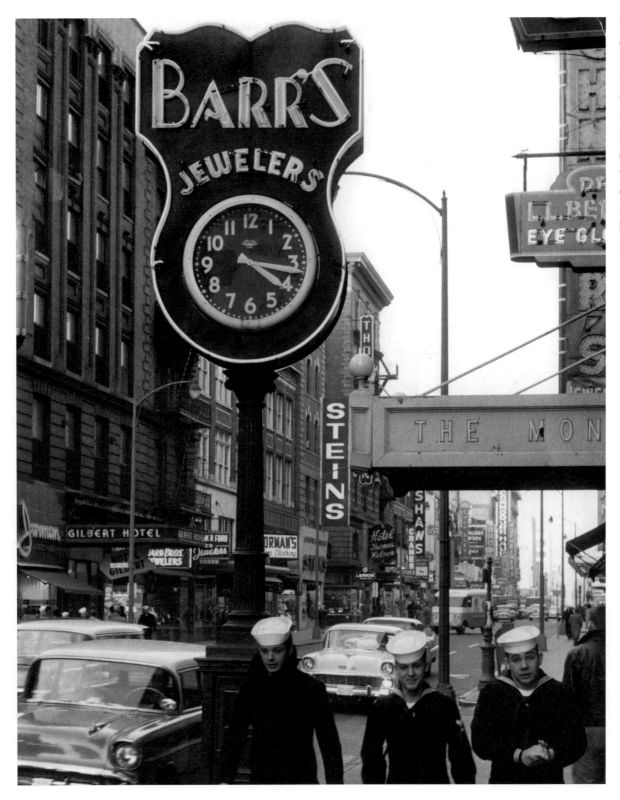

"Bell bottom trousers, coat of navy blue." Enlisted men assigned to Norfolk's Naval Operating Base, with their distinctive pea jackets, middy blouses, and Dixie Cup hats, were a familiar sight downtown when this trio was snapped passing beneath the Monticello Hotel marquee in 1959.

It was a grand day in Norfolk on May 23, 1952, as the first tunnel crossing underneath the Elizabeth River between Norfolk and Portsmouth was officially opened to traffic. Gone were the long waits to gain space for one's vehicle on the car ferry—now one could motor through the tunnel in a matter of minutes for a toll of only a quarter.

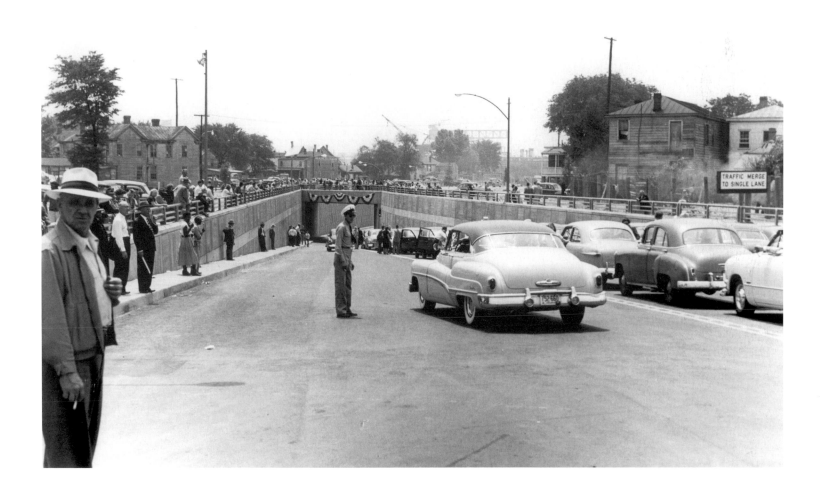

Looking south on Brewer Street from Market Street in February 1960, as the markets and provenders that grew up as adjuncts to the City Market in the 1930s and 1940s are enjoying their final days. The old City Market and Armory were torn down in 1959, to be replaced by the Rennert Building, or "Maritime Tower." Soon these smaller satellites will be gone as well, as much of the old downtown is cleared to make way for a revitalized commercial area.

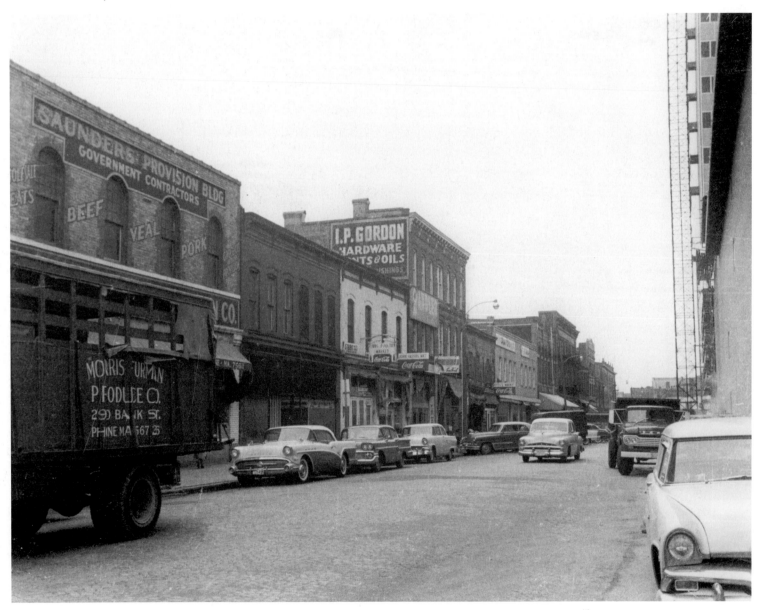

Charles Emmanuel "Sweet Daddy" Grace founded his first House of Prayer for All People in Charlotte, North Carolina, in 1926. A church was established in Norfolk in the 1930s and, by the time of Bishop Grace's death in 1960, his flock numbered in the thousands, with red, white and blue–painted Houses of Prayer in 67 major U.S. cities. The congregation worshiped in the East Freemason Street building shown here from 1955 to 1960. The building, constructed in 1828, originally served the congregation of Christ (Episcopal) Church.

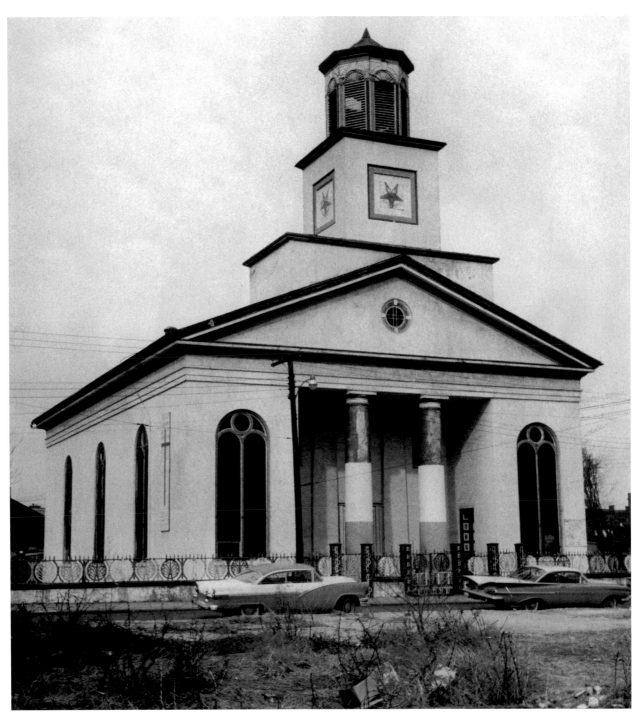

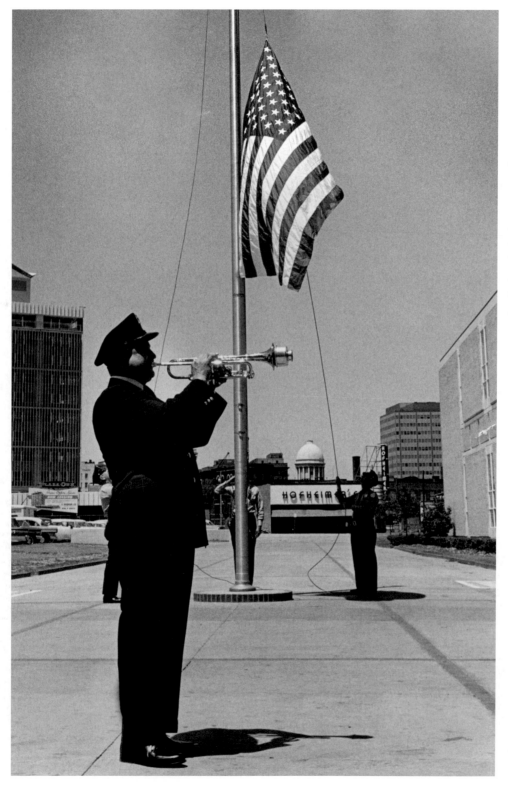

The U.S. Congress enacted National Police Week in October 1962, authorizing President John F. Kennedy to declare May 15 as Peace Officers Memorial Day, when special tribute would be paid annually to fallen officers across the nation. The week in which May 15 falls is observed as Police Memorial Week. Here, in May 1963, a Norfolk officer plays "Taps" and the American flag is lowered to half-staff in City Hall plaza in honor and memory of the 28 members of the Norfolk Police Department who had died in the line of duty.

Eastward aerial view on East Main Street from the National Bank of Commerce, around 1962. The City Jail and General District Court building, upper left, have just been completed, and ground has been cleared for the rest of the new Civic Center complex—the two-story Norfolk Circuit Court building and 11-story City Hall.

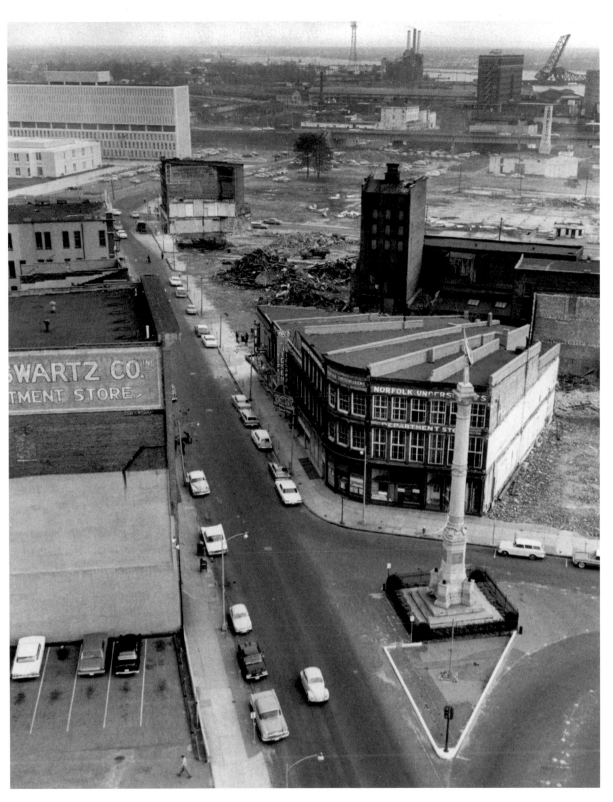

Five-star General Douglas MacArthur was the youngest child of a career Army officer and grew up on Army bases around the world. Because his mother, Mary Pinkney "Pinkie" Hardy, was born in the town of Berkley in Norfolk County, young MacArthur thought of Norfolk as his home. After retirement, the general agreed to house his papers and memorabilia in the newly vacant 1850 Norfolk court building (now the MacArthur Memorial) and asked that he and his wife be interred beneath the building's rotunda upon their deaths. MacArthur died at Walter Reed Medical Center on April 5, 1964, and was buried in Norfolk on April 11 following a religious service at St. Paul's Church.

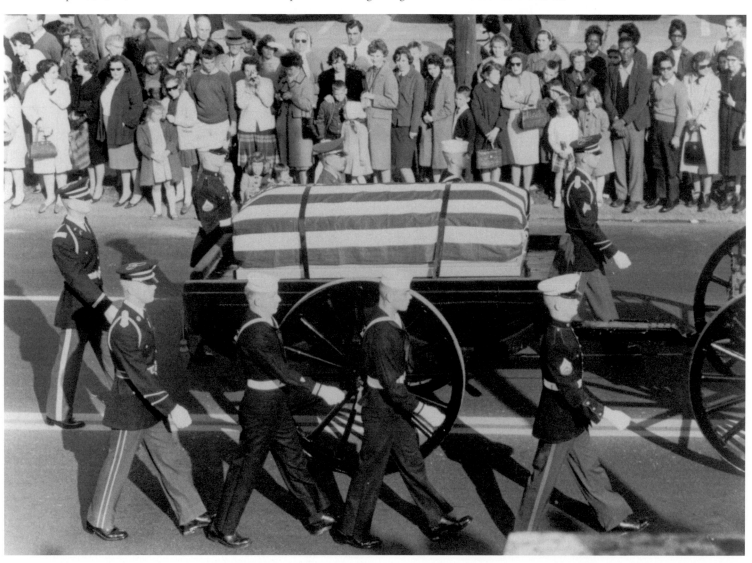

Looking north on Bank Street from the National Bank of Commerce building in July 1960, with the steepled Freemason Street Baptist Church in the background. Later dubbed the "17 acres," this was the site of Norfolk Town's first expansion in the early eighteenth century, after its population began to overflow the original 1680 boundaries. Many of the tired-looking buildings seen here would soon be torn down for downtown revitalization. The acreage would remain vacant for many years, until MacArthur Center opened on the site in 1999.

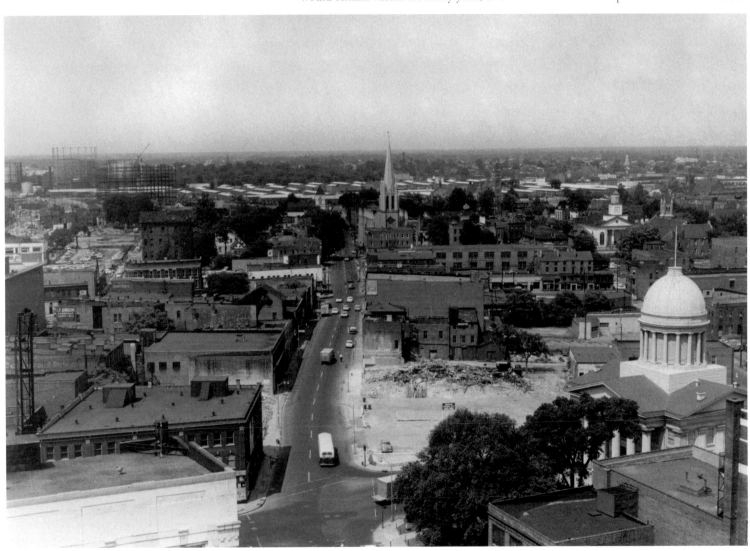

Notes on the Photographs

These notes, listed by page number, attempt to include all aspects known of the photographs. Each of the photographs is identified by the page number, photograph's title or description, photographer and collection, archive, and call or box number when applicable. Although every attempt was made to collect all available data, in some cases complete data was unavailable due to the age and condition of some of the photographs and records.